MEXICAN
FOLK
RETABLOS

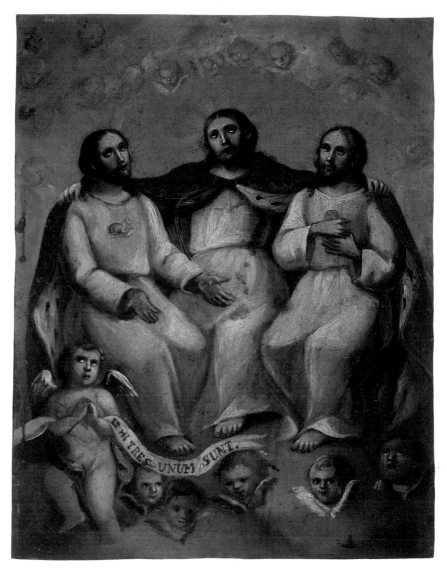

La Trinidad
9¼″ x 14″

MEXICAN FOLK RETABLOS

REVISED EDITION

GLORIA FRASER GIFFORDS

PHOTOGRAPHS BY JERRY D. FERRIN

UNIVERSITY OF NEW MEXICO PRESS

ALBUQUERQUE

This book is dedicated
 To the Mexican people,
 For it is their story.
It is dedicated to my family,
 For their unselfish effort
 Made my work possible.
But this book especially
 Is dedicated to my sister,
 Ruth-Joyce Vacin,
For her love, faith, and courage
 Have taught me to understand
 The silent testimony of
The Mexican folk retablo.

Library of Congress Cataloging-in-Publication Data

Giffords, Gloria Fraser, 1938–
Mexican folk retablos/Gloria Fraser Giffords;
photographs by Jerry D. Ferrin.—2nd ed.
 p. cm.
Includes bibliographical references and index.
ISBN 0-8263-1368-X
1. Votive offerings—Mexico.
2. Painting, Mexican.
3. Folk art—Mexico.
I. Title.
ND1432.M45G53 1992
755'.2'0972—dc20 92-10494
 CIP

CONTENTS

LIST OF ILLUSTRATIONS

Part 2. Retablo Saints (in alphabetical order)

Part 3. Ex-Votos (in chronological order)

ABBREVIATIONS

Because the text accompanying the illustrations uses a number of abbreviations to designate religious orders, ecclesiastical or social position, manner of death, and so on, a list is presented here for the reader's assistance. These are standard abbreviations found in almost every hagiography or iconographical work. In addition to these standard abbreviations, the reader will find a number of localized or idiosyncratic abbreviations on the retablos and ex-votos. A list of the nonstandard abbreviations which appear in this book with their Spanish meanings has also been provided.

STANDARD RELIGIOUS ABBREVIATIONS

Abs.	Abbess
Abt.	Abbot
A.C.	Approved Cult
B.	Bishop
b.	born
Bd.	Beatified
Bl.	Blessed
Card.	Cardinal
C.C.	Ancient cultus confirmed by Holy See
Cd.	Canonized
Comp.	Companions
D.	Deacon
d.	died
Dr.	Doctor
Ev.	Evangelist
H.	Hermit
h.d.q.	hanged, drawn, and quartered
M.	Martyr
O.Carm.	Carmelite Order
O.Cart.	Carthusian Order

O.Clare	Poor Clares Order
O.F.M.	Friars Minor (Franciscan) Order
O.Merc.	Mercedarian Order
O.Min.	Minims Order (or Hermits of St. Francis)
O.P.	Dominican Order (Ordines Praedicatorum)
O.Praem.	Praemonstratensian Order
O.S.A.	Augustinian Order
O.S.B.	Benedictine Order
O.S.B. Cam.	Camoldolese Order
O.S.B. Vall.	Vallombrosian Order
O.S.N.	Servite Order
U.S.Trin.	Trinitarian Order
P.C.	Popular Cult
Q.	Queen
R.M.	Roman Martyrology
S.J.	Society of Jesus (Jesuits)
V.	Virgin
V.M.	Virgin Martyr
W.	Widow

NONSTANDARD ABBREVIATIONS

Da.	Doña
Dn.	Don
Ma.	María
Na.Sa.	Nuestra Señora
NN.SS.	Nuestras Señores or Señoras
N.S.	Nuestra Señor or Señora
Sma.	Señora
Sn.	San
Sor.	Señor (Dios)
Sr.	Señor (Dios)
SSmo.	Santisimo
Sto.	Santo
1a., 2a., 3a., etc.	primero, segundo, tecero, etc.

PREFACE TO THE
FIRST EDITION

The painting of religious images on sheets of tin was a flourishing folk art tradition in central Mexico during the nineteenth century. Popularly called *retablos*, these small paintings can be found today in scattered Mexican homes and shrines and in many antique and curio shops both in Mexico and the United States. Modern interest in folk art has created a market for retablos, which are being purchased by tourists and collectors, but very little serious study has been made of them.

The lack of scholarly attention is interesting, for the Mexican folk retablo has intrinsic value as primitive art and offers deep insights into Mexican society of the past. It has often been said that to understand a society one must understand its art. The virtually unknown and largely unappreciated retablo speaks a language that is unique and understandable, reflecting the customs and beliefs of a Mexico that has now virtually disappeared.

This book attempts to initiate serious study of this minor artistic genre, including analysis as well as description. The volume consists of four elements. The first part describes the characteristics, development, and distribution of the retablo. The second part concentrates upon iconography (the study of conventional imagery), describing and analyzing the significance of the images which appear on these small paintings on tin. Next comes a brief consideration of the ex-voto, with emphasis on those characteristics which compare interestingly with the retablo. A fourth element of the study, which is interspersed among the first three parts, consists of illustrations of retablos and ex-votos with descriptions and commentary. Appendixes, notes, and a selected bibliography supplement this material.

The Illustrations

The reproductions of Mexican folk retablos presented in this book show Christ, Mary, popular saints, and angels in various manifes-

tations. Included are the saints which, to judge by their frequent appearance, were the most popular during the period of roughly a century when this art form was being produced. Others have been selected for their uniqueness, interesting aspects, or artistic merit.

The text accompanying the illustrations discusses each holy personage as he appears in retablo art. Significant elements of the lives of the saints are included, since they may assist in demonstrating a point or explaining some attribute or element of patronage, but there is no intention to provide complete accounts of the saints' lives. In areas of conflict between references, Butler's *Lives of the Saints* was preferred because of its recentness, accuracy, and wide use by modern hagiographers and scholars. To relate the saints to their historical periods, death dates are given, and each saint's day or feast day (according to the *Roman Martyrology*) is indicated for the benefit of readers who may wish to consult hagiographies for further data on individual saints. The patronage that a particular saint represented has been indicated because this often influenced the manner in which the saint was portrayed.

Retablos depicting Christs and Madonnas occur in Part 1. Retablos which picture saints will be found in alphabetical order in Part 2. The illustrations in Part 3, "The Mexican Ex-Voto Painting," naturally consist of ex-votos, in chronological order.

The ex-votos illustrated are samplings from various Mexican shrines and churches. They depict an assortment of miracles over a span of 170 years. All of them are painted on tin with the exception of the earliest (an ex-voto dated 1797, fig. 65), which is on canvas, and the most recent (ex-voto dated 1961, fig. 81), which is on Masonite.

In the transcripts of the text are included both the original Spanish as it appears written and an English translation, which is most often literal in an attempt to retain the original flavor. Blanks represent words no longer legible.

All illustrative materials in the book have been photographed by Helga Teiwes-French from the author's collection. The collection exceeds four hundred pieces ranging from works of obviously trained artists to the efforts of those delightful, self-styled painters whose humor and individual mannerisms have made retablo art down to earth and very human. All of the paintings illustrated are done in oil on tin, except where otherwise noted. The sizes indicated under the figures are to the nearest quarter inch. Four unusually small retablos—figures 21, 25, 32, and 48—appear in this book in their actual sizes.

The Research

Throughout the book, existing references were utilized whenever possible. However, these were so scattered and inadequate that independent research was necessary in almost all areas. This research had two major goals: (1) to determine the date, artist, and place of production of each retablo examined in hope of discovering major trends, and (2) to determine the identity, function, and patronage of each saint pictured, revealing the fluctuating popularity of individual saints through the years in Mexico. Research approaches differed for each of these objectives.

Work toward the first goal was particularly difficult. The fact that most retablos are undated, unsigned, or signed with an untraceable name or initials often made identification of dates, artists, or locations impossible. The main clues to this information were ex-votos, votive paintings which usually include the date and location in a written text and which were often painted by the same artists who painted the retablos. Unfortunately, because of the vast quantities of both ex-votos and retablos and because of human limitations in examining and comparing thousands of them, this method of date and area correlation was not totally satisfactory. The method that thoretically was so neat proved to be staggering when it was applied to the large area and amounts of material.

As it was, the comparison of the two types of religious art did show broad patterns of development and later deterioration which enabled the writer to make general conclusions concerning dates and locations. This method also made it possible for conclusions to be drawn about changes in techniques and abilities of the artists as well as changes in saints' costumes and local legends concerning the saints.

Another revealing area of comparison was provided by the New Mexican folk retablo. Fortunately, a tremendous amount of research has gone into this North American folk art, whose genesis and disappearance roughly parallels the dates of its Mexican counterpart. Although the similarities between these two types of retablos are balanced by dissimilarities,* both the written material

*Mexican and New Mexican folk retablos were both painted by artists who had negligible formal training, expressed a devout feeling, and displayed ingenuity in overcoming technical difficulties of media. The paintings also frequently portray the same holy images. However, the differences between the two arts are numerous. In Mexico the greater population logically provided more retablo painters, so that there was a wide variety of

concerning the New Mexican paintings and physical examination of the paintings themselves provided helpful information regarding dates and saint identification.

In the process of examining approximately 3,500 retablos, it became clear that some saints and manners of representation appeared more frequently than others. Through constant recurrence, these patterns of similarity assumed significance helpful in identification of artist, date, and area, adding to the clues provided by the ex-votos and New Mexican retablos.

Research concerning location consisted mainly of questioning dealers in retablos in Mexico about the general areas where the paintings might be found and then investigating those areas. Local clerics and townspeople were asked if they knew what a retablo was, if they had ever seen or possessed one, and, if not, whether they knew of anyone who did. Persons who showed any knowledge were asked other pertinent questions.

The interviews yielded no tidy conclusions. But with the material collected, the areas visited, and conversations recorded, sufficient background was obtained for a basic study. Because of the inability to determine exactly the artist, date, and area of production for most retablos, only the broadest plotting of this information has been used in this book, rather than citing specifics for a few retablos and giving none for most.

The second goal of research—to determine the identity and patronage of each saint pictured on the retablos examined—has had little, if any, previous attention. Work in this area was greatly aided by the use of hagiographies, old missals, and books on iconography. Fortunately, retablo artists were generally faithful to prescribed iconography. If personal idiosyncrasies and purely regional notions had been followed, the entire retablo movement would have been reduced to utter confusion. The artists, however, adhered strictly to the dictates of the Catholic Church and the Twenty-fifth Council

readily distinguishable styles and a wider geographic area of distribution. There was also a difference in media, as tin was abundant in Mexico while New Mexico depended on an equally inexpensive and available material, wooden planks. The Mexican retablos are much more sophisticated because the artists who painted them were in closer contact with metropolitan areas and with imported and trained art, whereas the New Mexican artists worked in a cultural backwater. An untrained eye would have trouble distinguishing between the work of different New Mexican artists, but the Mexican work can be more easily classified due to the greater variety of influences and the greater number of individuals and areas involved.

of Trent and carefully presented the holy personages in the pre-
scribed manner and with the traditional symbols, albeit at times
familiarized or "Mexicanized."

Interviews with people who might be acquainted with retablos—
priests, dealers in antiques, and the possessors or ex-possessors of
the paintings—were also employed in an attempt to determine
identities and patronages. Spontaneous and enjoyable though they
were, these visits simply did not yield informative narratives or
establish contact between the modern Mexican and his ancestors'
religious aids. Retablos had been too ordinary and humble to cause
much reflection by their owners, and their ages indicate that they
outlived their original devotees. With each succeeding generation
forgetting more and caring less about the retablo, it was often futile
to discuss the subject with individuals. The fact that the paint-
ings frequently have been discarded and replaced by inexpensive,
machine-produced lithographs or photographs indicates a loss of
interest on the part of modern Mexicans in the continuation of this
tradition. The inability of individuals in most cases to recall which
saint a retablo portrays, excepting a handful of favorite saints who
are also popular today, is indicative of the modern emphasis on a
few holy persons rather than the previous large numbers. This lack
of knowledge extends even to the clerics in Mexico.

Despite such difficulties, the research led to identification of
many of the saints pictured on the retablos. This information was
then analyzed to determine the popularity of specific representa-
tions in the nineteenth century. By recording the percentages of
the various images, and comparing these with the results of two
previous surveys, a broad and changing pattern of popularity was
determined.

Modern inability to recall the identifies of retablo saints is
matched by a lack of memory for their patronages. The area of
healing or other aid in which each saint was particularly effica-
cious frequently has been forgotten. This problem is compounded
with Christ or Mary, who can rarely be identified with any specific
area of protection because they were usually invoked for many
complaints. Books on iconography were used to supplement the in-
formation concerning popular patronage beliefs which did come
from the interviews.

In this book local beliefs regarding patronage—such beliefs as
might be held in only one village—have been omitted in favor of
more general beliefs, for only confusion can result from including
all the variations. For example, San Cayetano is regarded as a
founder of the Theatines and, on the basis of his life, may be

sought for money. However, one individual queried about his patronage remembered that in her childhood he was appealed to by her family to bring rain. There is no element of his life or legend connected with rainmaking, and such a belief, while it could be considered as part of his extended protection, must be set aside as a purely local or personal idea.

Although the research for this book took years and was at times frustrating, it was infinitely rewarding. The trips into Mexico, the many interviews with the people, offered insights into the meaning of the folk retablo in nineteenth century Mexico. In the simple home the little image of a saint painted on tin, probably lighted by the only candle in the room, was the touchstone to another life. The value of the retablo may thus be appreciated as a testimony to an era when images were produced for the faithful, by the faithful. Like the icon, the retablo was a common object of veneration, and it has been recognized today as an art form that is distinctive and unique.

Acknowledgments

I wish to thank various individuals for their help during the preparation of the thesis from which this book developed. Justino Fernández, director, Instituto de Investigaciones Estéticas, Universidad Nacional Autónoma de México, provided insight and direction. E. Boyd, curator of Spanish Colonial Art, Museum of New Mexico, Santa Fe, and Robert L. Shalkop, curator, Taylor Museum of Fine Art, Colorado Springs, generously discussed the material and allowed the comparative New Mexican art to be examined. Jorge Olvera, Instituto Nacional de Antropología e Historia; Charles di Peso, Amerind Foundation; Arturo Woodward; and Francisco de la Maza all contributed ideas and identifications.

Appreciation is also expressed to Charles Polzer, S.J., and Kieran McCarty, O.F.M., for assisting on theological points. Special acknowledgment is made of Elizabeth Wilder Weismann and Pál Kelemen, who were kind enough to read and comment on the manuscript. Mary del Villar provided valuable editorial help.

Olga de Jong generously labored on the translations and provided her background as a scholar and a Mexican. The photographs of the retablos and ex-votos were done by Helga Teiwes-French, Arizona State Museum. I thank Marshall Townsend, Karen Thure, and the rest of the staff at the University of Arizona Press for their confidence, cooperation, and skill in projecting the book into its published form.

Finally I am deeply indebted to the many individuals in Mexico
and the United States who generously shared their knowledge.
They range from museum personnel and professors to clergymen
and collectors. My last word of thanks, however, must be voiced to
the people of Mexico, to whom this effort is dedicated.

GLORIA FRASER GIFFORDS

PREFACE TO THE SECOND EDITION

I am gratified by the desire of the University of New Mexico Press to make this material once again available to the public. Appreciation of retablos has grown considerably over the last thirty years, and the original book stimulated interest in the subject.

It has been almost twenty-five years since I began studying retablos, and oddly enough my interest has never waned. I never ceased examining them wherever and whenever possible. It would not be an exaggeration to say I have looked at more than 25,000 pieces, the overwhelming proportion being the retablo santos.

The first edition of this book was the result of research for my master's thesis at the University of Arizona (1968). Having married a man who had family and friends in Mexico, we traveled throughout the country extensively. I was more than just attracted to Mexico, and to its art and people; it was like an intoxication. I wanted very much to do research in some specialty that would require me to be in Mexico. I wanted to study something both accessible and unique, something that would require primary sources.

No author, Mexican or otherwise, had published on the topic of the retablos santos, although some made reference to the retablos ex-votos. Out of necessity, my sources were hagiographies, lives of saints, *novenas*, and *estampitas* (inexpensive popular religious prints of prayers and images), *buscadores* (Mexican peddlers), dealers in Mexico, members of the religious communities in Mexico, and the Mexican people. I knew only a couple of collectors then, but academically they weren't very helpful. I'm not even certain now if I thought it was important to seek out others. Sometimes I facetiously felt like the Biblical inspiration for *La Vendimia Mística* (a title I used incorrectly for representations of El Varón Eucaristico de los Dolores, Plate 9): "I have trodden the winepress alone; and of the people there was none with me." The retablo was a fascinating subject made more mysterious by the difficulty of identifying sources. (Dealers and peddlers are generally not willing to share their sources.) A few collections consisting mostly of re-

tablos santos existed in museums in the United States, but without any provenance or research, and none existed in Mexico. A number of Mexican sanctuaries were festooned with ex-votos, but access to them was severely limited. Many middle- and upper-class Mexicans acquainted with the subject tended to denigrate retablos as common trinkets of the unsophisticated, not worthy of collecting or preserving. At that time in Mexico, popular art was generally regarded as inferior to European academic or polished examples of "fine art," an attitude shared even by academics here in the United States. Among the former owners of retablos santos the objects had lost their cherished status and spiritual importance and were sold to peddlers to be replaced by something modern. I did find bright spots in my research, though. Individuals like Justino Fernández and Francisco de la Maza were willing to discuss the subject with me, encouraging and admonishing me to treat retablos with the respect they were due. The lack of written material on the specific topic forced me to broaden my research and spend time in the field interviewing people.

If I were completely to redo the material today, I might make a different selection of illustrations, owing to a greater number of pieces in my own and other collections. (The illustrations here represent a collection gathered between 1965 and 1968.) However, the variety of topics and artists in the present book is a good mix, and in reading the text I think it remains relevant today, containing much useful information on the topic in general and on specific subjects. Errors made in iconography and titles have been corrected in this edition.

In the past twenty-five years the retablo as a subject has greatly expanded because of a much larger number of collections and a wider appreciation of popular art. Furthermore, the study of folk retablos and their use is a springboard for researchers, curators, and artists in a number of ways. For me and others, retablos helped create a framework for research on other Mexican religious imagery, nineteenth-century Catholic cult beliefs and practices, the distribution of goods—including means and methods—manufactured in the United States and Europe throughout nineteenth- and early twentieth-century Mexico, a people's history, demographic distributions, narrative art in general, and influences and use of religious imagery in Latino and Chicano art.

One thing became readily apparent to me: although no one else had done the research or had written on the subject, as soon as the book was published, I heard a great deal of advice from a pool of people as avid as I. Collectors and dealers identified themselves—people to whom I had not previously had access; scholars, histo-

rians, and iconographers made corrections or revised terminology; and most important, new ideas for development of further research began to formulate.

First, there was the matter of other names for the subject. I had used *retablo* in general to describe the small, nineteenth-century Mexican paintings on tinplate of religious subject matter. I identified the two types in the text as retablos santos (images of religious personages intended for personal devotional purposes) and ex-votos (paintings done to commemorate and give thanks for a healing or a rescue from certain death or physical damage, intended for placement in a church or sanctuary near the image of the religious figure that had provided the assistance). I have learned that in certain parts of Mexico, particularly in the central section, the paintings of the saints are called *láminas* (referring to the tinplate support) and the ex-votos are called retablos. These terms vary from region to region.

From 1988 through 1991, I examined 12,000 retablos santos and photographed 1,000 in Mexico and the United States in a concerted effort to assemble a traveling exhibit which opened at the Meadows Museum of Art in March 1991.[1] This exposure created a unique opportunity for me to form impressions concerning the authorship of these mostly anonymous paintings. Seeing that number of pieces in such a short time allowed me to recognize certain common features and identifiable hands and workshops. I even had the opportunity to match a few painters of the retablos santos to ex-votos, indicating possible areas of production and dates. I was able to give some of these artists working titles. For example, Figures 24 and 54 were done by the same individual and share certain characteristics, particularly in the way the mouth is deliberately highlighted to create a "bee-stung lip," hence the "bee-stung lip painter." Ex-votos by this artist have been found that date to the late 1880s and early 1890s, and the area for production may be around Zacatecas. The artist of Figures 12, 21, and 25 I call the "calligraphic line painter" because of the decorative quality of the line. No ex-votos have yet been found by the same hand. Figure 63 was done by an individual who used very little paint and modeling. Given the title "the skimpy painter," he or she painted many images of nineteenth-century European manifestations of certain Virgins, figures that were imported into Mexico in the last two decades of that century. The imagery and the light pastel colors strongly suggest late nineteenth-century/early twentieth-century production, but I have identified no ex-votos by this hand.

Certain groups of paintings share a number of characteristics that are not always present in each painting. Because some of these

clements and their appearance in combination with other traits are unique, I could make a strong case for a family or workshop operation using a production-line system. This may be the case for members of the "red bole group" represented in this book.

Greater understanding of folk art traditions as well as feminist approaches to history have convinced me that some retablo artists could have been women, either working on their own or in association with family groups. Traditionally Mexico has always had women artisans with no enforceable restrictions against them; one would expect their participation in a family venture.

Dr. Yvonne Lange, director emeritus of the Museum of International Folk Art in Santa Fe has done research on the impact the imported European prints had upon popular religious art of the nineteenth century, research that has greatly expanded the issue of influences upon retablo artists.[2] It now appears reasonable that Italo-Byzantine features such as pouting lips, bulging eyes, swirling drapery, and certain poses seen in works by the red bole group, the "calligraphic line painter," the "bee-stung lip painter," and in Figures 4, 31, and 47, are not coincidental, but the result of nineteenth-century Mexican artists being inspired by the lithographic prints of certain Near Eastern subjects. Dr. Lange's skills as an iconographer were especially helpful. She, in fact, is responsible for bringing to my attention most of the errors in iconography and titles in the previous edition as well as contributing significantly to the section on the Eucharistic Man of Sorrows.

My work as a conservator of paintings makes the deterioration of the support and paint more than an academic issue for me. As the value of the retablos increases, the better pieces are becoming worth restoring. Treatment of these pieces requires a special understanding of the degradation of the paint film, oxidation of the support, and delaminations in the layers between the support and the paint. Currently analyses of paints, binders, and support are being undertaken. These analyses may be useful in the future in determining age as the increase in prices has greatly encouraged the manufacture of fakes. Recently, fairly sophisticated examples of such retablos have appeared on the market. Their creators are using what appear to be former retablos or at least pieces of old tinplate the same size, sanding down the surface but leaving the back rusted and pitted, and painting images in browns and dark yellows, hoping that the murky surface will deceive the viewer into believing it is much older than it is.

My wish twenty-five years ago was to be able to write the definitive book about retablos, maybe not in the first publication but in

continuing sagas. Considering the subject from its physical, artistic, and spiritual angles, I realize now that that was a little naive. But I have great hope and optimism that understanding and appreciation of the topic will continue to expand and that the reissue of this book will encourage a new generation of enthusiasts.

Notes

1. Gloria Fraser Giffords, *The Art of Private Devotion: Retablo Painting of Mexico* (Dallas: InterCultura and the Meadows Museum, 1991).

2. Yvonne Lange, "In search of San Acacio: The Impact of Industrialization on Santos Worldwide," *El Palacio* 94, No. 1 (summer/fall 1988): 18–24. See also her "Lithography, an Agent of Technological Change in Religious Folk Art: A Thesis," *Western Folklore* 33, no. 1 (January 1974): 51–64; and "The Impact of European Prints on the Devotional Tin Paintings of Mexico: A Transferral Hypothesis," in *The Art of Private Devotion.*

For the development of the cult and image of El Niño de Atocha, see Yvonne Lange, "Santo Niño de Atocha: A Mexican Cult Is Transplanted to Spain," *El Palacio* 84, no. 4 (1978): 4–7.

PART 1
THE MEXICAN
FOLK RETABLOS

The worship of a household god or image representing supernatural powers is as old as man himself. Logically, then, the replacement of the New World's native gods with Christian religious personages was an obvious step in the conversion of the Indians. Catholicism supplanted an already deeply ingrained image-worshiping tradition with a new set of holy persons, often strikingly similar to the old gods. The desire to possess an image to ensure health, fertility, and abundance of crops often led to a simple transfer of beliefs from a pagan image to one of the Catholic hierarchy of saints.

Immediately after the conquest, then, the new religion created a demand for paintings, statues, or prints depicting the numerous saints. For almost three hundred years this need was rather inadequately filled for the humble people by small paintings on wood and canvas. Since most of these have not survived the ravages of time, it is difficult to determine just how prevalent these early household images were. In the 1800s, however, a highly durable and inexpensive material became available, and thousands of small religious paintings on tin have endured to give us touching insight into village life of nineteenth century Mexico.

Retablos are small oil paintings, usually on tin, most often done by primitive, untrained artists from the provinces. They were specially commissioned by individuals or purchased from artist/peddlers, who offered them door to door or sold them in stands set up around the church during holidays and feast days. Devout Mexicans placed them on their home altars, where they were appealed to for everything and could be depended upon to remedy both specific and general situations—ailments of every conceivable sort, social problems, and meteorological phenomena.

Retablos, unsigned and of unknown origins and dates, present a great variety of subjects and treatments. The art flowered and flourished in a limited area of Mexico—the middle states section.

1

Although the beginning of the production of the tin retablo is difficult to date, it is thought to have begun sometime in the early nineteenth century and can be seen to disappear at the beginning of the twentieth, with the surge perhaps beginning after 1820 and coming to a climax before the 1880s. Literally thousands were painted during this time.

The beginning of this art form can be partially related to the abundant and cheap medium provided by the tinplated iron sheets. It is possible also that the impetus of the revolution provided artistic independence among the provincial painters and encouraged this prolific output.[1]

A clear-cut stylistic distinctness, leaning heavily toward the baroque, accompanies a subject matter which modifies and mirrors both Christian and pagan beliefs, making the retablo a genuine manifestation of Mexican folk art. Icons and small religious paintings have existed from the earliest years of Christianity, but this type, painted for and mostly by the common people in a limited time and area in Mexico, has a quality all its own. These tin paintings reflect the intense, sincere beliefs of the people and radiate the naive charm of the primitive.

The Terminology

There are several words used in referring to these small tin paintings of saints, often interchangeably. The technical term preferred and used by many modern Mexican historians and critics is *imágenes pintadas*. However, an individual possessing one in his home altar would refer to it simply as a *retablo* or *santo*.

The word *retablo* comes from low Latin, *retaulus*, meaning a rear table or an area behind the altar (Latin: *retro-tabulum*), and is used in Mexico in a number of senses. Before 1800 it applied to the great gilded, painted, carved screens created in the apses of churches behind the altars. These huge confections of statuary, paintings, and architectural framing, often lavishly gold-leafed, contained representations of the church's patron saints, the Holy Family, and always God, Christ, and Mary. The representations were either realistically carved statuary or painted canvases or other surfaces, incorporated into arrangements which during the baroque era in Mexico reached fantastic and overwhelming proportions. "Retablos Mexicanos," no. 106 of the Artes de México publications, contains excellent examples of this original intent of the word.[2]

After 1800 the word *retablo* may also apply to small, votive paintings by popular artists made for their clients as thank offerings for miraculous recoveries. Similar materials, sizes, and, in many cases, creators, caused it to be applied to the small paintings of the saints as well.

To avoid confusion, in this book the term *retablo* will apply only to the small saint paintings. The term *santo* has been avoided because it also denotes carved figurines. To further simplify, the small votive paintings will be referred to as *ex-votos*, not *retablos* or *milagros*.

The Materials

Immediately following the conquest, missionary priests instructed Mexico's already-skilled native craftsmen in the new iconography and carefully supervised them in building and adorning religious edifices. However, demands for religious items for the home were largely unmet. While the wealthy might afford paintings on canvas (either imported from Europe or produced in Mexico by immigrant painters), the poorer classes had to be content with small images painted on wooden panels or crude canvases by themselves or by artists of little or no training.

Later, during the eighteenth century, paintings on copper sheets became popular, but because of the cost of the medium, only those of more substantial means could afford them. The developing folk art tradition continued producing images for the poor on the wooden panels or on canvases locally produced in Mexico.

Late in the eighteenth century the metallurgical process of applying a thin coat of tin to a leaf of iron was perfected. These tin sheets, developed for other purposes, provided the naive artist with an inexpensive and readily available painting surface. Paint adhered well to the tin, and under protective conditions it was as durable as copper and much lighter. In the 1830s sheets of tin began to replace both copper and canvas as the preferred medium of retablo painters. The fact that tin was easily available made it the material used; if it had not been abundant, something else would have been found to meet the need of a flourishing folk art.

After the advent of tin, copper continued to be used limitedly, and there is often a direct correlation as regards the quality of painting and craftsmanship between retablos of copper and those of tin from approximately the same date. The copper paintings often are typical of the work of trained artists: frequently slick and unin-

spired. Most of the paintings done on tin lack the finesse found on copper retablos but, although cruder and less technically skillful, reflect a distinctly livelier spirit.

It should be noted that retablo artists used sheet tin for their paintings. The consistent size, heavier metal gauge, and flatness of retablos refute the often-heard explanation that they, as well as ex-votos, are "paintings on sides of tin cans." Also, actual evidence of the presence of a recognizable stamp or mark identifying the piece of tin as part of a tin can or container is negligible, in comparison with the thousands of retablos and ex-votos bearing no such identification.

Indicative of the mass production of retablos is the fact that they ranged through several standard sizes in tin. The largest, measuring 14 x 20 inches, are the fewest in number, along with the very smallest in size, 2½ x 3½ inches. The next largest sizes, 10 x 14 inches and 7 x 10 inches, were the most popular. The other standard size, 5 x 7 inches, was followed by 3½ x 5 inches, which was relatively rare, and the even rarer 2½ x 3½ inch size. Each successive size is simply achieved by cutting the piece of tin in half along its short axis.[3] It is probable that the 14 x 20 inch size was created by cutting a still larger piece of tin into four equal parts.

Spots of solder can be seen on the sides and backs of many retablos, testifying to frames which were probably installed in the studio or workshop of the artist. Occasionally they are found still attached to the retablo and are generally elaborately worked tin, either a frame only or a box with a hinged glass door (see N. S. de Guadalupe, fig. 22, and San Benito de Palermo, fig. 32). Sometimes the frame was made of rectangular pieces of glass backed by tin. The glass would be painted on the underside in floral decorations or bright stripes, or colored paper or cloth would be sandwiched between the glass and the tin backing. The scarcity of frames on tin retablos now available for sale is a result of removal either to facilitate transporting by dealers in antiques or to improve the appearance of retablos with broken or rusty frames. Sometimes the frames even have been removed to sell separately, for they are often ingeniously worked and attractive in their own right.

The Artists

While exceptions do exist, the percentage of retablos signed by anyone who can be traced or chronicled is infinitesimally small.

But somehow their names are not necessary. Idiosyncratic and often delightfully human in their portrayals on tin, retablo folk artists have left us far more of themselves than their more technically sophisticated peers.

The overwhelming majority of retablo production was done in the provinces, that is, in areas outside the immediate vicinities of metropolitan Mexico City and Puebla. With the exception of several rich mining areas which could afford large monuments and churches, the provincial areas of Mexico had neither the desire nor the funds to import academically produced art or trained artists from the cities. Thus the folk artist had little opportunity for study under academic painters and almost no exposure to the stylish mode of painting.

While the neoclassic and romantic styles were being propagated by Mexico's official artistic center, the Academy of San Carlos in Mexico City, the rural retablo artist remained unaffected by and probably unaware of these fashions. He and his clients were less interested in the most stylish manner of painting than in representation of images in a familiar way with decoration lovingly lavished on them. Encouraged by a natural feeling for drama and the exuberant baroque, the retablo artist managed to continue to the twentieth century the stylistic devices of the seventeenth and eighteenth centuries. (See Appendix B, "A Capsule History of Mexican Colonial Art," for additional background.)

The provincial artist usually had only a smattering of training; at best he had been an apprentice to an accomplished retablo painter. Most generally he was an individual who was endowed with the ability to observe and copy. It is logical to assume that the local retablo painter for a small village probably had another trade, was self-taught, and painted in his spare time. Some might have painted retablos in workshops, where the tin paintings were mass-produced under the direction of a master. (See discussion of the "red bole group," pp. 10–12.)

In comparison to the work of trained artists from the cities, the paintings of these folk artists may seem crude, but their ingenuity in accomplishing desired effects, their freshness, and the spontaneity they achieved from over-worked subject matter are worthy of consideration. Although almost all clung closely to the conventional baroque style, among them are a "number of primitives with native genius who developed an identifiable style of their own, and whose work had the enchantment that only the primitive can lend."[4]

The Artistic Characteristics

The distinct appearance of a typical Mexican retablo occasions no confusion in identifying it among other religious art. The general consistency in the artists' styles and abilities; the customary clichés used to portray the images; and the similarity of colors, materials, and size all present a framework into which the differences and varieties fit.

As already indicated, in most retablos the baroque vocabulary and apparatus can be easily discerned, even though highly modified and conventionalized in most instances. Attempts at drama, chiaroscuro or tenebroso, realism, movement, and expression—often used with only superficial understanding—frequently fail.

Retablo artists concentrated on the shape of a thing and were more concerned with the contour and decorative effect than with any serious illusionistic attempts at chiaroscuro or modeling. Their art often is pervaded by a naive view of nature that reduces details to the barest essentials.

The artists producing retablos tended to be non-realistic, choosing to deal with what they felt and knew rather than with the life around them. The subjects were copied from other works, not painted from models, and thus tend to be abstract and conventionalized. The element holding this type of painting together is not realism but an instinctive feeling for design. Moreover, even when the intention was to produce a realistic piece, through technical limitations the results are apt to be conventionalized or unconsciously expressionistic.

The figures on retablos strictly follow the church's official, predetermined iconography, or conventional imagery. The holy persons are identifiable by their costumes and attributes, following a much earlier tradition in the Christian church, that of pictography. Because most Mexicans could not read, introduction to religious characters was by pictorial means. The figures portrayed had to be identifiable by what they wore and carried. The stylization and frontal orientation of retablo saints can in part be explained as an aid to instant identification.

Generally speaking, the drawing on retablos is naive, and rules of anatomy and perspective are unknown or misunderstood. All elements of the person or articles portrayed are reduced to the simplest shapes. The main personage is almost never portrayed in profile and seldom fullface or full on, but generally in a three-quarter view. The personages shown fullface are usually paintings

of revered statues, but even in copying statues the painter generally contrives to achieve a three-quarter view. Sometimes a three-quarter facial view will be used with a figure shown full on, but ordinarily the retablo image presents the body and head in harmony with the view shown.

The figures tend to be presented singly and are isolated in feeling. Should a group be shown, the impression of space often is obtained by vertical projection of figures or entire scenes. If there are figures subordinate to the main holy image included to illustrate his attributes, his patronage, or some incident in his life, they are shown in hierarchical scale. Shadows appear only rarely, and when they do they lack subtlety and effect, recalling the work of the Italian masters of the trecento.

The baroque tradition perpetuated by retablo art often includes an attempt to achieve a "grand manner" effect. In many instances the figure of the saint is found in a grand manner setting with a bit of drapery and a piece of furniture, upon which might rest his attributes, or he may be holding his attributes, much the way the grand manner portraitists showed the individual's rank or profession by including the tools of his trade.

This level of painting reflects the trend of the Mexican primitives toward decorative use of detail. Their love and flair for the decorative is most evident in the handling of textiles and other objects capable of embellishment, which are always elaborately depicted. Sometimes real textiles or sequins are attached, or slits are made in the retablo into which jewelry or artificial flowers can be inserted, giving an impression of a Near Eastern icon.

Rarely in retablo art does architecture appear, apart from carefully drawn tile floors, usually in incorrect perspective or an equally incorrect window. Landscapes are found in some retablos, but with no illusionistic attempts at depth they seem like backdrops, limited in space and creating the same decorative effect as the previously mentioned floor patterns.

The colors used are mostly clear reds, dark blues, and dark yellows. Flesh tones are frequently achieved by what appears to be some type of red oxide or burnt sienna mixed with white. Greens appear occasionally and seem to be either a chromium oxide or the result of combining yellow and blue to create a dark olive. White is used alone or to achieve toning effects in flesh or to lighten colors. Black is used for lettering, for indicating metal implements, for certain religious costumes, and for darkening colors. The rest of the colors are earthen browns.

The expense or even unavailability of a great variety of shades of colors, coupled with a primitive desire for brightness and sharp contrasts gives the immediate impression of unsubtlety or even garishness in many cases. However, the gradual darkening and yellowing of paints and varnishes through exposure to dirt and smoke have made many paintings more mellow than originally intended.

Although the tinned plate provided a surface that retablo artists could paint onto directly without any previous preparation or underpainting, an occasional unfinished retablo reveals a brown wash over the surface as a priming coat. In addition, there are the retablos in the "red bole group," which exhibit a burnt sienna underpainting (see discussion, pp. 10–12). However, the uniqueness of such practices indicate them to be the peculiarity of one man or workshop rather than any standard method of preparation of the tin surface.

Retablos for sale today frequently are severely damaged by rust. Beyond this natural destruction, the little paintings often are deliberately mutilated, scratched, or scribbled upon. Figure 3, Verónica, which has been cut up to make a pattern for huaraches (sandals), points up strongly the disregard in which these once-revered religious pictures are held by modern Mexicans.

The Inspiration

Lack of artistic training and a strict iconography predetermined by the Inquisition and rigid religious canons forced Mexican retablo artists to follow a time-honored tradition of Mexican artists—they copied other works. The inspiration for the content and mood of the tin retablo came from three main sources: woodcuts, etchings, and engravings, either distributed separately or in profusely illustrated religious books; paintings done in a manner popular during the previous centuries; and religious statues, revered for their miraculousness and portrayed in two-dimensional likenesses.

The first source—woodcuts, etchings, and engravings—at first was not indigenous but imported from Europe. As early as 1530 monks and their Indian converts in the Mexican provinces were working in fresco, using as guides woodcuts from European religious books, which probably accompanied the early missionaries.[5] Later the colonial painter, who had no opportunity to enrich himself creatively through travel and exposure to important works of European art, also had to depend upon this type of imported material for inspiration and the latest modes.

The metal engraving process had been developed in Europe in the mid-fifteenth century, and it soon became common practice for famous or popular paintings to be reproduced in engraved form either in the atelier of the original artist or in the shop of a specialist. From the sixteenth century on, engravers were attached to printing houses, which in turn had their agents in foreign lands.

The prints which came to Mexico were not produced in Spain but in Flanders. Through a monopoly granted to the Plantin Press in Antwerp in about 1570 by Philip II, the firm managed to supply voluminous quantities of illustrated religious books and prints to Spain for importation to her colonies. This trade to Mexico continued for almost 250 years, bringing stylistic influences from Europe, including those of Picter van der Brocht, Martín de Vos, the Wierix brothers, and later, Rubens' studio.[6] (See Appendix B for additional detail.)

The tremendous role played by this type of source in the diffusion of iconography and in direct influences upon new compositions by Mexican artists concerned the retablo both directly and indirectly. There are many marked similarities between the painted images on tin of the nineteenth century and the baroque prints that appeared in missals and books of daily devotion dating from as early as the sixteenth century. These profusely illustrated books, available in every church, could have been blueprints for the unschooled provincial retablo painter. By the time these religious books began to include the stylish neoclassic mode, the baroque tradition had been firmly established among retablo artists.

The Mexican naive artist also went to the churches for inspiration from large paintings of a variety of saints, Christs, and Virgin Marys, many of which were considered to be endowed with healing powers. While these were frequently imported from Europe, more were created in Mexico through the inspiration of these imported paintings, following the same artistic canons. Some retablos were direct reproductions of these works, representing them in non-deviating manner, with the only variety provided by the abilities of different artists (e.g. N. S., Refugio de Pecadores, figs. 27 and 28).

In addition to prints and paintings, churches and shrines held popular or miraculous statuary. For the most part, these statues were done in Mexican workshops under group, guild-separated efforts. Inspired by Spanish artists, they are frequently saccharine and theatrical. They often appear in retablos in literal transplantation, in their niches, bordered by candles and/or flowers and often still on their bases (see El Cristo Negro, fig. 7; N. S. de Atocha, fig. 20; N. S. de San Juan de los Lagos, fig. 26).

Soon after the conquest, it became extremely popular in Spain to attempt the creation of greater realism in statues. This was effected by constructing an extremely realistic face and hands on a manikin figure. The bust was then placed on a pyramid-shaped frame and clothed in stiffly starched, sumptuous garments. Older statues that were entirely carved in the round were modernized by being covered with a frame and dressed in a similar manner.

These ideas in due course were transferred from Spain to Mexico. Statues which were originally sculptured carvings were revamped to accommodate a tentlike canopy of clothing (see N. S. de San Juan de los Lagos, fig. 26). Villages soon formed the custom of soliciting donations from local individuals or organizations for the purpose of dressing the statues in various costumes. It thus is possible that retablos of the same statue painted at different times might not resemble one another at all due to changes in costume.

Basically, then, retablos are copies of other works. Originality appears in many of them principally because of the personal manner in which they were conceived and created by devout craftsmen who, although striving for faithful duplication of correct and acceptable images, could not help but interpret them through their own idiosyncrasies or cultural beliefs. As a result, the paintings in many cases constitute a very enjoyable and palatable form of art, despite the repetitive and stagnant sources from which they derived.

The Red Bole Group

Each unsigned retablo raises a provoking question: who was the folk artist who painted this small picture on tin? Upon viewing a group of retablos such as the collection illustrated in this book, it is hard to resist the temptation to compare stylistic similarities in an attempt to determine a common artist for several paintings.

One must beware of arriving at firm conclusions while speculating in this manner. Trying to positively attribute an individual artist to a number of similar paintings is a frustrating effort at best. Just at the time when a consistent pattern has revealed itself, a new retablo turns up with characteristics which disrupt all neat theories.

Despite these cautions, it seems important to offer a few remarks concerning one rather large group of retablos with a number of very distinct resemblances. Analysis of the stylistic similarities and dif-

ferences among these paintings points up many of the problems associated with cataloging retablo art and provides a good opportunity for comparison of the paintings.

The retablos illustrated in this book which can be placed in this group are figures 1, 2, 3, 7, 9, 14, 15, 16, 17, 22, 24, 26, 29, 32, 35, 37, 42, 46, 49, 50, 53, 54, 55, 58, 59, 60, and 64. The reader will note that other retablos exhibit one or more of the characteristic features, but they are not as obviously related, and one is more reluctant to speculate upon their common origins.

The first distinctive characteristic of the group—one which is shared by all the retablos in it—is a red bole underpainting applied to the tin as a preparation for the oil paint. Red bole in the strictest sense is the red clay first used over gesso on early frames and wooden panels in preparation for the gold leaf. Later it became common to use it or a burnt sienna color as a priming coat for an entire canvas, a practice which resulted in desirable transparent effects in the finished work. Highlights were thickly applied, light-colored pigments, while shadows were thinner, darker colors which allowed the red underpainting to show through. The technique was particularly effective for figures, as it gave them a reality, aliveness, and warmth.

On the Mexican folk retablos in the group under discussion, the burnt sienna priming is sometimes used over the entire surface of the tin, but occasionally just in the figure area. The red underpaint is not actually the traditional red bole clay, but it serves the same function and has demonstrated the same fugitive quality as true bole. The warm, realistic flesh tones and highlights are the same as those achieved centuries before on paintings prepared with red bole priming. Originally the effect of these retablos was probably much more subtle, but with age the thin pigments have become increasingly transparent, allowing the strong red underpainting to shine through and give the paintings a rosy cast. Because of the uniqueness and distinctiveness of this priming technique, the related retablos which exhibit it will be referred to as the "red bole group."

The paintings in this group are especially appealing and well executed. There is an unusual amount of attention paid to decorative detail, and often great care is devoted to a monstrance, the trim on a robe, or a vase of flowers on a table. Flamboyant brushwork describes foliage in a peculiarly stylized manner. Clouds are also stylized and often are used to create an aura effect around a figure. Dark, loosely brushed-in hills in the background are a common characteristic.

Colors are limited in range, being mostly dark blues, grays, touches of chrome yellows, and some reds. Greens seem to be a combination of blue and yellow. Areas of dark color are frequently terminated in lines of a contrasting color; often robes and sometimes entire figures are outlined in a fluid yellow to create a depth effect.

In comparison to those on other retablos, hands are almost always nicely executed, with fine lines used to delineate the details of the fingers. Faces are often of a type, exhibiting almost identical, strongly modeled features. Eyes are especially distinctive, with heavy, fleshy eyelids; lips are often thick and pursed. Labels identifying the saint pictured are not infrequently found on paintings in this group.

How do we explain these similarities of technique and style? The great number of retablos involved (only a sampling is illustrated in this book) makes the theory of a single artist unlikely. A more logical explanation is that these retablos were mass-produced in a single workshop where several artists, perhaps members of a single family, worked under the direction of a master. Each artist might have painted retablos on his own, from start to finish, or production could have been on an assembly-line basis, with one man cutting the tin, another priming the surface with the red underpainting, another designing and blocking in the figure, and another putting in the details and such finishing touches as the contrasting yellow borders.

Differences in style and quality can be explained by variations in individual ability. An apprentice would be less likely to produce a polished piece than a long-time member of the work group. Variations in quality also might have been deliberate—more careful and finished retablos could be sold for higher prices. Less precise work could be sold to less prosperous patrons.

It is feasible to postulate that occasionally an artist broke away from the workshop to paint on his own. This would account for retablos which exhibit some of the characteristics of the red bole group along with features which are very unique and different. Other independent artists might copy the popular retablos painted by the workshop artists, accounting for still more deviations.

Such speculation cannot be conclusive, but it does give some insight into one probable method of retablo production. With thousands of these little paintings appearing rather suddenly in a limited area of Mexico, the workshop theory is difficult to resist.

The Area of Distribution

Retablos were popular, not throughout Mexico, but in a defined area, much less widespread than originally imagined. Although retablos have been found as far north as Arizpe, Sonora, as far south as San Cristóbal, Chiapas; from San Blas, Nayarit, to San Luis Potosí, and scattered in between, their area of production is clustered around the central states: San Luis Potosí, Zacatecas, Guanajuato, Querétaro, Jalisco, and Michoacán. The northeastern limit of their distribution might be tentatively set at San Luis Potosí. To the south, the richest area of production was the Bajío, which includes the states of Guanajuato and Querétaro. Westward they reach through Michoacán into Jalisco, while to the northwest, the limit of the area extends into Zacatecas.

Very few retablos are to be found in Mexico City. Possibly many might have been done there originally, with interest in them on the part of collectors resulting in their dispersal, but more likely this folk art form was not widespread this far south. Further southeast, in the city of Puebla, a similar situation exists. Although Puebla was heavily populated in the nineteenth century and contained an abundance of artists, it, like the capital, seems to have been outside the area of heaviest production of this particular artistic expression. The retablos available today in antique and tourist shops in these cities and throughout Mexico presumably have been brought from the central states area and do not reflect the real origin.

On the basis of research to date, three main centers of production can be pinpointed: around the city of Guadalajara, around Zacatecas, and in the surrounding areas of the Bajío, especially Guanajuato. There are retablos from these areas which show similarity of style, motif, and colors (for example, the red bole group), suggesting that a thriving business was being conducted by relatively few workshops or artists, who produced the bulk of the retablos sold.[7] The scattered distribution of the paintings with little or no pattern suggests that they were done in certain areas, then peddled in others.[8]

The reasons why these three main areas were so prolific are obscure. The prosperity of these states might have encouraged the output of art and the importation of artists for work in churches as well as in private homes, and the stimulation was perhaps contagious, reaching even to the less prosperous levels. However, other rich areas to the north and south produced no retablos. The abundance of tin was not exclusive in the central part. One can assume

that the devout feelings of the people and the availability of folk artists would not be radically less in other sections of Mexico. Until other conclusions can be reached, the oversimple explanation that "it was not the custom" will have to suffice.

The Development and Decline

Like all folk art, the retablo remains nearly static. It may have deviations in development within an area or era, but as an expression of simple individuals whose way of life changes very slowly, the retablo shows no radical changes over a period of a century. In a particular area or during a specific time, some development or further sophistication might be found, but this is a difference among individuals rather than a continuing and contributing influence. There is in retablo art little evidence of evolution of traditions maintained over the years in local schools or workshops.

With the rise of mechanization, the tin retablos gradually ceased being made. The appearance in the last third of the nineteenth century of abundant, inexpensive colored lithographs and steel engravings was a heavily contributing factor. The desire for more realism, bright colors, less expense, and perhaps simply something new gradually reduced the demand for the painted folk retablos until they ceased being made altogether. It is difficult to say just when production ended.

There is a distinct correlation between the diminishing numbers of these charming folk art products and their decline in quality. Not only do the drawing, composition, and workmanship worsen, but the colors lose their subtlety and mood-creating ability. The painterly quality present in many earlier works also disappears. The desire for more realism is strongly evident.

The loss of the earlier qualities results in harsh, mechanical, and careless representations. Lack of interest is indicated by the endless repetition of the same theme or format by the same individual. Even a concern over the quality of paint lessened, and the use of cheap materials, such as ordinary house paint, caused the pictures to crack, flake, peel, and become transparent.

It is, therefore, safe to assume that the largest bulk of retablos was done before the twentieth century, with the quality deteriorating in the late nineteenth century and production ceasing in the early twentieth century. Apparently a "Golden Age" existed for a period of perhaps fifty to sixty years in the middle of the nine-

teenth century. This, of course, is a generality; an exceptional individual after these dates may have continued the previous tradition. Further research may provide more exact information on the dates. But when inexpensive, colored paper reproductions became available, the great demand no longer existed for the painted retablo, and fashion dictated the demise of a charming folk art.

LA SAGRADA
FAMILIA

This representation was extremely popular among the primitive painters. Murillo's painting of this subject may be considered a prototype for the hundreds of subsequent copies. However, rarely does God the Father appear above the Holy Family in retablos, as he does in the original. Instead, a dove, the symbol of the Holy Ghost, always is present.

This concept of the saintly family is not based on any scriptural text, but is rather a result of Franciscan meditation inspired by the Counter-Reformation. Although the theme might fit into a narrative of the return from Egypt, or be considered by the Church to be the Holy Triad, a Trinity on Earth, the Mexicans simply regarded it as an example of a perfect family and revered it as such.

In this context, Christ is always shown as a young child walking between his parents, who gaze upon him adoringly. Mary traditionally appears in a red gown with a blue mantle; the Child usually appears in some shade of red; while Joseph is dressed in his colors, green and yellow, and always carries the blossoming staff.

Although the draftsmanship on the retablo shown here is a little crude, especially in the rendering of the hands, the faces and figures are solid and indicate some knowledge of anatomy and painting techniques on the part of the painter. There is a nice rhythm in the mantles of the three figures, and the light and dark color contrasts in the costumes provide interest and break any monotony. The diagonals of Mary and Christ are nicely countered by that of Joseph. Even though the format might have been copied from some imported European print or painting, the artist still has demonstrated a sensitivity to good design and creation of mood. The subtle and finished quality of the retablo, along with the distinctive, bulging eyes, places it in the red bole group.

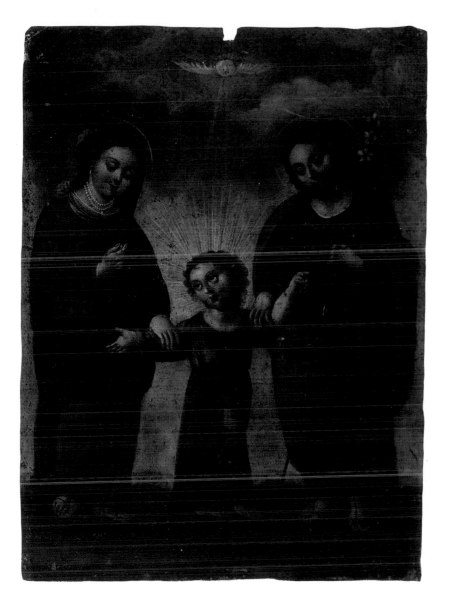

ECCE
HOMO

"Behold the Man," (John 19:5) introduced Christ to the mob after he had been scourged and crowned with thorns. This retablo represents one in a series of historical scenes in the Passion of Christ which begins with the scourging, includes him at the column, and finally represents the crucifixion.

This image was a common and popular theme in European art. Christ has yet to be crucified. He is represented as bound and bleeding, with a knotted cord around his neck. He looks out to the viewer with eyes imploring compassion and pity—a rare example in this art of an attempt to provide a psychological response. The staff in his hand refers to the legend that the soldiers who scourged and crowned him with thorns mockingly gave him a staff, reed, or scourge as a symbol of his scepter as king of the Jews.

Occasionally Christ is shown seated with the reed, which has become a plant more familiar to the Mexican, a stalk of cane. He then is commonly titled "N. S. de Caña." All these images are related to another popular Mexican theme in tin paintings, N. S. de los Trabajos (figs. 4 and 5).

In the retablo shown here, the misunderstood anatomy of collarbone, chest, and stomach muscles adds a decorative element that does not distract from the main theme. Other physical and facial characteristics place this painting in the red bole family. Nude or even seminude bodies are painted by retablo artists only in instances such as this one, which illustrate a specific moment in a holy person's life. This modesty can be seen not only in the work of Mexico's naive painters, but also in the paintings of her more sophisticated artists, both religious and secular, until the twentieth century.

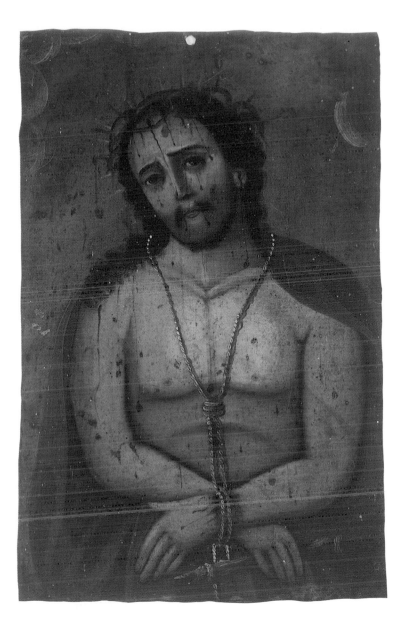

2
Ecce Homo
Behold the
Man
8″ x 13″

VERÓNICA

A commonly seen topic, the legend of Saint Veronica is the subject of this retablo. Veronica was a woman who was moved by compassion at the sight of Christ on his way to Calvary. Pushing her way through the crowds, she wiped the blood and sweat from his face. The imprint of his divine countenance—no longer visible on a towel preserved in Saint Peter's in Rome—was felt to be adequate testimony to the story. There is some evidence that this towel has been preserved in Saint Peter's since the time of Pope John VII

3
Verónica,
El Divino
Rostro, or
La Santa Faz
Veronica,
The Veil of
Veronica, The
Divine Face,
or The
Holy Face
10″ x 12″

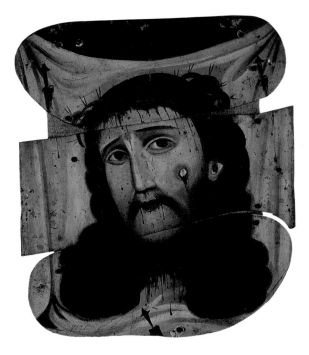

(705–7). However, there is no historical evidence of the origin of the towel or even of the existence of such a person as Veronica.

It seems probable that the name Veronica was applied to the legendary woman because of the image on the towel, for *Veronica* is derived from *vera icon* or "true image." Hence, it is more than likely that the towel was the primary instrument in the story, and the name Veronica was subsequently applied to the presumed owner of the towel. Although the story, appearing in the Apocryphal Gospels of Nicodemus, is an accepted legend of the Catholic Church, Veronica is not named in recent Roman martyrologies.

Although in European art the saint is often pictured holding the veil or towel, Veronica herself never appears in Mexican retablo art, but the piece of cloth is shown with Christ's image upon it. Occasionally, instruments of the Passion are included upon the veil, as the three nails on the retablo shown here. The tendency toward a display of great quantities of blood when depicting Christ sometimes confuses this topic with rare, older images of Saint John the Baptist. It is not uncommon in tin paintings of this subject to terminate the head or upper neck with blood, suggesting decapitation and hence Saint John.

The present condition of the retablo shown here helps prove the point of current disregard for the older images. Examination indicates that it has been cut up to make patterns for huaraches, Mexican sandals, an unlikely use of something truly valued or revered.

Although the Christ on the retablo shown here strongly resembles *Ecce Homo* (fig. 2), variations in the rendering of the eyes, mouth, and hair suggest different artists. Both, however, belong with the red bole group.

4
N. S. de los Trabajos de Puebla
Our Lord of Hardships of Puebla
10″ x 14″

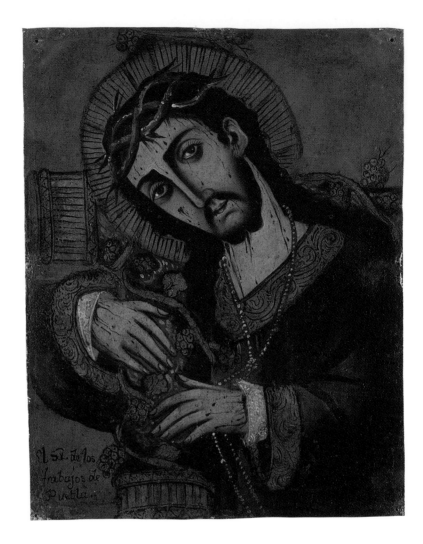

N.S. DE LOS TRABAJOS

These two figures illustrate some of the difficulties involved in identifying the holy persons who appear on retablos. Figure 4 includes the title *El Sr. de Los Trabajos de Puebla*, a local variant on the name. Our Lord of Hardships, however, is shown on many ex-votos as he appears in figure 5, that is, not carrying the cross. An image of Christ bearing the cross which closely resembles figure 5 is commonly referred to in ex-votos as "Padre Jesús de los Tres Caminos." The Christ in figure 5 appears similar to a statue entitled Jesús Nazareno revered in the church of Santa Prisca in Taxco. To add to the confusion, this image and similar statues also are called "Padre Jesús."

5
N. S. de los Trabajos
Our Lord of Hardships
10″ x 13½″

The titles are not of great importance, but this confusion does illustrate how problems can arise when local people attach a special name to an image and are ignorant of the generally accepted title.

Figure 4 is unusual, not only in content but in the manner in which it is represented. The icon effect is strengthened by the Byzantine appearance of the face and hands and by the addition of gold leaf on the garment, cross, and halo. The sinuous quality of the thorns is repeated in the grapevine wrapped around the cross and in Christ's long, tapered fingers. The oriental quality of the face and its strength make this particular retablo seem foreign.

Figure 5 is more typical. The figure is devoid of any lifelike element, and the statue-like quality is increased by the arrangement of flowers, candles, and draperies. An attempt at depth with the placement of the flowers and candles is destroyed by the misunderstood perspective of the tile floor, a common occurrence in retablo art.

Although the marks on the hands and feet in figure 5 would indicate that Christ has already been crucified, this much-represented theme is iconographically closely related to the *Ecco Homo* figure (fig. 2), which shows Christ dressed in a purple robe after having been scourged and crowned.

EL NIÑO
DE ATOCHA

This image is an overwhelming favorite among the representations of Christ in this folk tradition. With the exceptions of La Guadalupana and San José, El Niño de Atocha is the only subject of extreme popularity in the last century that has continued to be produced today in abundance in the retablo's modern equivalent, the colored lithograph. He also maintains about the same degree of popularity as he did then, around five percent.

The image originated at the time of the Moorish invasion of the town of Atocha, Spain. Legend tells of the Moors forbidding anyone to visit the prison full of Christians on errands of mercy except children. The prisoners' families prayed daily for deliverance of their dear ones, knowing that those imprisoned lacked sufficient food. One day a child dressed as a pilgram came to the prison carrying a basket, a staff, and a gourd of water. Even after he had served all the prisoners, the basket and gourd were still full.

The Child Missionary's most famous shrine in Mexico is in Plateros, near Fresnillo, Zacatecas. His image there is the source of great veneration, as the tremendous number of ex-votos attest. Although the exact date of when this image from Spain arrived at Plateros is undeterminable, paintings and engravings of the miraculous Child were widely distributed during the nineteenth century after the first recorded miracle in 1829, chronicled by an ex-voto at Plateros. The image in use today dates from 1886 but does not radically differ from the previous one.

The Child wears a brimmed hat with a plume (a cockleshell sometimes appears on his hat or costume indicating a pilgrim from Compostela) and a robe and cape. He holds in his left hand a pilgrim's staff and gourd, a few spears of wheat, and a pair of shackles, perhaps referring to his original appearance at the prison in Atocha. In his right hand he holds a basket, which may contain flowers or bread. He usually is shown seated.

The artist who painted this retablo devoted fussy attention to details in an attempt to achieve greater realism. The careful details

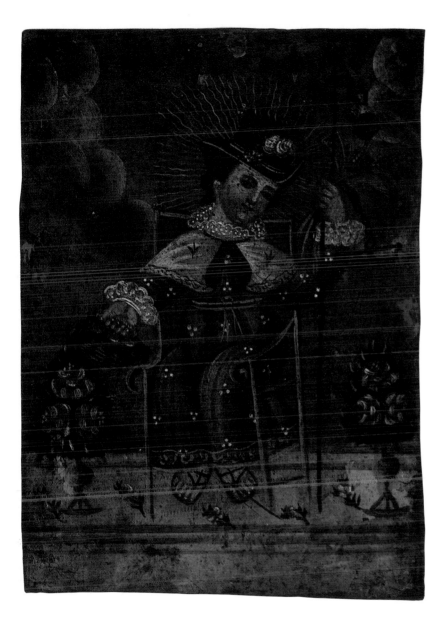

6
*El Niño de
Atocha*
or *El Niño
Misionerito*
The Child of
Atocha
or The Child
Missionary
5" x 7"

of the embroidered garments, plumed hat with flowers, the staff,
and even the fingernails make the figure delightfully busy and dec-
orative but very doll like. The fold of the garments and the place-
ment of the feet, legs, arms, and head give him a liveliness that is
difficult to achieve in a seated figure flanked by balanced elements.

The Child of Atocha is patron for freeing prisoners. He also per-
forms miraculous rescues for people in every kind of danger, espe-
cially from violent acts and, in particular, for travelers.

7
El Cristo
Negro
The Black
Christ
7″ x 10″

EL CRISTO
NEGRO

This retablo portrays the interesting phenomenon of the Black Christ and could be any one of the many images in Mexico and elsewhere in Latin America that were purposely made dark.

There are three very popular Black Christs in Mexico and one in Guatemala. In Mexico NN. SS. de Chalma, de Villa Seca, and de los Milagros command the largest followings, while in Guatemala the most famous is N. S. de Esquipulas. The latter is the earliest and was created in 1594 by a Portuguese sculptor, Quirio Cantaño, at the request of the Guatemalan bishop. Although it is difficult to determine, the three Mexican Black Christs quite possibly are variations of the Guatemalan image.

The dark color, chosen by the early clergy with no small psychological insight, enabled the Indians to identify with the suffering and sacrificed Christ as a release for their own emotional tensions. Degraded to the lowest caste in their own land, they embraced the realistic agonized Christ and interpreted him in their own terms. The accentuated blood, thorns, and wounds represented their own martyrdom; and in making Christ a symbol of their suffering, they remade him in their own brown image. For some figures this darkening was actually a natural process due to exposure to smoke and incense.

Although the brown was meant to represent the Indian skin color and provide a bond between the image and the worshiper, many Christs fashioned by the Indians were created black. Possibly the use of black may represent the survival of pre-Christian beliefs, for black has always been considered sacred and divine in middle America.

Although this particular Black Christ is not identifiable as to title, it is clear from the placement of the curtains and the flower vases that the painter copied a statue or a print done from a statue. The bloody wounds, the hands fixed in benediction, and the tres potencias (the ornamental silver crown suggesting thorns and halo) are commonly seen in this theme. The techniques used to depict the flowers, vases, and draperies strongly suggest the red bole group.

8
La Mano
Poderosa
or *Las Cinco*
Personas
The Powerful
Hand or The
Five Persons
10″ x 13½″

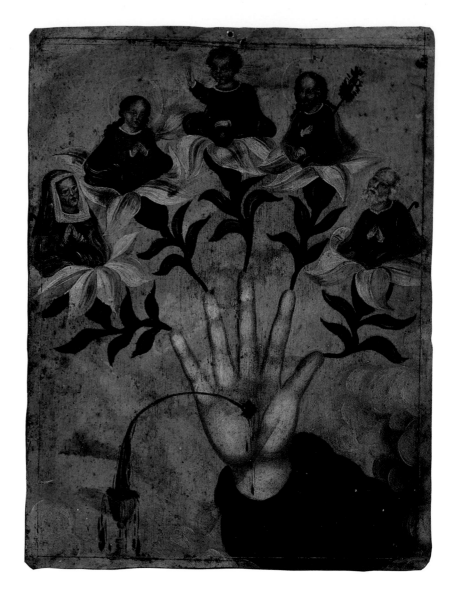

LA MANO
PODEROSA

This theme, not uncommon in retablo art, alludes to an unidenti-
fied allegory. It may be related to the Eucharistic Man of Sorrows,
since occasionally in this theme lambs are placed at the bottom to
catch the blood in their mouths. Some special significance within
the Franciscan order is suggested by the blue Franciscan robe
clothing the arm and by the stigmata of Saint Francis. The lilies
signify purity.

The five figures in the lilies are the holy family, including Mary's
parents Anne and Joachim. This is the only retablo theme the au-
thor has seen which shows these five together. The costumes,
attributes, and other characteristics of the figures typify their tradi-
tional portrayal on retablos. The intricate detail on the tiny figures
and the very realistic portrayal of the hand make this retablo par-
ticularly interesting.

9
El Varón
Eucaristico
de Dolores
The
Eucharistic
Man
of Sorrows
10″ x 14″

EL VARÓN EUCARISTICO
DE DOLORES

The image of the Man of Sorrows is based upon a Post Crucifixion devotion taken from mystical contemplation and does not depict any historical event. Christ is shown crucified, alive, and suffering; through his eternal suffering he brings Redemption. It is an amalgamation of Late Middle Age pious attempts to represent the imitation of the Passion of Christ that include the veneration of the wound in Christ's side, the Sacred Heart, and the stigmatization of St. Francis of Assisi.

When emphasis is placed on Christ's wounds in the advocation of the Man of Sorrows, particularly to the wounded side and the blood, this distinguishes a specific subcategory—one that establishes him as the supreme example of the Eucharist, the sacramental meal. "Whoso eateth my flesh, and drinketh my blood, hath eternal life; and I will raise him up at the last day" (John 54). The significance here is God suffering for the daily sins of mankind as well as the main element of the sacrifice of the Mass, Christ, purposely giving his blood and body. It is quite likely that this representation of Christ, whose blood flows from his side into a chalice, can trace its roots to the eucharistically oriented cult of the Holy Blood in the fifteenth century.

The grapes and vine are eucharistic symbols of the blood of Christ, the lambs represent sacrifice and his role as the living Lamb of God. There are usually seven lambs, signifying the seven sacraments of the Catholic Church, and they may be standing on a book with tags initialed for each sacrament. The presence of wheat or corn signifies Christ's body. The tilt of his head and upturned eyes are deliberate, portraying him as interceding for mankind—devices present in early sixteenth-century German examples of the same theme.

The manner in which the theme appears on the retablo shown here is extremely common. Christ is kneeling in an attitude of prayer, and the color combinations are quite pleasing. The handling of the eyes, expression, color combinations, modeling, and decorative foliage relate this painting to the red bole group. It is especially similar in feeling and format to *Ecce Homo* (fig. 2).

LA ALEGORÍA
DE LA REDENCIÓN

Christ appears in this elaborate allegory surrounded by the symbols of the Passion. God the Father appears in a separate block above Christ holding an orb and bestowing a benediction. The sun and moon are usually present in scenes like this, alluding to the astronomical phenomenon at the time of the crucifixion when the skies darkened and the stars and moon could be seen. The Tenebrae also symbolized the sorrow of all creation at his death.

The archangel Michael weighs souls to Christ's right while Mary in her advocation of "Mater Dolorosa" is to his left. Below them in a darkened area are souls in flames praying, while Adam and Eve are accepting apples from the tree of wisdom. Allegorically the scene signifies that Christ, the second Adam, saves the world through the sacrifice of his body. The archangel and Mary are intercessors through whom people are redeemed. The souls in flames could either represent those in limbo who were saved by Christ's harrowing of hell, or mankind, the seed of Adam and Eve, who through their prayers and the intervention of Mary are saved. The inclusion of the tree of wisdom is significant, for according to legend the wood of the cross came from a tree that grew from a seed of the tree of wisdom.

While these theme is not common, it is of interest to note several elements which do reappear in retablo art. At the left of the Virgin, note particularly the stalk of corn, the cane Christ was given as a scepter transformed to New World vegetation. The other elements of the Passion are also interesting. Clockwise they can be identified as: the three nails with which Christ was attached to the cross, a grill probably representing prison bars, the hand of Pilate with the cloth he used to wipe it, the ewer from which Pilate washed his hands, and the cock that crowed three times in Peter's denial of Christ. Here the cock is grouped with the pillar at which Christ was scourged, the lance that pierced his side, the vinegar-soaked sponge on a pole, and Christ's coat. Beneath are a scourge and shackles. Clustered around the mourning Mary are the above-

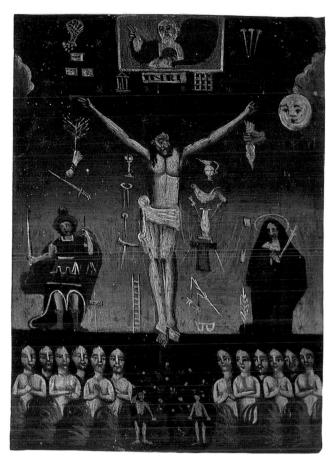

10
*La Alegoría de
la Redención*
The Allegory
of the
Redemption
10″ x 14″

mentioned cornstalk and two unidentifiable objects. One looks
like a hammer, but the hammer-like object on the other side of
Christ is more likely intended as such, since it is grouped with the
ladder used to lower the body, the awl for making holes in the
hands and feet, and the pincers used to remove the nails. The cup
and wafer refer to the Last Supper.

At Michael's foot is the INRI written by Pilate and placed on the
cross after Christ had been crucified. The sword above Michael is
the one with which Simon Peter cut off the right ear of Malchus,
and the object above suggests a tree sprouting from a bone, possibly
alluding to the legend of Adam's burial beneath the tree of wisdom.
Above the cross is the lantern Judas used in the betrayal, the dice
cast for Christ's coat, and the pieces of money Judas received.

The composition of this retablo is nicely balanced, and it pre-
sents a pleasing combination of colors. The elongated, gothic-
like figure of Christ clearly spans the divisions of heaven, earth,
and hell.

LA CRUZ
DE ÁNIMAS

Similar in theme to the Allegorical Redemption (fig. 10), this retablo is a direct copy of one of the small carved and painted crosses that were popular on home altars during the nineteenth century. The symbols of the Passion, Saint Michael, and Mary remain the same as in the Allegorical Redemption. The only addition here is the dove descending from God upon the Son.

Although they are not present on this retablo, Adam and Eve are usually found on the base of the wooden crosses, and the praying figures on the steps of the base are carved in the round. The nakedness seen here is a faithful duplication of the original wooden images.

This subject is very uncommon: the author has seen only a few retablos depicting the wooden crosses. The figure of Christ is strongly reminiscent of Romanesque art. The spots on the tin were caused by dripping candle wax, which prevented even darkening from grime and smoke.

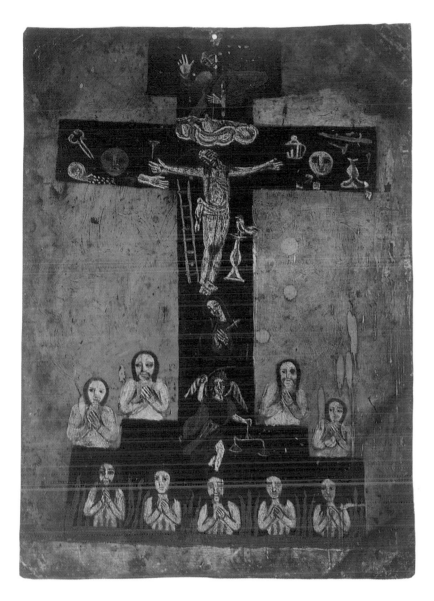

12
La Trinidad
The Trinity
4½″ x 6½″

13
La Trinidad
The Trinity
14″ x 20″

LA
TRINIDAD

The Father, Son, and Holy Ghost almost always appear in retablo art as three images of the same person in complete disregard of the ban imposed by Pope Benedict XIV in 1745 on depicting the Holy Trinity as three identical personages, as was common in Byzantine art. Representing the Holy Ghost in human form had been previously condemned by Pope Urban VIII in 1623.

Retablo Trinities are repetitious, reflecting the vast popularity of Juan Cabrera, for they appear to be almost exact duplicates of his Trinity paintings. Although there is some discussion as to whether or not the widely imitated Trinity was Cabrera's invention, his popularity cannot be disputed nor can the use of his Trinities as the basis for many copies, including retablos.

The members of this much-duplicated Trinity appear as identical young men identifiable only by symbols on their breasts. God the Father generally appears in the center with the sun, holding a scepter; the Son is on his right with a lamb, showing the marks of crucifixion and sometimes holding a cross; the Holy Ghost is on the Father's left with a dove. The positions of the Father and the Holy Ghost are sometimes reversed.

The colors of the robes may be all white, but usually only God the Father is dressed in white—a symbol of purity, faith, light, and integrity. The Son is either clothed in a blue robe or in red with a blue mantle, symbolizing heaven and divine love. Red is traditionally the color of the Holy Ghost and also is a symbol of martyrs' blood and royalty.

Although this theme is rarely reproduced today, it is frequently seen in retablo art. The retablos shown here reveal the variety with which a single popular theme can be handled.

Figure 12 represents a readily distinguishable painter who has created a great deal of statement and action with lines (see also N. S. de Cueva Santa, fig. 21, and N. S. de Carmen, fig. 25). The treatment of faces and use of lines suggests an oriental feeling.

Figure 13 includes a scene of the creation with a number of animals, both identifiable and mysterious. The rainbow might imply the rainbow of Noah's covenant with God. The figures interact nicely with the scene below, and even in its weathered and darkened state this retablo is quite pleasing. Notice the addition of the heart symbol, held by the figure at the right.

Figure 14 features elongated faces, bulging eyes, and a remarkably complex handling of the garments. These characteristics place this retablo in the red bole group. The straight edges of the two-toned triangular devices behind the heads adds a surrealistic touch. For some reason the artist has added ten stars over the group and switched the symbols of the central and right figures.

A similarity in techniques in figures 14 and 15 suggest that both were products of the red bole group painters. Figure 15 is the only retablo the author has seen that represents the "correct" version of the Trinity. The Father is an old man; the Son is Jesus Christ as he usually is depicted; the Holy Ghost is symbolized by a dove. The quality of this painting as well as the correct iconography indicate that this red bole group artist was academically influenced, if not trained. There is a strong similarity in technique between this retablo and La Sagrada Familia (fig. 1).

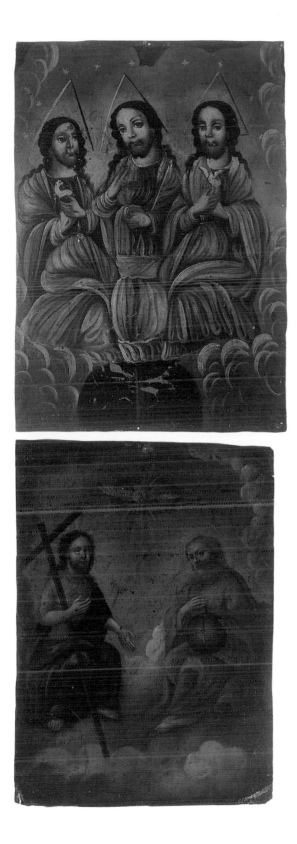

14
La Trinidad
The Trinity
9½″ x 13¾″

15
La Trinidad
The Trinity
10¹⁄₁₆″ x 14¹⁄₁₆″

16
N. S. de la
Encarnación
El Alma de
María or
N. S. de la
Encarnación
Popularly
called The
Soul of Mary
or The Virgin
Annunciate
5" x 7"

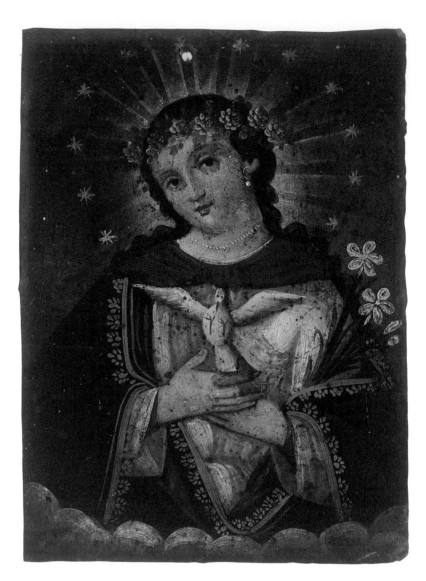

EL ALMA
DE MARÍA

This title essentially relates to the descent of the Holy Ghost upon
Mary and the announcement of the Incarnation. She is pictured as
a young girl wearing a crown of roses, and her hands crossed over
her heart seem to be pressing the dove toward her. She holds in one
arm a staff of lilies and occasionally in the other, roses.

The Virgin has been called a "rose without thorns" or a "lily
among thorns" to symbolize her purity and exemption from the
sins of the world. The lily, therefore, is considered her flower and a
symbol of her purity. The garland of roses on her head may be a
carryover from a device found in Renaissance art alluding to the
rosary of the Blessed Virgin. The dove, of course, represents the
Holy Ghost.

Although not abundant, this subject is not uncommon in retablo
art. The aspects of the Immaculate Conception are always pre-
sented in retablos in this manner, and the theme of the Annuncia-
tion with the Angel Gabriel is never seen.

The Virgin in the retablo shown here is quite nicely done in the
manner of the red bole group. Her features, draperies, and modeling
are all skillfully handled. The dove, however, as is evident on most
retablos which depict animals, remains a symbol for the intended
creature rather than a lifelike representation.

17
*La
Lamentación,
el Llanto
sobre
Cristo Muerto*
The
Lamentation
for the Dead
Christ, The
Bewailing of
Christ, or The
Mourning over
the Lord's
Body
7" x 10"

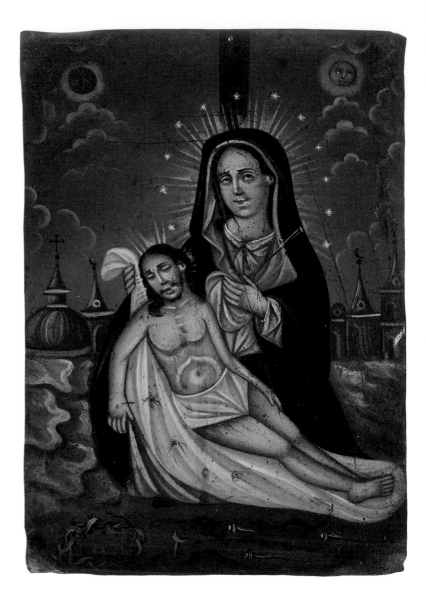

LA
LAMENTACIÓN

This motif in retablo art always depicts only the Madonna and her Son; he has been removed from the cross and she is holding his inanimate body. The theme probably was derived from substitution of the crucified Christ for the infant Jesus in the traditional representation of the Madonna and Child. Derived from the popular scene in early Christian art, The Lamentation at the Foot of the Cross (*Beweinung Christi*), the figures of Saint John and the Three Marys are never included.

The European painting or print used as a source for this retablo is reflected in the background containing spires crowned with half-moons, an attempt to provide an atmosphere of the Near East. With its predominant red and blue coloring; strong linear qualities; peculiarly misunderstood anatomy; and elongated faces, noses, and pursed lips, this retablo acquires an almost Byzantine air. The facial features place it in the red bole group.

Mary appears veiled and has the sword of sorrow in her chest. The dagger indicates the incorporation of this Virgin with N. S. de los Angustias or La Virgen de los Cuchillos. The careful display of the instruments of the crucifixion below the figures is commonly seen. In the retablo shown here, above Mary's head is the upright member of the cross and one bleeding nail.

Although regarded as a symbol of motherly love and reflected upon during the hour of death, there is no particular patronage attributed to this topic.

18
Mater Dolorosa or *N. S. de los Dolores* Sorrowful Mother or Our Lady of Sorrows
4¾″ x 6¾″

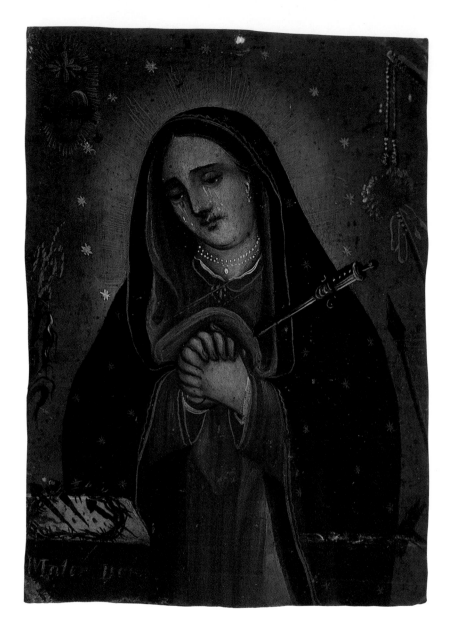

MATER DOLOROSA

This image is among the most important of the representations of Mary without Christ. Although she may be presented with minor variations, essentially she is shown as the mourning mother.

She may be seen crowned with thorns over her veil, but most generally she appears as illustrated here in a grieving attitude, head covered, usually with hands clasped, and tears streaming down her face. Always there is at least one dagger in her breast; occasionally there are seven. This attribute distinguishes her in this role. It alludes to Luke 2:35 when upon presenting Christ to the temple Mary was told that a sword would pierce her soul. This text has been elaborated upon to include the seven sorrows of Mary, hence seven swords or daggers.

In the retablo shown here the dagger seems to specifically symbolize the death of Christ, for the symbols of the Passion are included. As in La Alegoría de la Redención (fig. 10) the reed or cane used to scourge Christ has been interpreted as a cornstalk.

The jewelry shown here is unusual, for the mourning Mary rarely wears any ornaments. There is a certain smooth quality about this painting; the modeling and handling of the draperies is quite sophisticated. But it always appears to the author that this Virgin somehow has one too many fingers!

In the bottom left corner has been written "Mater Dei"; however, this Virgin would by description be "Mater Dolorosa." Extremely popular in retablo art but rarely seen today in prints, N. S. de los Dolores was invoked against worry, sorrow or pain, or at the hour of death.

LA
INMACULADA

The title "La Purísima Concepción" or "La Inmaculada" may be properly assigned to a variety of Mary figures. These all refer to the purity of Mary, although they may appear in a milieu of different poses and allegories.

The basic format is similar to that illustrated here: the Virgin stands on a globe which might indicate a new moon with the crescent pointing downward, or she stands on a crescent moon pointed upward, which in turn, rests on a dark globe. The variations upon this one aspect may be traced in Spanish art, but more interesting is the adaptation of motifs from another representation of Mary, incorporating a variety of biblically unrelated features.

Since the mid-fifteenth century the Virgin in her manifestation as "La Purísima" was frequently shown as Saint John's vision of the Apocalyptic Woman, "a woman clothed by the sun, and the moon under her feet, and upon her head a crown of twelve stars." (Compare N. S. de Guadalupe, figs. 22 and 23, and see text, p. 70.) The theme of "La Purísima" in the seventeenth and eighteenth centuries emphasized Mary suspended from the realm of this world, surrounded by cherubs and symbols of the rosary. An iconographically similar subject, "La Virgen del Apocalipsis," always included the serpent as a part of the allegory but omitted the personal attributes of Mary and the rosary.

In the large oil painting by Francisco Antonio Vallejo, "Mater Inmaculada," painted in Mexico in 1714, the combination of these elements appears. Mary is the Apocalyptic Woman and is accompanied by various attributes held by angels. The militant Woman of the Apocalypse has been softened to accept the mood and title "La Inmaculada" or "La Purísima." Now, an added element appears. The serpent grasps an apple in his mouth, and Mary represents not only the handmaiden of God and the woman of Saint John's vision, but a second Eve, as Christ is often equated the second Adam.

This combination of biblical elements commonly appears on retablos. Modifications such as the placement of the stars encircling the Virgin's head or on her robe, the presence or absence of the

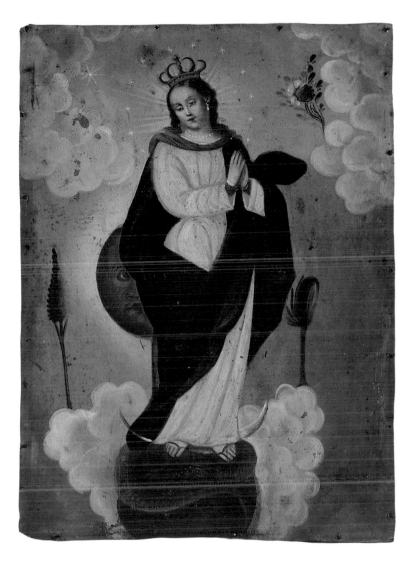

19
La Inmaculada
or
*La Purísima
Concepción*
Most
Immaculate or
The
Immaculate
Conception
10″ x 14″

serpent, or the representation of personal attributes (here a rose)
distinguishes one from another. Consistent, however, is Mary's de-
mure attitude, her hands in prayer, the sun behind her, her feet on
the globe. There are frequently two trees flanking her, probably a
palm and a cypress, the cypress symbolizing death and the palm
signifying triumph over sin and death. These may result from a
misunderstanding of one of the symbols of the rosary in older
paintings and prints—the walled garden.

 In this particular retablo and many others like it the Virgin ap-
pears directly derived from paintings by Murillo, several of which
(and many imitations) were imported into Mexico in the eigh-
teenth century. A not particularly inspired painting, this retablo is
of interest only for its type and for the iconography it expresses.

N.S. DE ATOCHA

Since earliest times in the court of Madrid and in almost all of Spain there has been a predilection for devotion to the Most Holy Virgin of Atocha. A religious leader of Antioch, according to a respectable tradition, brought the image of the Virgin made by Saint Luke to Spain and placed her in a modest hermitage in some fields seeded with *esparto* grass or *atochales*. The cult spread, and soon the hermitage was converted into a sanctuary. The site was leveled during the Saracen invasion in the tenth century. Afterward a pious gentleman proposed to dedicate a new chapel in a different place, since the image was being stored in another area anyway. History indicates that by 1162 she had been added to the church of Santa Leocadia in Toledo. Here her cult continued to grow.

Carlos V in 1523 built a great temple and an enormous convent for the Dominicans, who were responsible for the cult of Our Lady of Atocha. The cult reached its peak during the Spanish conquest of New Spain, and it is not unlikely that N. S. de Atocha arrived in the New World in the form of statues or medallions with the conquerors.

The images of the Virgin and Child venerated at Plateros in the state of Zacatecas, Mexico, are considered a direct continuation of the Spanish devotion. This Virgin is particularly revered by the miners in these cities.

She is always seen on retablos with the Child in her arms, for without him in his distinctive costume she would be unidentifiable. She is not particularly remarkable in the retablo shown here except for a certain doll-like charm and a good-natured plumpness. It is interesting to note that only she wears a halo.

21
N. S. de la
Cueva Santa
Our Lady of
the Sacred
Cave
4″ x 6¼″
(Shown actual
size)

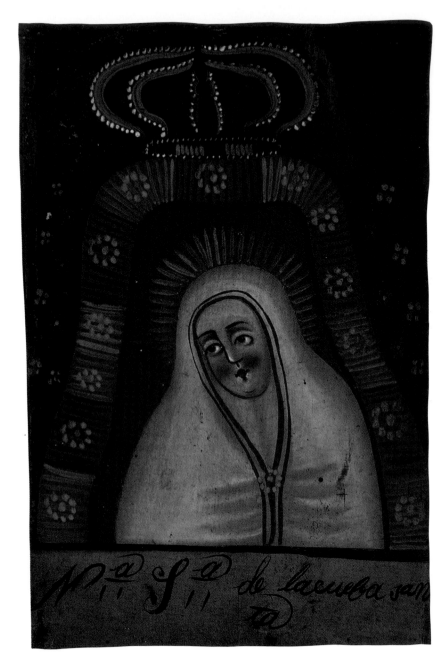

N.S. DE LA
CUEVA SANTA

The cult of N. S. de la Cueva Santa is of Spanish origin and had very little popularity in Mexican art. A retablo depicting this Virgin is included here because of its charming simplicity and feeling for the abstract. In an almost oriental fashion, the body is indicated by a few lines and shadows. Our Lady appears in a bell-shaped grotto, and the placement of the crown atop the cave heightens the bell illusion.

An examination and comparison of the crown, lips, eyes, and shadows indicate that she was painted by the same individual who painted the retablos of La Trinidad (fig. 12) and N. S. de Carmen (fig. 25). In all three of these retablos the artist's outline of forms with a different color creates the impression of volume, while his use of two-dimensional decorative dots and dashes simultaneously flattens this depth.

We see a really sophisticated use of line in the figure of N. S. de la Cueva Santa. Her face is defined by a single stroke, and the subtle curve of her head and torso is indicated by the double red lines of her clothing joined by a piece of ornament constructed from dots, tying together the figure, cave, and surrounding vegetation. The slightest amount of shading appears in the figure, and, when used to indicate folds in her drapery across her bodice, a rhythmic pattern is established that slows the eye from moving off the format and redirects the attention back and around the figure. Whether this was done consciously by the artist or not is impossible to tell, but certainly intent can be established in the production of a delightful piece of work.

Another interesting feature of this retablo is the phonetic spelling of the name, a characteristic that sometimes makes translation impossible.

22
N. S. de
Guadalupe
Our Lady of
Guadalupe
10″ x 14″

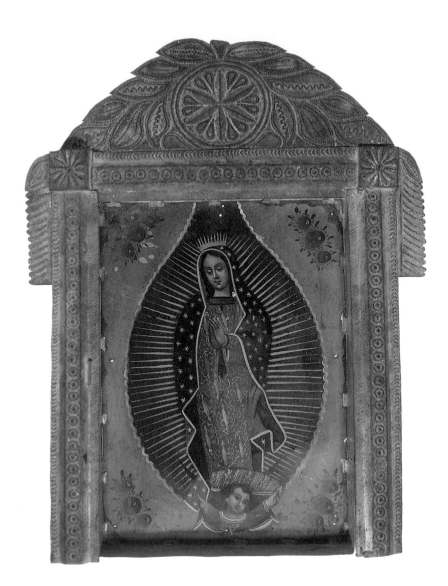

N.S. DE GUADALUPE

In December 1531, the Virgin appeared to an Indian neophyte, Juan Diego. In a series of appearances to him, she stated her desire to have a church built upon the site of her appearance, the hill of Tepeyac, just outside the Mexican capital. Her wishes were fulfilled when Juan Diego presented a cloak full of roses that she had given him for the unbelieving bishop. The cloak appeared miraculously imprinted with her image. This *tilma* is presently in the basilica of Guadalupe, where it has been since it was transferred in 1709 from earlier chapels, and is the basis for any subsequent reproduction of N. S. de Guadalupe.

The original image is on a piece of very roughly woven material with a seam running from top to bottom. Mary is represented as almost life-sized and Indian in appearance, with hands together in a prayerful attitude and lowered eyes. She is completely surrounded by a *mandorla* of golden rays and stands on a crescent moon supported by a cherub. This type of praying Madonna, standing on the moon and encircled by a large halo or aureole, was developed from medieval illustrations of the Apocalyptic Woman and can be traced back to the tenth and eleventh centuries.

This Mexican version displays the Apocalyptic Woman in Renaissance forms at their height. She stands with a quietness and restraint later forsaken for the surge of the baroque. Her pose is a subtle tilt of the head and a gently curving body. Her garments are not confused with details, and their softness is in harmony with her oval-shaped face. The color scheme, a blue mantle with gold stars and trim, and a red robe enriched with gold embroidery, never deviates. Nor does the patient cherub with brightly colored, Byzantine-like wings who appears beneath her. N. S. de Guadalupe is one of the few Virgins in Mexico who is immediately recognizable.

Her miraculous appearance was an important factor in the conversion of the Indians. On the hill of Tepeyac there stood at the time of the conquest a temple to the goddess Tonantzin, "Mother

of the People, Our Mother," also known as Teotonantzin, "Mother of the Gods." Although a statue of the Virgin Mary had been placed in the Indian shrine in hopes that the Indians would cease to worship the pagan goddess, this move was not successful, and attendance to the site was slight. Then came the miraculous appearance of the Virgin in 1531 with her dark complexion and compassion for the poor and humble. She even wore, like Tonantzin, the garb of the Mexican heaven, a blue mantle dotted with golden stars.

This Virgin in figure 22 is precisely and nicely painted, with descriptive lines highlighting the details of the fingers, suggesting the work of the red bole group. The adroitly painted flowers in the corner reinforce the assumption, for this group made free and frequent use of this decorative element. This retablo includes the original frame, which once had a glass door. Most likely this door usually was closed, accounting for the fresh appearance of this painting.

Figure 23 depicts La Guadalupana in a slightly different context. Here Juan Diego is shown holding the *tilma* as if he were presenting the miracle to the viewer, much as he did to the doubting bishop.

N. S. de Guadalupe is the most popular and well known of all Mexican images, and her popularity has increased since the nineteenth century with honors bestowed upon her by various popes. Patroness of Mexico and of the Americas, she is besought to remedy all ills.

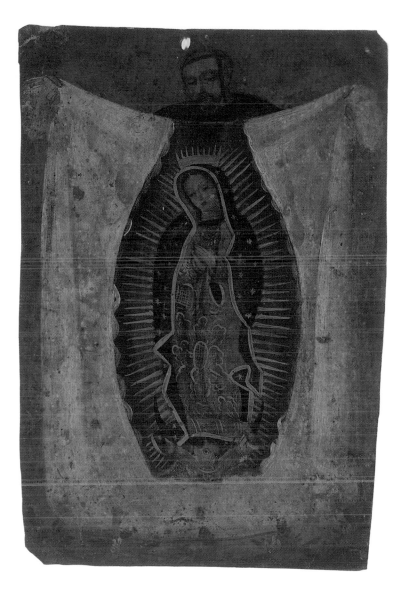

23
N. S. de
Guadalupe con
Juan Diego
Our Lady of
Guadalupe
with Juan
Diego
6¾″ x 10″

LA MADRE
SANTÍSIMA DE LA LUZ

This image is in the Cathedral of León, Guanajuato. One of the legends tells of its being painted by an artist under the direction of a very holy nun who lived in Palermo, Italy, during the early 1700s. The nun had been asked by Giovanni Antonio Genovese, a Jesuit missionary, to help him in determining a suitable image of the Virgin—one which would move the hearts of men. Through her prayers and visions, the nun was able to direct an artist to create an image that Mary herself posed for. Father Genovese carried the painting for the rest of his missionary life, converting many. Its fame spread through Sicily, as did the devotion.

Through the efforts of another Jesuit with the same last name, José María Genovese, also a native of Sicily, the devotion came to Mexico. He arrived in Mexico in 1707 with the painting and subsequently became master of the novitiate at Tepotzotlán. Various Jesuit establishments in Mexico vied with one another for the canvas, but through a lottery León was selected. La Madre Santísima de la Luz has resided in León since 1732 as chief patroness of the city and patroness of the diocese of León.

The painting has a complex design, here well rendered by the red bole group. Mary pulls a naked man from a dragon's mouth, and Christ takes men's souls from a basket held by an angel. Retablos invariably faithfully reflect the original painting, making identification of this Virgin quite easy. Although occasionally two small angels are included supporting a crown over Mary's head and the monster is sometimes varied in size, the calmness of the Virgin is consistent, as is the reversed S-curve of her stance. The individual she so easily grasps is also constant in his devotion and trustful expression.

La Madre Santísima de la Luz is not only revered as the patroness of León and reliever of all ills, but is especially remembered for her role in the protection of the city against plagues, storms, and invasions during the various wars and revolutions. In modern times she has become the patron of electricians.

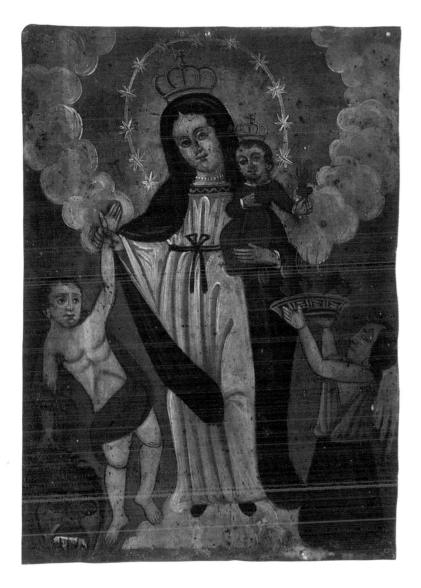

24
La Madre
Santísima
de la Luz
The Most
Holy Mother
of Light
7″ x 10″

25
N. S. de
Carmen
Our Lady of
Mt. Carmel
4½" x 6½"
(Shown actual
size)

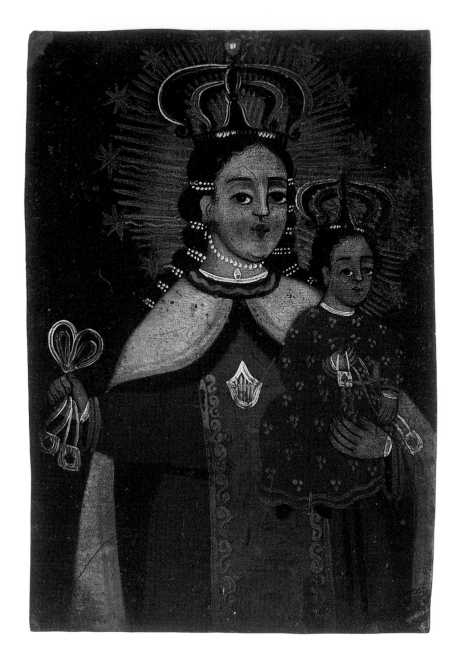

N.S. DE CARMEN

Although the Order of Our Lady of Mt. Carmel claims to have been founded by the prophets Elias and Eliseus, modern scholars deny its existence previous to the second half of the twelfth century. The scapular dates from 1251 when the Virgin gave St. Simon Stock the promise in a vision that "whoever dies wearing this scapular shall not suffer eternal fire." The second Scapular Promise given in 1322 promises that she would descend on the Saturday after an individual's death and "whomsoever I shall find in Purgatory, I shall free." She is the patroness of that order.

In the retablo shown here, N. S. de Carmen appears in her role as protectress, holding the Child. Both clasp scapulars resembling the shield of the Carmelite Order. This shield (correctly drawn it contains a cross on a mound with stars on either side) and the colors of her robe and cape identify this figure as N. S. de Carmen. The white-robed N. S. de Mercedes, who holds the Child and scapulares of the Mercedarian emblems, is otherwise indistinguishable from the Carmelite image, although she is not as common.

In the illustration here, the treatment of Mary's mouth, eyes, and double chin suggest the same painter who did La Trinidad (fig. 12) and N. S. de la Cueva Santa (fig. 21). Quaint and naive, this Virgin seems very Mexican with her dark complexion, black hair, and elaborate jewelry and decoration.

N.S. DE SAN JUAN DE
LOS LAGOS

Miracles attributed to this small image of the Virgin are said to
have begun in 1623 with her returning to life a young circus per-
former who was accidentally killed. Other miracles followed, and
in 1631 a sanctuary was constructed especially for the figure. Be-
cause of the multitude of pilgrims flocking to seek favors, a much
grander temple was begun in 1732, the structure that today houses
the statue. She continues to attract thousands of devotees yearly
who appeal to her for solutions to all problems.

The actual figure is probably from Michoacán and is made from
a mixture of corn pith and a glue from bulbs of an orchid abundant
in that state (*Sobralia citrina*)—a process called *tatzinqueni* and
developed prior to the Spanish. Traditionally the paste is molded
and smoothed by hand over a framework of cane, wood, and some-
times rolled paper (*amate* in some instances). The figures are given
a coat of gesso and then painted. Varnishes and mediums are pro-
tein-based, possibly from gums of certain trees which act as a hard-
ener and preservative. This complicated system using natural
materials appears to resist insects. There are a number of impor-
tant figures in Mexico of the Virgin and Christ made in this man-
ner, among them N. S. de Salud de Pátzcuaro, which resembles this
figure in type (the Virgin as the Immaculate Conception, see figure
19 and pages 48 and 49), size, and clothing.

The Virgin's appearance has changed over the years; clothing has
been added over her molded dress and embellishments made to her
crown and base. The practice of shaving down the wood or paste
figure to accommodate the fashionable European method of dress-
ing the images in robes of enriched material can be seen in a num-
ber of instances throughout Latin America. These garments are
changed occasionally as acts of devotion. In retablos she is distinc-
tive with a white lacy collar and a blue cape with its red lining
providing a nice contrast to her white dress embroidered with red
roses. This retablo shows her as a figure in good proportion to her
base and crown. The actual statue is currently dwarfed by an or-

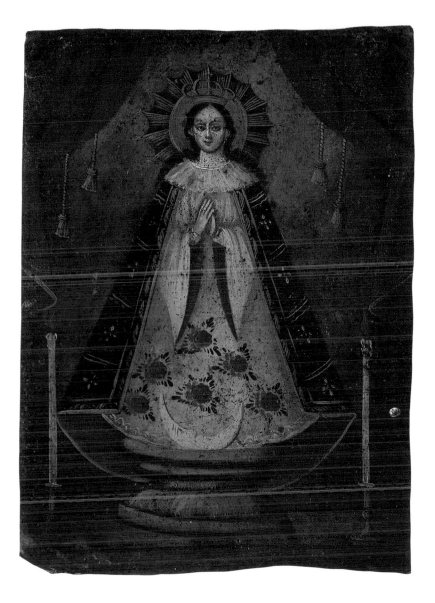

26
N. S. de
San Juan
de los Lagos
Our Lady of
San Juan
de los Lagos
10″ x 12″

nate, jeweled gold base and crescent moon and an elaborate crown
suspended between two angels. While making her appear more pre-
cious, these additions almost overwhelm the figure.

Particularly characteristic of this figure in retablo art is the non-
deviation of the elements in her garments and crown/halo, the two
candles, and the swags of drapery. These consistencies strengthen
the theory that the retablo artist copied religious prints. This piece
exhibits some of the characteristics of the red bole group.

27
*N. S., Refugio
de Pecadores*
Our Lady,
Refuge of
Sinners
10″ x 14″

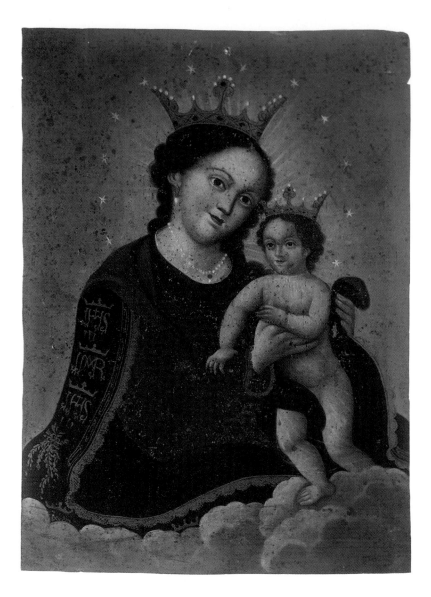

N.S., REFUGIO DE PECADORES

Representations of Our Lady, Refuge of Sinners constitute perhaps twenty-five percent of the entire production of retablos. The original painting of this theme is said to have been done in the early eighteenth century for an altar formerly at Frascati, Italy, in the style of Guido or Salvator Rosa. A copy of the painting was brought to Mexico in 1719 by a Jesuit missionary and placed in the city of Zacatecas, where N. S., Refugio de Pecadores became patron. The

28
N. S., Refugio
de Pecadores
Our Lady,
Refuge of
Sinners
10″ x 14″

numerous retablos depicting this image are indicative of Zacatecas' heavy output of retablo art.

This Virgin is always presented without deviation from the original in theme or format, the artists' abilities providing the only differences. She appears crowned and supports the crowned Child, whose nude body is covered by a transparent robe. A scarf is drawn across her right shoulder, and her blue cape is initialed with her

ciphers. The Child rests his right hand on her right arm and grasps her right thumb in his left hand. Half-length, they appear resting on clouds. The tenderness, warmth, and dignity of the scene could well have occasioned its great popularity.

The two retablos shown here provide examples of the identical subject, painted according to the rules and tenets for its correct representation, yet reflecting entirely different techniques and skills. Figure 27 is merely a careful copy of the original painting in Zacatecas, but 28 was done by an individual who responded to the subject as a format or basis for an idea. His treatment made the traditional theme something distinctively original.

The ciphers on the mantle of Mary have become merely fanciful scrolls, and the auroras of Mary and the Child are pulsating glows. The Child has been gowned in a gossamer affair, which does little to conceal his nudeness but does provide additional areas for embellishment. No effort at realism in the clouds has been attempted. They appear as shaded cardboard stage props, yet they fit nicely with the understood but unapplied principles of anatomy and shading used for the figures.

The Refugio in this retablo cannot be considered more primitive or crude than the rendering in figure 27. In a way it might be appreciated for having risen above mere slavish copying. There is a special warmth between the Mother and Child, and the Infant's chubbiness and unaffected awkwardness make him a believable baby.

PART 2
SAINTS AS
SUBJECTS

An important second aspect of the study of Mexican folk retablos is consideration of the pictures per se, concentrating upon identification of the painted saints and determination of their functions and relative popularity during the time of retablo production. Although an occasional retablo bears a label identifying the saint portrayed (thirteen labeled retablos are illustrated here), most of the tin paintings have no such aids. Identification of subjects often is difficult, requiring much familiarization with iconography, hagiography, and Mexican folk culture.

Problems of Identification

In 1961 in the Western Hemisphere territories originally colonized by Spain there were between the tropics of Cancer and Capricorn approximately 160 million Catholics, 70 thousand churches, and "Christs and Madonnas beyond number."[1] As hagiographer Donald Attwater explains:

Saints have this in common with hymns, that they are exceedingly numerous, but only a few are well known to everyone. No one knows, or can know, how many holy men and women have received a cultus, veneration, official or "popular," in the church during the course of nineteen centuries.[2]

There exists no single list or canon for the saints—their names have to be sought in a variety of sources, such as martyrologies, calendars, and relic lists. The *Roman Martyrology* alone contains some 4,500 entries, including 67 saints called Felix, to mention only one name.[3] Combined lists and martyrologies would amount to a staggering total.

Although not every saint was venerated in Mexico during the period of retablo production, the number of venerated saints was huge. The subject matter for a retablo could be any one of these

saints, or any story from the Bible, station of the cross, sorrow of Mary, or legend that was considered "correct" by the Council of Trent or the Inquisition in Mexico.[4]

This vast number of official themes was multiplied by numerous local variations. Even though the saints in Mexico remained essentially the same as those imported from Europe, their names and functions sometimes changed as they became a part of the Mexican culture. When the image of a saint, Madonna, or Christ brought from Spain reached the New World during the sixteenth century, it took the name of the place where it was fixed. The various orders had their own popular images, of course, but when the new arrival was very popular or had especially miraculous abilities, their cult would spread, taking with it its place name. Thus, there are many Christs with such names as Lord of Chalma, Lord of Amecameca, Lord of Sacromonte, and Lord of Izmiquilpan; saints like San Antonio Itzcuintla and San Francisco Ecatepec; and Madonnas such as the Lady of Zapopan, the Lady of Atzcapotzalco, and the Madonna of Juchitán. Some are stronger and more miraculous than others, "depending on the prestige, wit and devotion of their respective zones."[5] Unfortunately, however, retablos depicting these locally popular images may not resemble their prototypes, often deviating enough to cause confusion and doubt regarding identification.

Within this great array of official themes and local deviations, some images portrayed on retablos closely resemble other saints. These similar themes pose particular problems of identification. Even though there might not have been a shadow of doubt in the mind of the painter or devotee as to what holy person such an image represented, without a title on the painting it is virtually impossible to know for certain if the name it is known by today is the original one.

Despite such problems, identification of retablo saints usually is possible. Although the great number of images is confusing, certain saints are vastly more popular than others and can be identified easily. Beyond this repetition of favorite themes, the careful reproduction of official attributes by retablo artists offers a code for identification of each unlabeled holy image.

Identification Through Attributes

The first and most obvious step in identifying a saint is consideration of his personal attributes—those objects or incidents closely associated with him by conventional usage. Saints' attributes developed and crystalized very early in the gothic period, when the

European artist sought a means of identifying and characterizing the saints in his pictures.

The impetuous development of religious iconography during this time resulted in many cases where a simple figure with perhaps the emblems of martyrdom could represent a dozen distinct personages. Thus, depicting what the saint was doing and showing his collective attributes sometimes were not enough to individualize him. The artist then would select the incident of the saint's life or legend that most personified him, synthesizing it and reducing it to a symbol. This became the saint's personal attribute. Many times it was an implement of torture or martyrdom, but it could also be an element of the saint's life or an aspect of the miracles he had performed. The intended significance of these symbols was sometimes forgotten with the passing of the artist. Often such unexplained attributes gave rise to other legends which tried to explain them.

The assignment of attributes began in the thirteenth century, and by the second half of the fourteenth century almost all had been fixed. In 1563 the twenty-fifth session of the Council of Trent was dedicated solely to images; it eliminated dubious legends and superstitions and, occasionally, a saint. This greatly influenced iconography, for the council also established rules as to how artists should represent the saints. These rules were imparted to Mexican retablo artists three hundred years later through the copying of previously approved prints and paintings.

Attributes may be divided into six categories: [6]

1. Those related to instruments of martyrdom or tortures.
2. Those related to a miracle or important event in the saint's life.
3. Those related to the profession or social standing of the saint.
4. Those related to the patronage they extend, as Saint Raymond Nonatus and pregnant women.
5. Those related only to the name, such as the correlation between Lucy (Latin, *light*) and eyes or a lamp; Agnus (Latin, *lamb*) and the lamb; Rose and roses; and Veronica and the image-imprinted veil. (In the latter example, the name comes from the attribute, Veronica being derived from the Latin *vera icon* or *true image*, rather than the attribute from the name.)
6. Those not really related, but only symbolic of some phase or act of the saint, such as symbols of evangelists, the lily of purity, or the trumpet of Saint Jerome.

The specific locations that attributes occupy are significant. For example, a royal crown is a symbol of the Virgin Mary. However, when a crown is at the feet or to the side of a saint, it signifies the

renouncing of this world's honors for heavenly ones. When a crown is worn, it symbolizes noble birth. When it is held in the right hand, it is the symbol of the virtues.

In retablo art attributes appear reduced in scale, as they do in traditional prints and paintings. Many include other people considered necessary to demonstrate the saint's life but subservient to him in importance (see San Leonardo, fig. 49 and Santa Rita de Casia, fig. 59). Frequently the conventional attribute is familiarized, or Mexicanized,[7] as when the skull of San Jerónimo appears as the skull on an Aztec temple. To a Mexican such a skull might be more than merely an accepted sign of contemplation. The cane that Christ was scourged with becomes a cornstalk and appears also with the Virgin in her aspect of Mater Dolorosa. The Crown of Thorns bristling with spines is characteristically of cactus. Cooking implements become ollas, and ceramics become Guanajuato majolica.

In most cases such transformation of attributes poses few problems in identification of the saint portrayed. But when attributes have been omitted through error, or added in order to individualize or describe additional powers that a particular religious personage had in a certain area, identification can be greatly hampered. This is especially true regarding retablos depicting the Virgin Mary, who has extremely complicated and involved traditions and attributes (see discussion beginning on p. 69).

The retablo painter was, of course, an individual, and the possibility of his including a personal concept in depicting attributes cannot be ignored. Such individualizing, however, more often appears in border decorations, in the ornaments, clothing, or jewelry, or in specific clichés in rendering, such as a special manner of painting eyes.

Fortunately, for the most part the official iconography was strictly adhered to by retablo painters. The religious significance of the images dictated that the rulings of the Church be obeyed. Furthermore, in the source material from which retablos were copied, the depiction of attributes was exactly correct. It is the faithful reproduction of traditional attributes in a nondeviating manner which makes possible the identification of most retablo saints.

The Function of the Saints

Every illness has its protection, each worry a helper, each social station, profession, celebrates a patron. In droughts, floods, meteorological dangers, on trips, saints are resorted to. With them are

related plantings and harvests. New villages, mountains, and in general the topographical phenomena carry saints' names. They all forcefully influence religious art.[8]

These words point up the manifold functions of the saints. Every saint in some way is a patron saint, but the aid of most of them is limited to a particular area. Although many are revered in one locality and only for one certain thing, there are a few who are worshiped universally through Christendom.

The worship of many of the saints in Mexico follows European traditions brought to the New World by its conquerors. However, there are occasions where patronage is not based on European usage. Valid conclusions about the functions of holy personages in Mexico may be drawn by analogy with European usage, but the possibility of local Mexican variations and different saintly functions must always be kept in mind. The conversion of the Indians to Christianity brought additional powers to Christ, the Virgin Mary, and certain saints. Similarities between the attributes of the Indian gods and those of the Christian hierarchy helped ease the transition from the old faith to the new.

Often the powers ascribed to an Indian god were transferred to a corresponding Christian saint. For example, Tonantzin, worshiped in a preconquest temple on the hill of Tepeyac, was replaced by the Virgin of Guadalupe (figs. 22 and 23), who miraculously appeared on the same site and now is worshiped in the basilica at the foot of the same hill. Tonantzin, meaning "Our Mother" in Aztec dialect, was the goddess of fertility and rain-bringing. Her feast day, like that of N. S. de Guadalupe, was celebrated before the rains; thus to La Guadalupana now are ascribed the same powers as the former goddess. In fact, Our Lady of Guadalupe is still referred to as Tonantzin by some Indian tribes.

The Virgin Mary in Retablo Art

Mexico has often been called by writers and theologians "The Land of Mary" because many popular sanctuaries are dedicated to the Virgin, and her popularity with the Mexican people is vast. The tradition was begun in the earliest days of the conquest by Cortés, who by means of a carved and gilded wooden statue of the Virgin introduced Catholicism to the Indians. The appearance in 1531 of the Virgin on the hill of Tepeyac reinforced Mary's right to add Mexico to the other establishments and dispersals of Marian cults.

Most images of the Virgin in retablo art show her associated with

her son, either in actual representation with him or in relation to the Passion. While the most popular subject of this art was N. S., Rufugio de Pecadores (figs. 27 and 28), numerous other themes of the Virgin were also extremely prevalent (see figs. 16–26). The multiplicity of these themes and representations, each with a specific name referring to some aspect of the Virgin's acts, history, attributes, patronage, or, most frequently, geographical location, makes identification often difficult. Many retablos of Mary have no special distinguishing features and cannot be given a more specific title than "La Virgen." Only occasionally is a title included, distinguishing a retablo that otherwise would have joined the ranks of the unidentifiable.

Although the correct name of each Virgin pictured may be difficult to ascertain, there need be no confusion about identifying Mary herself, for she is distinguished from female saints by several motifs. When she is not arrayed in white in her aspect of the Immaculate Conception or the Assumption, or in purple, as in some *Pietàs*, her traditional colors are blue, symbolizing fidelity, divine love, and truth, and red, standing for royalty and the Holy Spirit. Her head may be covered or uncovered. When shown as Mater Dolorosa or in scenes like the *Pietà*, her head is covered with a veil as a sign of mourning.

Many times there is a moon associated with her representation, in which cases she is shown either standing on it or framed by it (see La Inmaculada, fig. 19). Generally the moon signifies her virginity, but specifically it refers to the Woman of the Apocalypse: "And there appeared a great wonder in heaven, a woman clothed with the sun, and the moon under her feet, and upon her head a crown of twelve stars" (Revelation 12:1). This Apocalyptic Woman was interpreted as representing the Virgin as she existed before the beginning of time. The representation of Mary with the crescent moon under her feet was adopted by the Church and was extremely popular in all graphic forms of art and consequently in retablo paintings.[9]

Members of both the Mexican and American Catholic clergy, in discussion, interpret Mary standing on the moon as the triumph of Christianity over New World pagan beliefs. However, since this aspect of the Virgin existed in Europe long before it arrived in Mexico, the symbol would have to refer to Mary's powers over paganism in the Old World as well. In pre-Christian Mexico, the moon was an Indian emblem of Metzli, goddess of agriculture; thus Mary's association with the moon also can be seen as one of the many transfers of pagan beliefs to Catholicism.

Mary frequently appears in retablo art in obvious statue paint-

ings, complete with pedestal, flowers, and candles, framed by drap-
eries (N. S. de Atocha, fig. 20). These statue paintings are generally
readily recognizable not only by their settings, but also by the type
of clothing Mary wears. The custom of dressing a statue in real
clothing was particularly popular with statues of the Virgin, and at
least four historically important Mexican statues of Mary which
were originally sculptured carvings were revamped to accommo-
date a tentlike canopy of clothing. (N. S. de San Juan de los Lagos,
fig. 26, is one of them.)

The Popularity of Retablo Saints

The variety of the tin retablos and the many differences they
present depend to some degree upon shifts in the popularity of indi-
vidual saints. The popularity of Christs, Madonnas, and saints
changed from area to area and from one period to another, and the
pictures depicted on the retablos reflect these fluctuations.

Territorial differences in saints' popularity are partially due to
the fact that each of the mendicant orders from its arrival in Mex-
ico staked out an individual territory and started spreading its own
cult. The first to arrive in Mexico was the Franciscan order, which
came in 1524 and occupied the central and western provinces. The
Dominicans after 1526 had areas of control south of Mexico City,
including the entire province of Oaxaca. The last of the mendi-
cants, the Augustinians, after 1533 evangelized the areas to the
northeast of Mexico City and then spread westward to join the
Franciscans in Michoacán. After the evangelizing period, other
orders appeared, bringing their own hierarchies of saints, favorite
Madonnas, and Christs. These and other groups occupied areas
evangelized by the original three orders. With the increase and de-
crease of orders, it is possible to understand the dispersal of Fran-
ciscan, Dominican, Jesuit, Augustinian, and other saints, as well as
their popularity in certain areas.

The patronage of saints also influenced territorial popularity.
Occupations frequently had their special patrons. For example, a
farmer might pray to San Ysidro el Labrador, patron of farmers, or a
stockman to Santiago, for fertility of mares. Naturally an area with
a large farming population would show a strong preference for San
Ysidro, while in a ranching area Santiago might be the favorite.
The shrewd artist-peddler, of course, would have on hand retablos
depicting the saints most popular in the area in which he was
selling.

Patronage influenced the faithful in their selections of retablos in

other ways as well. An infant was likely to receive the name of the saint on whose day he was born and who thus became his patron, or his parents might name him for a favorite saint, whose day would then be celebrated as the child's birthday. Many retablos must have been purchased or commissioned by people named after saints. Likewise, a person seeking relief from some affliction or distress might purchase a retablo depicting the saint considered especially effective in this area. For instance, San Ramón Nonato might be invoked to aid in childbirth, to assist those falsely accused or imprisoned, or even to silence gossip or still the tongue of an over-talkative member of the household.

Some saints, of course, enjoyed a great general popularity, not as intercessors for particular problems but rather as mediators for all things. The popularity of these saints has fluctuated over the years. When the wooden prototype for the tin retablo was being made from the middle of the sixteenth century and through the seventeenth century, to be replaced by canvas and copper in the eighteenth century, the most popular motifs were the Virgin Mary and Child (aspect not specified); God the Father, with a sphere representing the creation of the earth; and Christ in the most painful passages of his life, such as Christ at the Column, or the seated *Ecce Homo* figure, popularly called Cristo de Caña. After these in popularity were the apostles; the founders of monastic orders; martyred saints; the archangel San Miguel; and the two knights of Christianity, Santiago and San Martín de Tours, riding on horses with almost human faces.[10] It is interesting to note that Our Lady of Guadalupe is not included in this list. She was present at this time but had little general popularity.

With the rise of the tin retablo at the end of the eighteenth century and into the nineteenth century, a number of changes occurred. Two separate previous surveys have been made concerning these shifts in saints' popularity.[11] Although these observations span a fifteen-year period and were independent of one another, the conclusions they draw about the popularity of some saints are similar to those arrived at by a survey conducted by this author and by examination of approximately 3,500 retablos during 1965 and 1966. The details of these surveys, along with tables of statistical results, are given in Appendix A of this book.

From these three investigations (the only three that research has managed to uncover or promote), a general pattern emerges. N. S., Refugio de Pecadores is the most persistent and popular image portrayed. She is followed in popularity by Mater Dolorosa, La Sagrada Familia, San José, La Trinidad, El Niño de Atocha (El Niño Mis-

sionerito), N. S. de Guadalupe, and S. S. Jerónimo, Francisco de Paula, and Antonio de Padua.

The high proportion of N. S., Refugio de Pecadores in these surveys is particularly intriguing. She is venerated specifically in two cities, Zacatecas, Zacatecas, and Puebla, Puebla. Since Puebla is not known for retablos, the numerous retablos of N. S. de Refugio must portray the image in Zacatecas, an area well known for retablo production. The very number of these images of Zacatecas' favorite holy person indicate that this area was one of the most prolific areas of retablo production and use. Further indications of Zacatecas' large output are strong resemblances in techniques and materials between some N. S. de Refugio retablos and retablos depicting other saints—all suggesting similar artists or traditions. The fact that most peddlers we interviewed acknowledged that they found the majority of retablos in and around this city and state supports the evidence of Zacatecas' importance in the retablo movement.

Additional support of this conclusion comes from the high proportion of retablos portraying Saint Anthony of Padua, a Franciscan monk highly venerated by that order. Zacatecas was the site of a magnificent missionary college for Franciscans, who, like all Spanish and New World friars of that order, wore blue robes instead of the traditional gray-beige as a sign of their devotion to the immaculateness of the Virgin. Church paintings in Zacatecas depicted Saint Anthony of Padua in blue, and these probably were copied by local retablo artists. Even after the Mexican friars changed from blue to russet brown, Zacatecas retablo painters must have continued to copy the church paintings and old retablos, for in later retablos Anthony still is shown in a blue robe.

Modern Popularity Patterns

Since the nineteenth century there have been new changes in emphasis,[12] and N. S., Refugio de Pecadores has lost her place of importance to N. S. de Guadalupe, whose popularity was only five to ten percent in the tin retablo. Lithographs and statues of La Guadalupana may be found in almost every Mexican home. Honors bestowed upon her in the nineteenth and twentieth centuries and her significance in Mexican nationalism may be the causes of her surge in popular veneration. It seems logical that the Virgin whose image adorned Hidalgo's banner and whose name was a battle cry during

the Revolution of 1810 would influence the Mexicans in the selection of an image that is truly their own.

La Guadalupana is followed in modern popularity by San José and El Niño de Atocha, both of whom were also popular during the time of the retablos. The other past favorites on the retablos, however—Refugios, San Jerónimo, San Francisco de Paula, La Trinidad, Mater Dolorosa, and La Sagrada Familia—have lost their appeal and are rarely seen in modern reproductions. San Antonio de Padua manages to maintain, if not increase, his popularity, but today's trend is toward a few saints rather than the wide spectrum previously seen.

The opposite seems true of the advocations of the Virgin. Although scarce in retablo art in comparison with the great bulk of other images, NN. SS. de San Juan de los Lagos, Zapopan, Pueblito, Talpa, and Remedios are now commonly seen in plaster statues and lithographic forms. Since there seems to be a movement away from a variety of images sought for individual causes, these Virgins are appealed to for everything rather than for specifics (although the Virgin of Remedios may be especially invoked by women wishing children). A testimony to the popularity of these Virgins can be seen in the quantities of modern ex-votos found in their shrines, offered for every type of complaint and miracle. These are some of the most popular shrines for pilgrimages.

Outside of this overall pattern, photographs or reproductions are sold of a favorite local saint or of the miraculous image of an area or shrine. But this is, as it always has been, a local selection and not indicative of any general trend.

Since the turn of the twentieth century, two images have been enjoying particularly great acceptance. The most notable is San Martín de Porres. There does not exist, to this researcher's knowledge, a Mexican retablo of San Martín. The fact that he is an immensely popular saint in Mexico today is attested to by his image in almost every church and his availability in every religious supply store in print and statue form. He shares a place of honor with La Guadalupana in private shrines; in homes; and on the dashboards of taxis, buses, and private cars from one end of Mexico to the other. San Martín died in 1639, but he was not beatified until 1837 and did not receive official sanctification until 1969. During the time of retablo production he was either not popular enough to require the painting of his image, or, more likely, he was not even known in Mexico at that time.[13] The recent dates on ex-votos dedicated to him and the newness of his statues in churches attest to the fact that his great popularity has arisen since the turn of the twentieth century.

San Martín's rise in popularity is simultaneous with the upsurge of nationalistic pride in the Western Hemisphere, for he was born in Lima, Peru. In addition, his mulatto background makes him attractive to people of mixed blood. He has been selected in America and elsewhere as a patron for interracial justice and harmony, and his life has been the subject of a number of books, both devotional and popular.

Another holy personage whose popularity is recent is N. S. de Perpetuo Socorro. Her tenth-century Byzantine painting was rediscovered only in the 1860s in Italy, and the Redemptorist Fathers, the order responsible for the dispersal of her cult, did not arrive in Mexico until the end of the nineteenth century. Because the cult's inauguration in Mexico occurred after the period of intensive retablo production, not a single tin painting bearing her image has been found.

Over the years in Mexico the popularity of saints has increased and decreased in harmony with the religious temper of the times. During the high period of retablo painting a galaxy of holy personages flourished, many of whom are virtually unknown today even to the devout. Similarly, some of today's most popular saints were unknown at the time the retablo painters were at work. The modern trend to pray to one image for all protection rather than to specific saints for particular problems is as easily observable as the reduction in the number of saints invoked.

The modern lack of interest in the former great array of saints might be explained by the greater sophistication of the modern Mexican or by a more skeptical attitude. With the passing of this specialized devotion, however, a library of delightful folk beliefs is being lost, as each succeeding generation fails to observe or record them. The current lack of interest is made clear by the destruction or sale of retablos whose holy personages are now nameless to the average Mexican and whose special powers are forgotten.

SAN
ACACIO

Acacius was a supposed martyr of the second century. After an appearance of an angel, he and his nine thousand Roman soldiers during a campaign to subdue certain Syrian tribes were said to have been converted to Christianity. They retired to Mount Ararat in Armenia and founded a community for the contemplative life. Attempts were made first by the Emperor Hadrian (A.D. 76–138) and then by Antoninus Pius (A.D. 138–61) to return them to military duty. An additional force of one thousand sent to capture them was in turn converted, bringing the complement to ten thousand. After a series of miracles, all of the community were tortured and martyred by beheading, crucifixion, or being thrown over a cliff. The legend fails to relate who exterminated them, but presumably it was a Roman emperor. Although greatly venerated in Germany, Saint Acacius is unknown in the Near East, including Armenia, the supposed site of his death.

This medieval theme was elaborated upon by the Spanish, who made Acacius and his companions Spaniards. Some of their breviaries include lections for the feast taken from these apocryphal acts.

Although Spanish missals indicate that the chief attribute of Saint Acacius is a crown of thorns, some histories state that his martyrdom was first by flagellation on a walnut tree and then by crucifixion, or being impaled on a tree of thorns. He is represented in Mexican folk retablos crucified and occasionally crowned with thorns, and his costume is roughly contemporary with the Mexican Independence movement in the early nineteenth century.

His cult in Mexico is not widespread. His identification is confused or unknown by most Mexicans, who either refer to the image mistakenly by the names of other crucified martyrs or even assume that it is a costumed Christ.

The legend relates that at the time of their death, the Lord gave the ten thousand and one martyrs the power of bestowing health and earthly goods to those who would cherish their memory. For this reason, Saint Acacius is considered one of the "Fourteen Holy

29
San Acacio
Saint Acacius
of Mount
Ararat, R.M.
June 22
10″ x 14″

Helpers in Need," a group of saints with special intercessory powers. He was also sought to cure headaches.

In the retablo shown here, Acacius appears crucified with military paraphernalia at his feet, including a drum, cannonballs, banners, and beribboned spears. The limited use of colors—dark blue, red, and green; the fluid outlining in yellow; the cloud effect around the figure; the dark, loosely brushed-in hills on the horizon; and the lettering all indicate that this is a retablo which belongs in the red bole group.

SANTA
ANA

Nothing in the Bible specifically refers to Anne's life or background, but at the time when early Christians were eagerly seeking additional information concerning holy personages a rather complete life was compiled. This material is contained in the apocryphal books.

According to one tradition, Anne was married twice before she espoused Joachim, the father of the Blessed Virgin. The first marriage was to Cleophas, by whom she bore Mary, wife of Alpheus and mother of Saint James the Lesser, Thaddeus, and Joseph Justus; the second husband was Salome, by whom she bore another Mary, who married Jebedee, a wealthy merchant of Galilee, and whose children were Saint James the Major and Saint John the Evangelist. Other traditions simply make the statement that Anne and Joachim had no other children; but all the sources suggest that they were a wealthy, noble couple.

Anne, unusual in retablo art by herself, appears in connection with her daughter, the Virgin Mary, or in the theme of Las Cinco Personas (fig. 8). However, since neither of these are common themes, she appears rarely. When shown with her daughter, she is depicted as an older woman instructing the Virgin in reading.

In the retablo shown here the Virgin appears as a miniature adult, as do most representations of infants and children in retablo art. She wears the jewelry which we have come to expect in retablo depictions of her. An interesting attempt at a window includes a view of birds and trees. The hands of both mother and daughter are interestingly done, with an oddly bent small finger.

Saint Anne is considered a patron of the old, is prayed to by women during maternity, and is especially effective against sterility.

30
Santa Ana
Saint Anne,
R. M. June 26
10″ x 14″

31
*San Antonio
de Padua*
Saint Anthony
of Padua,
O.F.M.,
d. 1231, R.M.
June 13
14″ x 20″

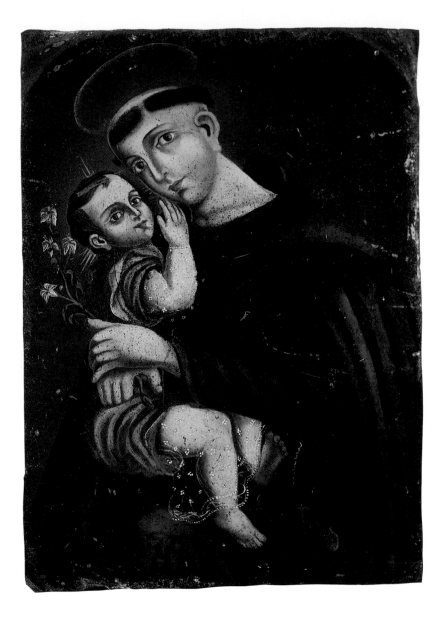

SAN ANTONIO DE PADUA

The theme shown here dates from the Counter-Reformation, when mystical contemplation was inclined toward the childhood of Christ. This type of emotional religious sentimentality was first exploited by artists during the sixteenth and seventeenth centuries, and the sweetness and softness evident here were popularized not only by Murillo but also by his Mexican imitators.

The motif illustrated is the one most commonly used in Mexican art to portray Saint Anthony. The saint appears as a pleasant young man, holding the Child, a lily, and occasionally a book. According to legend, the host of a house where Anthony was lodging saw radiant light pouring from under the door of the saint's room. Peering through the keyhole, he discovered that the source of the light was Christ as a child seated in the saint's arms.

The blue robe shown in this retablo is not unusual in paintings of Franciscans at this time. Spanish Franciscans commonly adopted blue robes for their singular devotion to the immaculateness of the Virgin, and not until after a papal decree in 1897 did brown become the universal color for Franciscan habits.

The Child on this retablo is somewhat unusual. The exposed areas of his body are modestly draped in some filmy material, as in figure 28, N. S., Refugio de Pecadores. His halo has been reduced to the *tres potencias* motif, somewhat unusual in representations of Christ as a child. The modeling is strong, and although the pose is a little awkward, there is a liveliness and warmth that is appealing.

Saint Anthony's patronage and his aspect in art reflect a curious paradox. Although he is always pictured as a sweet and meek individual, in real life he was far from this image. He had a blistering tongue and was noted for boldness, rather than meekness. An aristocrat, he became a special advocate of the poor and downtrodden. A scholar having no living rival as a biblical expert, he was adopted by the illiterate to become the finder of lost trifles and the saint of trivial appeals. He is also sought to find husbands for unmarried girls and by married women for fertility.

32
San Benito de Palermo
Saint Benedict of Palermo or The Black or The Moor O.F.M., d. 1589, R.M. April 4
2½" x 3"
(Shown actual size)

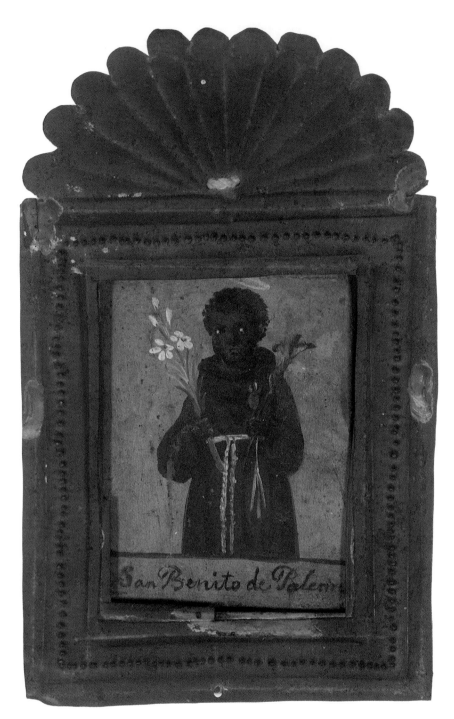

SAN BENITO
DE PALERMO

Benedict was the son of Christian African slaves. He was born in Sicily, and his father was promised that his eldest son would be free. Devout and pious from earliest childhood, at the age of ten he was given the nickname "The Holy Black," which remained with him his entire life.

He joined a group of hermits when he was twenty-one; and when he was about thirty-four, his group was ordered by Pope Pius IV either to disband or to join a regular order. Benedict chose the Friars Minor of the Observance, a Franciscan order, near Palermo. His understanding of the scriptures astonished inquirers, for he could neither read nor write. It is also said that he could read men's minds.

Of moderate popularity, Benedict was the patron of Negro slaves in the Americas. He is shown as a black man and always dressed as a Franciscan, in blue. He usually holds a crucifix and lily. Occasionally a flaming heart is shown on his breast, indicating the burning fervor of his faith.

The retablo shown here is unusually small, but the artist has managed to paint a remarkably lively figure despite this restricted format. The nose and eyes are indicated by deft shading, the body is modeled with skill, and the attributes are nicely sketched. These qualities suggest that this retablo might be associated with the red bole group.

The tin frame pictured here is original, and despite its crudeness, it shows how Mexican craftsmen achieved charming and effective ornamentation through such simple devices as scoring and punching the tin.

Besides being patron of Negro slaves, for a reason undeterminable by the author, Benedict was besought against smallpox.

33
San Blas
Saint Blaise,
B.M., d. 287
or 316, R.M.
Feb. 3
7" x 9¾"

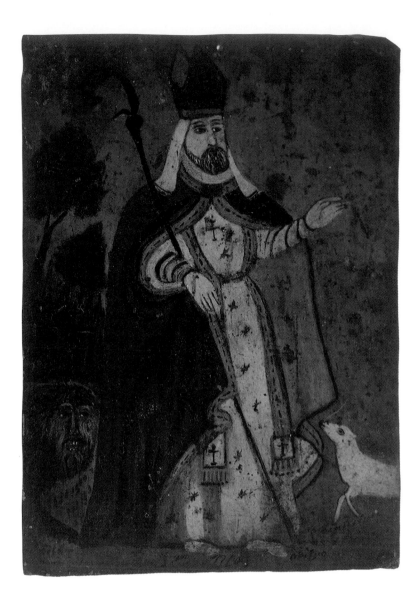

SAN
BLAS

This saint was born in Armenia and devoted his life to medicine until his election to the episcopal see of Sebaste. Withdrawing to a cave on Mount Argeus, where sick people and animals came in crowds to consult him and be healed, he cured them and sent them away with his blessings.

During the reign of the Emperior Licinius, the Christians were persecuted by Agricola, governor of Cappadocia. During this time Blaise was discovered when hunters searching for wild beasts for games in the arena found an accumulation of tigers, lions, and wolves waiting at the mouth of his cave. He was arrested and given opportunities to apostatize, which he steadfastly refused. It was in prison that he returned to a poor woman a pig that a wolf had eaten and cured a child who had a fishbone wedged in her throat. From this last miracle came the habit of invoking him for maladies of the throat.

After enduring torments, Blaise was thrown into a lake upon which he walked, inviting his tormentors to do likewise to prove their pagan gods' power. The pagans received the challenge and were drowned. Although the elements of his life are somewhat legendary, most sources agree that he was martyred by having his flesh torn off with wool combs.

Always dressed as a bishop with a crosier, Saint Blaise is shown here in this costume accompanied by a wild beast and a lamb, referring to his secluded life in the woods with the wild animals and his martydrom. Not a polished painting, this retablo nevertheless has a certain amount of character in its simplicity.

In addition to his protection against afflictions of the throat, Saint Blaise is a patron of physicians and woolcombers, and one of the Fourteen Holy Helpers. Greatly venerated throughout Central Europe, this retablo is the only one the author has ever seen in Mexico.

34
San Bonifacio
Saint Boniface,
B.M., d. 306,
R.M. May 14
5″ x 6¾″

SAN BONIFACIO

This personage presents something of an enigma. As shown in these two illustrations he is a soldier, perhaps a Roman centurian. He is always shown with the martyr's palm, a three-plumed helmet, and sometimes with a skull, scourge, and crucifix. Yet in the recorded lives of saints, Saint Boniface of Tarsus is never mentioned as a soldier, although he was originally from Rome and perhaps acquired his costume by association. Nowhere in his life is there an indication that he spent any time in contemplation, penitance, or seclusion, as the scourge and skull would have us believe.

Boniface was a big, handsome man given to much dissoluteness

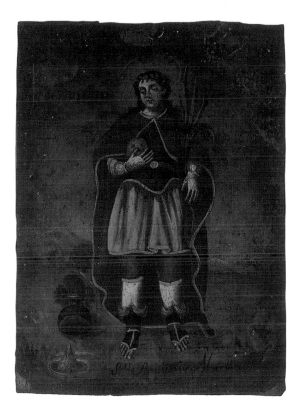

35
San Bonifacio
Saint Boniface, B.M., d. 306,
R.M. May 14
5" x 7"

and debauchery. He was extremely generous to the poor, though.
When Aglae, a wealthy Roman lady, converted to Christianity he
did likewise and to please her went to the East in search of relics.
In Tarsus he saw Christians being led to their death and, taking
their part, he too was condemned. It was his relics that Aglae re-
ceived, which she placed in an oratory near Rome, and at a later
date his body was placed in the church of Saint Alexis. Boniface's
patronage is unknown, and he is found indistinguishable by mod-
ern Mexicans and clerics.

Boniface is included here because of the problem he might pre-
sent in identification and because the author is enchanted with the
lacy pantaloons seen in figure 34. It is also interesting to speculate
upon the characteristic qualities of the red bole group seen in fig-
ure 35. The colors, decorative lines, background, lettering, and
certain facial features relate this retablo to others in this group.
However, the figure here does not display the same clearly under-
stood anatomy, and the fluidity of the garments and the hands is
not evident. Perhaps this was the work of a new apprentice or of an
artist copying the techniques of the popular and successful red bole
group.

SAN CAMILO
DE LELIS

Camillus is often called the "Red Cross Saint" for two obvious reasons. As founder of the Ministers of the Sick he instituted humane hospital treatment, and his order wore a red cross on the right breast of their black habit. (In retablo art, the cross is likely to appear anywhere on the garment.)

Camillus' early life was dissolute. Addicted to gambling, he managed to lose everything he owned. In observance of a vow to join the Franciscan Order that he had made in a fit of remorse, he accepted work as a laborer on the new Capuchin buildings at Manfredonia. Here, after hearing a moving exhortation by the guardian of the friars, he completed his conversion. He tried to enter the novitiate of the Franciscans but could not be admitted because of a diseased leg. He then returned to the hospital of San Giacomo, where he previously had been treated, and devoted himself to serving the sick.

Appalled at the conditions that existed in the hospital, he formed a project to attract persons who were interested in devoting themselves to charity. Feeling that the patients' spiritual needs were just as important as their bodily requirements, he took holy orders. Then with two other companions he left the San Giacomo Hospital and started his own hospital and his own order, the Brothers of Saint John of God, or Ministers of the Sick. In addition to caring for their patients physically, by their exhortations they disposed them for last sacraments and a happy death. The order increased, and they continued to serve through plagues, pestilences, and wars, although some of their own number were lost.

Camillus continued to care for the sick until his last days, even when he himself was severely ill. He died at the age of sixty-four and was canonized in 1746. He was declared the patron of the sick by Pope Leo XIII, and of nurses and the nursing associates by Pope Pius XI.

A frequent subject of retablo art, Saint Camillus always appears ministering to a man who looks more dying or dead than merely

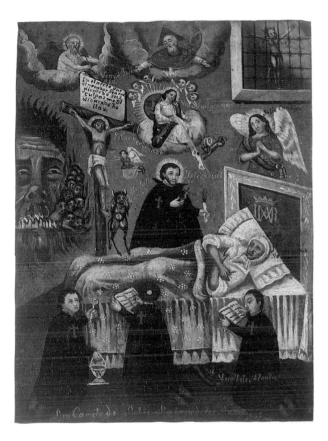

San Camilo de Lelis
Saint Camillus of Lellis
or Saint Camillo of Lellis
Founder, Brothers of
Saint John of God,
d. 1614, R.M. July 18
10" x 13"

ill, and the atmosphere of the last rites is suggested. In every case imps or devils are included, from whose clutches the saint has managed to secure the soul of the departed and return it to God. These creatures resent Saint Camillus and often are portrayed as making rather unkind remarks such as "Mata Usted, Camilo."

In the retablo shown here there is a little something for everyone. There are groups of figures everywhere, and with the varieties of perspectives presented, the sense of action is increased. Camillus and his group are busy with the last rites, while the soul is on its flight to the Virgin Mary with a winged imp in hot pursuit. This individual has obviously been saved, but those who were not are shown in the mouth of a monster. The figures at top are God the Father (in the center), and Saint Jerome blowing a trumpet because he was considered a powerful intercessor for a peaceful death. Dark little fiends are thrown in, around and under the bed and at the window to help make an unusually full format for this type of art and to further increase the atmosphere of the tense moments of the battle between good and evil. The scripts of dialogue coming from the mouths of the characters further emphasize the drama.

SAN
CAYETANO

The founder of several hospitals and co-founder of the order of the Theatines Regular Clerks, Saint Cajetan was greatly concerned with the corruption and indifference of Catholics during his lifetime. Although of a wealthy family and highly educated, he selected a religious life and was ordained when he was thirty-three years old in 1516. He re-founded a group called the Confraternity of the Divine Love, dedicated to the zealous promotion of the welfare of souls. No job was too menial for this group, who were small, select, and even aristocratic in composition. They strongly emphasized poverty and aiding the sick.

In 1527 Emperor Charles V sacked Rome. The Spanish soldiers, certain that the group was hiding great wealth, brutally tortured the members of the order, including Cajetan. The group fled to Venice, where Cajetan was selected as the leader of the Theatines. His humility became legendary, and stories of miracles multiplied during his own lifetime.

In Spain Cajetan usually is portrayed dressed as a priest, denoting his particular interest in the sacred rites, and holding the Christ Child, alluding to an early mystical experience in which the Virgin Mary entrusted to him the care of the Divine Infant. However, in Mexican retablos, such as the illustration here, he appears dressed in the black robe of his order without the Child, and a magnificently jeweled chain has been added. This New World addition possibly symbolizes his rejection of wealth or his leadership of his order. Most probably it is the former, for the Theatines took monastic vows of poverty. It is by this ornament that Cajetan is most easily distinguished on retablos. Because of his association with wealth, he is sought in Mexico to bring money and is considered by some to be the patron saint of gamblers.

This saint may hold a lily in one hand and not rarely has a cross shown behind him upon which have been placed crowns of roses and thorns and occasionally a gold crown. The cross and crowns present certain problems. Cajetan's desire to lie on a hard board

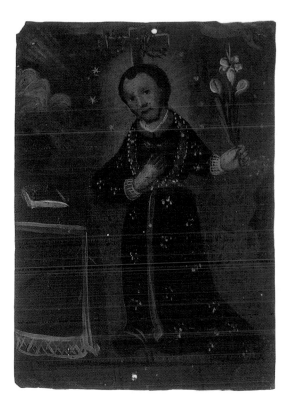

37
San Cayetano
Saint Cajetan or Saint
Gactano da Thiene
Founder O. Theatine,
d. 1547, R.M. Aug. 7
7" x 10"

while dying in as close an emulation of Christ as possible may explain the cross. However, the crowns of roses and thorns are reserved for martyrs, which he was not. The crown of gold probably is the traditional signification of rejection of this world's royalty and glory for a heavenly crown.

In one corner of some retablos depicting this saint there appears either descending rays or an equilateral triangle enclosing an eye. Both the triangle and eye and the rays are symbols of God. Miscellaneous symbols sometimes appearing with Cajetan are a book with or without pens and inkhorn (signifying his authorship or an attribute of his role as founder of an order), flames rising from the saint's chest (a symbol of religious fervor), a skull, and nails (referring perhaps to his mystical experience of the pains of the crucifixion.)

The retablo shown here has many characteristics of the red bole group, including the flowers, the tile, the clouds, and garment decoration. However, the usual careful attention to such details is lacking, especially in the right hand, which is scarcely more than a paw, and in the clouds, which are strangely angular. Besides these indications of carelessness or rush, the color is washed on, indicating that this retablo was left in a less finished state.

SANTO DOMINGO DE GUZMÁN

Saint Dominic, founder of the Dominican Order, was born in Cala-ruega, Old Castile, after 1170. At an early age he entered the service of the Church. After a mission in France trying to counteract the influence of the Albigensian heretics, he petitioned Pope Innocent III in 1215 for papal sanction for his order of preachers. In 1220 the order adopted a vow of poverty and became a mendicant brotherhood. Dominic traveled widely and constantly and died in Bologna in 1221.

This saint is generally represented as shown here, in the habit of the order he founded. His special attribute is the rosary, which tradition says was given him by the Virgin, who appeared and told him to go forth and preach. The dog with the flaming torch in his mouth is also an individual attribute, alluding to a dream his mother had before his birth. She dreamed she had given birth to such a dog, and the dream came to symbolize Dominic's activities in spreading the gospel, setting the world on fire. The symbol neatly coincides with the often-used pun on the name Dominicans—*domini canes,* dogs of the lord.

The star was said to have appeared on Dominic's forehead when he was baptized. The book is a symbol of his preaching; the lily of his chastity.

The retablo shown here has a very believable quality. It is nicely done, and special care has been given to the perspective and drawing.

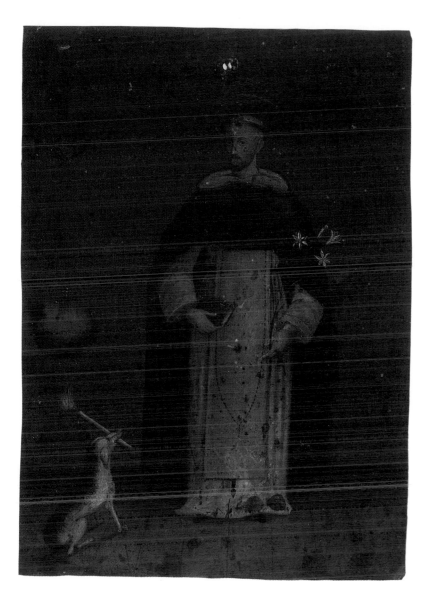

38
Santo
Domingo de
Guzmán
Saint Dominic
of Guzman,
Founder O.P.,
d. 1221, R.M.
Aug. 4
7″ x 10″

SANTA
ELENA

Tradition ascribes the finding of the true cross to the mother of the Emperor Constantine. She had been converted to Christianity after a vision appeared to her son predicting his victory in a battle. As a token of her piety she had a number of churches built, and at the age of eighty she undertook a religious pilgrimage to Jerusalem. There, particularly interested in the mount of Calvary, she had several excavations made in which three crosses were found. To determine which was the authentic cross, she had a severely ill man placed on each cross in succession. When he touched the true cross, he was miraculously cured. Similar legends tell of her later finding three nails which shone like gold. Two of these she gave her son for protection in battle.

The legends are conflicting, and details are not consistent concerning Helena's life and her role in finding the true cross. Furthermore, she was never mentioned in the writing of Saint Jerome, who lived later in nearby Bethlehem. Nevertheless, at one time she was considered one of the most important women in the world. Her significance during a period perhaps more perilous for the Church than that of the persecutions may have been her ability to focus the world's attention on something as simple as the planks of wood.

She appears, as here, exotically dressed to suggest a Roman empress, either crowned or wearing a turban. She holds the cross, and the three nails, if not still in the cross, are held by her or by cherubs. Although her hagiography does not attribute to her the finding of the crown of thorns, she is commonly shown with it. Well known, but not popular in retablo art, Saint Helena had no particular following in Mexico, except as mediator between the baptized newly born and God.

The retablo shown here points up the fascination with minute details that is common among folk artists. The elaborate decoration on the saint's garment and the complex pattern of the crown of thorns seem to have usurped the artist's entire attention, leading

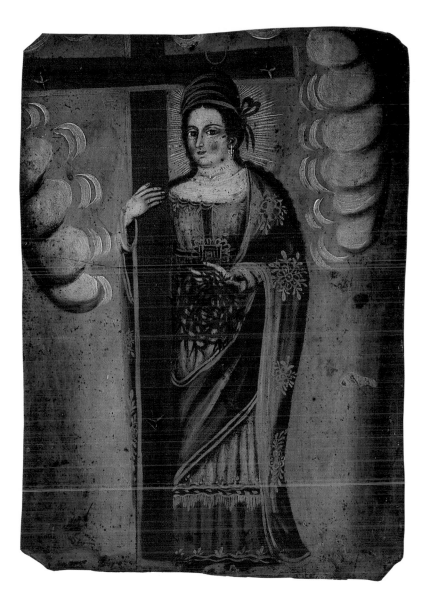

him to neglect many problems of perspective. It is not clear just
where Elena stands in relation to the cross, background, or clouds;
the saint's right arm and shoulder are in back of the cross while her
head is in front of it, an obvious impossibility; and the angles at
which the blood runs down the arms of the cross are in conflicting
perspective.

SAN
EXPEDITO

It is doubtful whether Saint Expeditus ever existed. Perhaps a copyist's error is responsible for the occurrence of the name Expeditus in groups of martyrs both on April 18 and 19, the martyr being assigned in one case to Rome and in the other to Armenia. There is no trace of any tradition to corroborate either mention.

Popularly it is related that the saint originated in modern times as the result of a misunderstanding: a packing case, containing a *corpo santo* from the catacombs, the story goes, had been sent to a community of nuns in Paris for placement in their new chapel. On the outside of the crate were the words "e spedito" and the date of dispatch. Ignorant of Italian, they mistook the words for the name of the saint and immediately set about spreading the cult. The story is destroyed, however, when it is recognized that he was worshipped as far back as the eighteenth century.

Expeditus' origin is considered to be an adaptation of pagan or mythical themes. He is always depicted as a classical warrior, holding the palm of martyrdom, a cross upon which is usually written *Hodie* ("today"), and stepping on a crow which, in the retablo shown here, is saying by means of a scroll, *Cras* ("tomorrow"). The patron saint against procrastination, he suspiciously resembles Mercury, whose rooster has been substituted by a raven, and whose caduceus has become a cross. But he has not changed his classical armor nor swiftness. Although he is almost completely forgotten in Mexico, there does exist a tradition of calling upon him in urgent cases.

Probably a statue painting, the retablo shown here depicts Expeditus with a distinct doll-like quality in his stiff pose and lack of modeling. The author has a retablo which shows an identical Expeditus, except for the addition of knee-length pants.

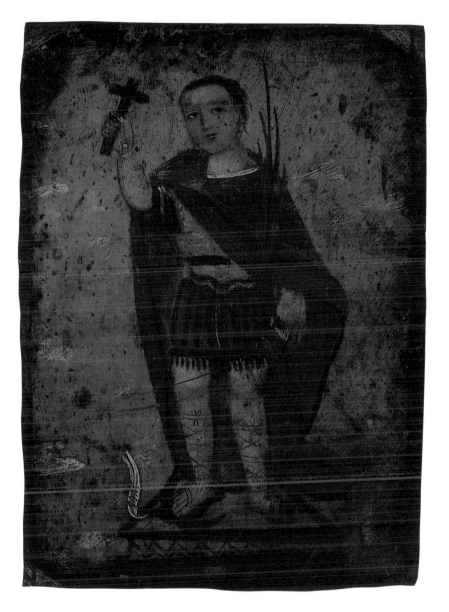

40
San Expedito
Saint
Expeditus,
legendary, no
date, P.C.
April 19
5" x 7"

SAN FRANCISCO
DE PAULA

This Italian saint received his name after a visit with his parents to the shrine of Saint Francis of Assisi. At the age of fifteen he became a hermit and retired to a cave near Reggio, where his fame drew disciples for whom the country people built cells and a small chapel.

In 1436 he founded the Order of Minims, or Hermits of Saint Francis, and preached to his followers with great emphasis on humility and charity. Miraculous cures, the raising of the dead, and the averting of plagues are attributed to him.

Saint Francis of Paola is seen in Mexican art as a venerable friar with the word *Caritas* or *Caridad* ("charity") surrounded by flames near him. The position of his hands suggests that he is holding something. There are little flames on both sides of the hands. The allusion is to several incidents in his life regarding his immunity to fire. A staff is usually present, and he is generally shown with a lamb emerging from a fiery oven. There is no satisfactory explanation in his life to explain this attribute, which seems to occur only in Mexico and which may also refer to his protection against fire. However, a lamb is the traditional symbol of sacrifice, and there may be some meaning based on Christ, the bread of life, and the sacrificial lamb.

Extremely popular in retablo art, images of this saint may constitute as much as five percent of the production of folk artists. He may be sought for protection against fires and plagues, and by lepers, the blind, and the maimed.

The retablo shown here is unusual in that it includes a date, 1871, and the artist's initials, D. A. This dated example helps confirm the author's suspicion that retablos such as this one, which exhibit flatness of color, lack of shading, and overall high-key color schemes, are of a later period and show the influence of the colored lithograph. In general, these later retablos are quite inferior to the older works, illustrating the general deterioration of a folk art.

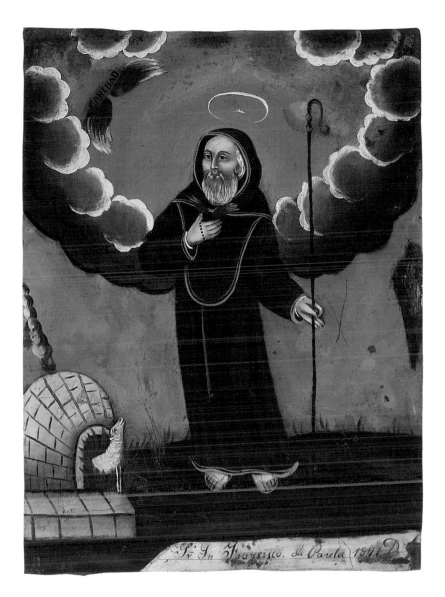

41
*San Francisco
de Paula*
Saint Francis
of Paola
Founder,
O. Minims,
d. 1507, R.M.
April 2
9½″ x 13

SANTA GERTRUDIS
LA MAGNA

There is nothing known of Saint Gertrude's birthplace or parentage. She entered the cloister of the Benedictine nuns of Helfta, Saxony, when she was five. Because she was a pupil of Saint Mechtildis, sister of the abbess Gertrude von Hackeborn, she is sometimes erroneously referred to by the title of abbess.

After a series of revelations which began when she was twenty-six, this saint applied herself to sacred studies and concentrated on the Bible and the works of the Church fathers. Five books and a series of prayers are associated with her, although she actually wrote only one book containing a succession of visions and mystical experiences. She was particularly devoted to the worship of the Sacred Heart and was said to have in visions twice reposed her head on the breast of Christ and heard his beating heart.

She is shown here as she commonly appears on retablos, in the habit of a Black Benedictine nun, holding the abbess' staff (a consistent mistake throughout this art) and the Sacred Heart, for which reason she is called the prophetess to its devotion. The veil attached to the staff is usually present, but on the retablo shown here it is a trifle more ornate than usual. The particularly fine treatment of the face, especially the eyes, are clues indicating that this retablo belongs in the red bole group.

Although Gertrude is the patroness of the West Indies, there does not seem to be any particular devotion to this saint in Mexico, nor are retablos of her common. She can be considered as mediator for those suffering from epilepsy or heart trouble.

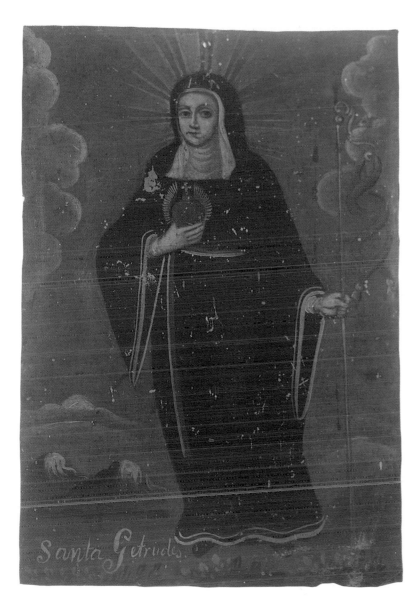

Santa Getrudes.

42
*Santa
Gertrudis la
Magna*
Saint Gertrude
the Great,
O.S.B., d. 1301
(02?), R.M.
Nov. 16
6½" x 9¾"

43
*San Gonzalo
de Amaranto*
Saint
Gonsalvus of
Amarante,
O.P., d. 1259,
A.C. Jan. 10
or 16
9¾" x 13⅝"

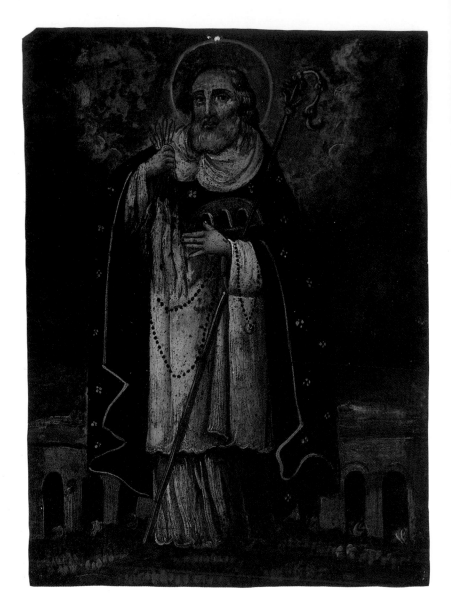

SAN GONSALO DE AMARANTO

The life of Saint Gonsalvus recorded by his biographer contains many suspect elements which make construction of a clear life history difficult. Once well-to-do, Gonsalvus resigned his wealth and after a lengthy pilgrimage was supernaturally directed to enter an order in which the office began and ended with the "Ave Maria." He became a Dominican and was allowed by his superiors to live as a hermit.

Of prime importance in his life is the fact that he built a bridge over the river Tamega near Amarante, Portugal, largely by himself. When he had helpers and their supply of wine ran short (an event that threatened to halt the work), Saint Gonsalvus prayed and struck a rock with his staff, whereupon an abundant supply of excellent wine appeared. When food ran low, he went to the river and summoned fish, which competed for the privilege of being eaten for such a worthy cause.

He is identifiable by the Dominican habit and rosary. He holds a string of fish, a model of a bridge, and a pilgrim's staff—all related to his life and supposed acts. In the background of the retablo shown here is a larger scale representation of the bridge.

This retablo demonstrates more sophisticated handling and skill than many others. Although the drawing of the hands is clumsy, the body is presented with bulk and conviction. The artist achieved depth, and the aureole created by clouds that appears so often in these paintings has a realism that is rarely seen.

Representations of Gonzalo are rare in Mexican art. He is not associated with any particular cause.

44
San Ignacio de Loyola
Saint Ignatius
Loyola, S.J.,
d. 1556, R.M.
July 31
5" x 7"

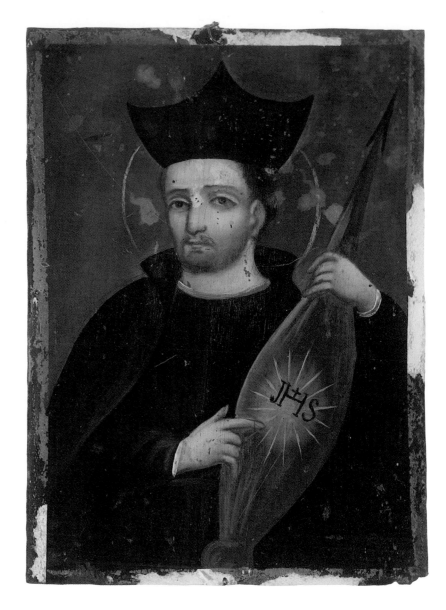

SAN IGNACIO
DE LOYOLA

Born of a noble Basque family, Ignatius at an early age received a military education which was far from morally edifying. He received severe wounds in defense of Pamplona against the French, and during the many months of convalescence he read books of the lives of Christ and the saints. He resolved to imitate the saints, and after his recovery he pronounced the vow of chastity, presented his sword to the altar of the Virgin of Montserrat, and prepared to depart to the Holy Land. While in Manresa he compiled his meditations, revelations, visions, and spiritual experiences, which, with his famous training manual entitled *Constitutions of the Society of Jesus*, won for him fame as a psychologist and trainer of men. He traveled widely during the next fourteen years and finally retired to Rome around 1537 to direct the institution he founded, later to become the Society of Jesus, or the Jesuits.

Ignatius is always shown in retablo art as a bearded figure in the habit of his order. The physical features seldom deviate, as they are based upon the portrait done by the saint's contemporary, Alonso Sanchez Coello. Ignatius always holds a banner with IHS on it and occasionally he holds a monstrance.

The retablo shown here gives some interesting insights into the painter's technique. The pencil lines around the hat and face, especially around the moustache, probably were not visible under the overpaint when the retablo was new. As the paint became transparent with age, however, these lines became noticeable. Note that the size of the biretta was changed after the sketching.

SAN
JERÓNIMO

During a serious illness Jerome experienced a vision in which Christ judged him. Profoundly affected, he withdrew to the wilderness for four years, although he had been a serious student and an active disciple of Christianity before this experience. While in the desert he suffered much from ill health and even more from temptations of the flesh. He resisted by fasting and beating his chest with a rock. It was in the desert that he studied Hebrew as a further measure of control over the flesh.

Jerome was ordained a priest after this retreat upon his stipulation that he would never have to serve any church but could remain a monk or recluse. He spent the following seventeen years in Rome, criticizing the existing conditions of the Church society and arousing much resentment. In 385 he embarked for Antioch. Later, through the generosity of a woman recluse, he built a monastery for men and buildings for three communities of women near the Basilica of the Nativity in Bethlehem.

It was here that Jerome accomplished his most important contribution to Christianity, his translation of the Old Testament from Hebrew into Latin and his critical labors on the scriptures. He revised every book of the Latin Bible, the Vulgate, except the books of Wisdom, Ecclesiasticus, Baruch, and the two books of Macabees. His studies included personal research in many areas of the Holy Land.

One of the four great doctors of the Church, Jerome is always seen in retablo art as a hermit in a setting suggesting the wilderness. Accompanying him are the symbols of penance and contemplation; the scourge, skull, and crucifix; and usually a horn in an upper corner directed toward his ear and signifying the final trump of judgment. Also, a book may be included, testifying to his scholarship.

Saint Jerome has been mistakenly called a cardinal because of his services for Pope Saint Damasus, and this false title is suggested here by his red robe. His chest may be wounded and bleeding, or he

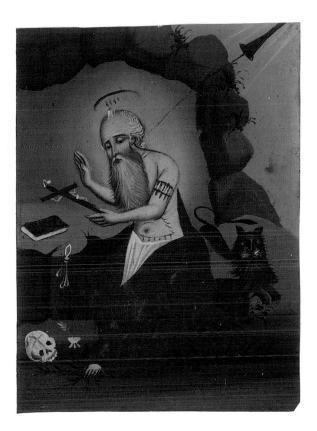

45
*San Jerónimo, Defensor
de la Fé y Abogado para
la Buena Muerte*
Saint Jerome, Defender of
the Faith and Intercessor
for a Holy or Peaceful
Death, Dr., d. 420, R.M.
Sept. 20
7" x 9½"

may have wounds on his arms to suggest his penitential beating
with the rock or use of the scourge. In the example shown here the
wounds become almost decorative, and the fact that the nearby
scourge is dripping blood indicates that this is the method by which
he chastized himself, rather than the traditional rock. Note that
the artist has depicted the scourge as something resembling a bolo.

Jerome's most characteristic and distinguishing attribute is the
lion. The beast was transferred to him because of confusion with
the legend of Saint Gerasimus. The Latin spelling of Jerome, *Geroni-
mus*, was so similar to that of Saint Gerasimus that Jerome ac-
quired from Gerasimus the lion and the tradition of removing the
thorn from its paw, whereby it remained loyal to him. Depicted as
an attribute rather than as a description of any legend, the animal
is greatly reduced in scale and commonly has, as seen here, human
facial features. The careful attention paid to the details of the lion's
face and to the face and beard of the saint transform this example
from an ordinary retablo into a lively work of art.

A popular subject among retablo painters, Jerome was sought for
protection against temptation and want. He is also the patron for
scholars, philosophers, and librarians.

46
San Joaquín
Saint Joachim,
R.M. Aug. 16
10″ x 13¾″

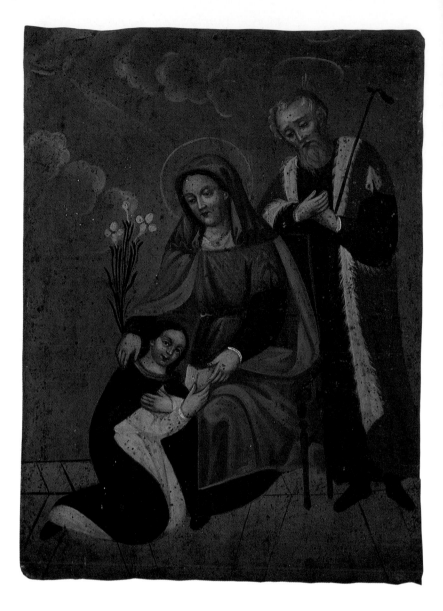

SAN JOAQUÍN

The husband of Anne, mother of the Virgin, is almost without exception depicted with his wife and daughter, not alone. He is shown as an older man, bearded, and traditionally gowned in a green robe and red coat trimmed in ermine. The ermine suggests wealth; the green robe symbolizes hope and new life, while red indicates royalty and love. The staff he carries shows that he was a shepherd. He usually appears in the background in scenes of Anne teaching the Virgin to read.

Nothing is known of Joachim's life for certain, but apocryphal tales relate that his gift at the temple was refused because of Anne's barrenness. He left with his flock to pray for forty days and nights. During this time an angel appeared to Anne announcing that her prayers for a child had been answered. She replied that be it male or female, it would be dedicated as an offering to the Lord. Another angel then appeared and informed her of Joachim's approach. Anne met him at the "Golden Gate" as he returned with his flocks and told him of the angel's visit only to learn that he had also been informed by an angel. Joachim, like Anne, is patron for the elderly.

It is interesting to note the secondary positions occupied by both Joachim and Anne on the retablo shown here. Even though they are greater in size, their eyes direct the viewer's attention to Mary, who accepts it with a direct gaze. The swollen hands, tile design, and facial features suggest that retablo belongs in the red bole group.

47
San José
Saint Joseph, R.M.
March 19
7" x 10"

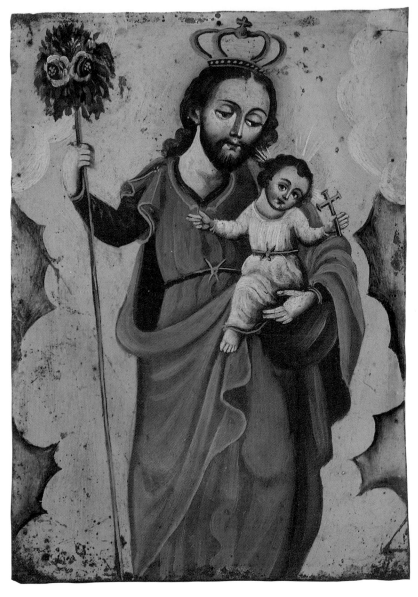

SAN
JOSÉ

This saint is a classic example of the tailoring of an image to meet Counter-Reformation needs. The seed of his cult took root during the time of Luther when the Catholic Church was searching for new heroes. Previous to this time the saint had been almost ignored. Sponsored by the Carmelite Order, he was appealed to by Saint Theresa for the protection of twelve of her monastic foundations, which she placed under his patronage.

To appeal to the temper of the times, the Church Militant re-

juvenated the saint. Previously shown in art as an old man en-
trusted with the guardianship of Mary, he was now interpreted as
much younger, for only in the prime of life, the Church argued,
could he have given Mary the proper care and protection. This new
Saint Joseph was developed by the artist into a virile man, full of
youth and strength. He continued to be portrayed as filled with
human tenderness, and this gentle and appealing characteristic was
exploited until he finally appears, as in retablo art, suspiciously
like a masculine Mary.

His attribute of a blooming staff or sometimes a lily and his title
refugium agonizantium ("refuge from agony") may be attributed to
the concern of Christendom about his little-known life. The de-
mand of popular curiosity and piety encouraged the "History of
Joseph the Carpenter," a chapter in the Apocrypha, perhaps dating
back to the fourth century A.D. Here it is related that Mary's hus-
band was selected by the placing of all eligible suitors' staffs in the
courtyard of the temple. The following day Joseph's had bloomed.
This staff became his attribute as well as a symbol of his purity.
Further legends tell of his death, comforted by the presence of Jesus
and Mary. The account of his death contains the promise of Jesus
to protect in life and death all thosen who do good in Joseph's name.
For this reason he became the patron for a good death, although
this was a much later aspect.

Saint Joseph is an image that provides no problem of identifica-
tion. He is never shown in retablo art except in company with the
Virgin and/or the Child. He rarely deviates from the traditional
pose of standing, holding the Child and a flowering staff or lilies,
and he may be crowned. He usually wears a green robe and yellow
mantle, the colors of new life, marriage, and fertility. Unfortu-
nately he is generally portrayed with insipid sweetness. In addition
to his protection at death, he is the patron of the family, of fathers,
husbands, carpenters, and those seeking a home.

The clouds in the retablo shown here are unusual from a design
standpoint, for they function as a separate design element, rather
than appearing as the usual areola. Although the faces and figures
are strongly portrayed, the unusual proportions give the retablo
an awkward look. The traditional three-quarter length portrait
ends at the knees, but here the figure of Joseph is terminated above
the ankles.

48
San Juan
Nepomuceno
Saint John
Nepomuk,
O.S.A., M.,
d. 1393, R.M.
May 16
4" x 6" (Shown
actual size)

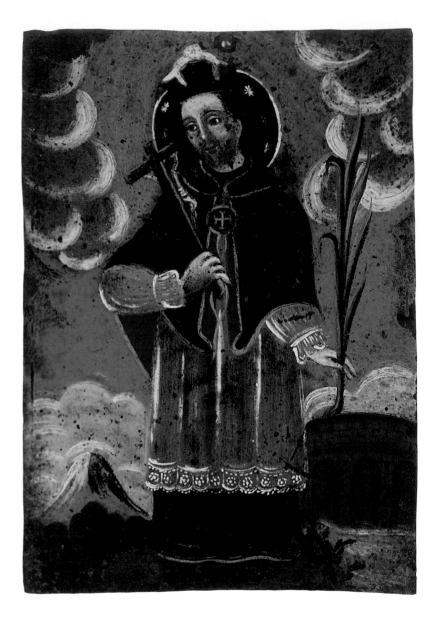

SAN JUAN NEPOMUCENO

This Bohemian saint arrived in Mexico from Prague via Rome with the Third Order of Saint Francis during the years of the Holy Roman Empire. He was one of the saints revived by the Church Militant during the Counter-Reformation.

Confessor to Prince Wenceslaus' wife, he refused all efforts by this king, including the rack and fire, to make him reveal what his wife had confessed. The saint was bound and thrown into the river Moldau, where his body was discovered floating with seven brilliant stars illuminating it. Centuries later, in 1719, the coffin was opened, and his tongue was said to have been perfectly preserved.

Not commonly found in Mexico on tin, Saint John Nepomuk is distinguishable by his cassock, the biretta, the stars encircling his head, the bridge in the background, and, of course, the martyr's palm, often suspiciously drooping, like the more familiar cornstalk. He may also be shown holding a tongue. He is the patron saint of Bohemia and of confessors, lawyers, and bridges. He is also invoked for secret-keeping.

In the retablo shown here, a mountain decorates the background in the lower left, while a bridge fills the lower right. The detailed lace, which is always shown in paintings of this saint, creates a precious feeling. Notice how deftly lights and shades are created with the use of a middle shade. This highly simple but effective technique became a formula for many miniature painters.

An unusually small retablo, this painting is shown here in its actual size, four by six inches.

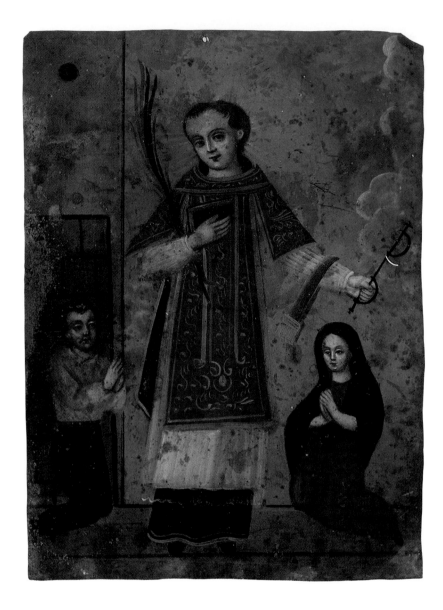

49
San Leonardo
Saint Leonard
of Noblac,
Abt., d. 559,
R.M. Nov. 6
7" x 9½"

SAN LEONARDO

One of the most popular saints of western Europe in the later Middle
Ages, nothing is heard of this Saint Leonard before the twelfth
century, when a life was written upon which little reliance can
be placed. According to this life he was a French nobleman who
was converted to the faith by Saint Remigius. Leonard's godfather,
Clovis I, offered him a bishopric, which he refused, choosing in-
stead to go into the country of Orleans to the monastery of Micy,

where he took the religious habit. Later the desire for a closer solitude led him to the forest near Limoges, where he built a cell and lived on fruit and vegetables. It was here that Clovis brought his queen hunting and she began a difficult labor. By the prayers of Saint Leonard she was safely delivered, and the king in gratitude gave him as much land as he could ride around in a night on his donkey. Here a community was founded which later became a flourishing monastery, first called the Abbey of Noblac and now Saint-Lèonard. The saint evangelized the neighborhood and died there in the middle of the sixth century.

The church at Noblac became a great pilgrimage center, and Leonard was invoked by women in labor and by prisoners of war. This latter aspect of his protection is due to the legend that Clovis promised to release every captive Leonard visited. This special devotion to him as a liberator of prisoners of war gained popularity from the story of the release of Bohemund, Prince of Antioch. This prince had been taken prisoner in 1103 by the Moslems, and it is historically certain that after his release he paid a visit to Noblac and presented an ex-voto in gratitude. Saint Leonard sometimes is included in the list of Fourteen Holy Helpers.

In the example here, the saint appears as a young abbot with a pair of shackles in one hand. The man kneeling must be interpreted as a prisoner, considering the grill design behind him, and the woman must be praying for an easy labor.

Like figure 42 depicting Saint Gertrude, this retablo demonstrates an especially strong concern for hands and face. This characteristic, along with similar color schemes, indicates that these retablos both were done by the red bole group. The saints in these two retablos have almost identical stances, but notice the subtle differences in body tilt.

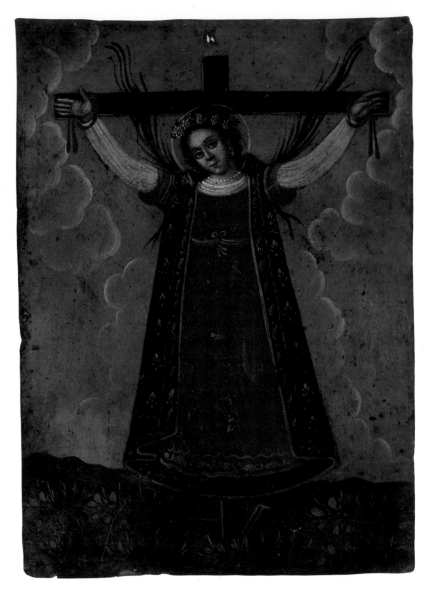

SANTA LIBRATA

This legendary saint is known by many names in many countries.
The story of her preposterous origin is one of the curiosities of
hagiography.

The popular tale relates how this saint was one of seven (or nine)
children born at one birth to the wife of a heathen king of Portugal,
and all seven (or nine) became Christians and suffered martyrdom.
Her father wanted her to marry the king of Sicily. However, she

had taken a vow of virginity, and when she prayed for help a beard and mustache grew on her face. The suitor promptly withdrew, and her enraged father had her crucified.

Actually, this saint is a complicated mixture of confusion, fact, and fiction resulting from pious devotion to the famous crucifix of Lucca, well known in the twelfth century. This image of Christ was gowned and crowned as were many others during the time. In the course of time the long gown caused people to think the crucified figure was a woman, who on account of the beard was called *Vierge-forte* ("Strong Virgin"). The legend of her refusing marriage and growing the beard began in Steenberger in North Holland around 1400 and was widely circulated. Since "her" real name was unknown, the image was called *Ontkommer*, "the one who takes away grief." Molanus, a Flemish scholar, had the unfortunate idea of Latinizing the name *Ontkommer* to *Librata*, even though he later dropped this name. The Spanish and Portuguese, who already had a Saint Librata, were greatly flattered that a flourishing cult had spread so far away and considered the two saints identical. Thus the original Librata, who had been martyred by beheading, now was absorbed in the Ontkommer legend and appears crucified.

In Spain and Mexico Librata never appeared bearded but was shown typically as illustrated in the example here, as a young girl crowned with roses and crucified. Palm leaves also are common as the traditional symbols of martyrdom.

Although there is a tradition in England of women seeking the aid of this saint to relieve them from burdensome husbands or unwanted suitors, in Mexico she was invoked in times of suffering and as a helper in distress. In both Spanish and Mexican beliefs she traditionally was one of the Fourteen Holy Helpers sought at the time of death, but her popularity has so waned that she is unknown in Mexico today.

Several retablos depicting this saint have been seen, and, as is peculiar to illustrations of crucified saints in this folk art, she is attached to the cross without nails. The coloration and format as shown here is generally in keeping with her prescribed treatment by artists. The drawing and technique link this retablo to the red bole group.

51
Santa Lucía
Saint Lucy, V.M., d. 304,
R.M. Dec. 13
7" x 9⅝"

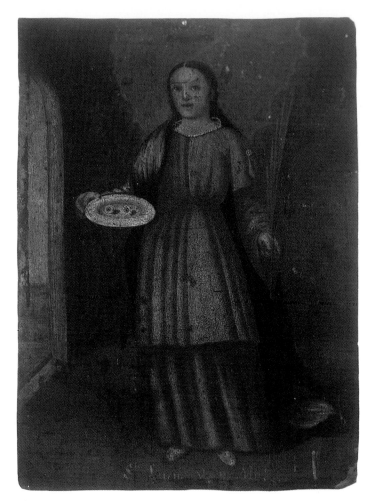

SANTA LUCÍA

Martyred because of her Christian beliefs, Lucy was an extremely popular saint in Europe. However, she is rarely found on the tin paintings in Mexico.

She is shown as tradition dictates, as a young woman holding a palm leaf and, on a small dish, two eyes. While legend relates that she plucked out her eyes to relieve the suffering they caused a suitor of hers, it is more likely that her name "Lucia" (light) inspired the attribute of the eyes (or a lantern, as is often shown in European art). Although Lucy is invoked against blindness, Mexicans usually call upon the Archangel Raphael, who is much more popular.

The effects attempted in the retablo pictured here are unusual in this art form. Not only is there a view presented through an open door (however slight), but realistic side-lighting from this opening creates shadows and highlights. The figure has a convincing bulk and form, which also is uncommon on retablos.

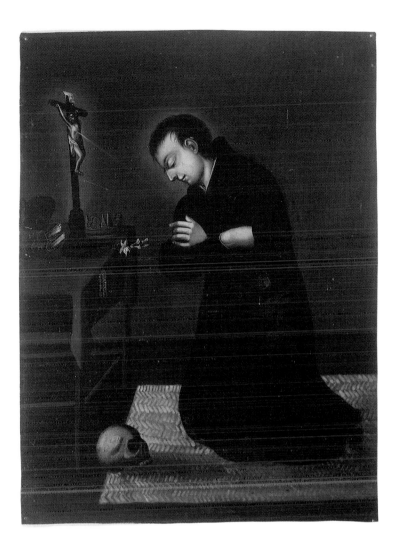

52
*San Luis
Gonzaga*
Saint Aloysius
Gonzaga, S.J.,
d. 1591, R.M.
June 21
10″ x 14″

SAN LUIS GONZAGA

The career of Saint Aloysius Gonzaga is exceptional in light of his background and heredity. His family were tyrants ranked with the Visconti, Sforza, and D'Este. When he tried to leave this circle of intrigue, power, and flattery to join the Jesuits, it was a great shock to his family.

From an extremely early age Aloysius practiced prayer and penance, and it was his desire in his early teens to join a religious order. His father, the Marquis of Castiglioni, at first grudgingly agreed, but then sought to discourage him and put pressure on him through relatives and eminent churchmen. At last, however, in 1585 the

youth renounced his birthright in favor of his brother Rudolfo and joined the Society of Jesus.

In 1591 plague broke out in Rome, and Aloysius persevered in his efforts at a hospital, though the conditions made him sick and faint. He caught the plague by carrying the sick to the hospital on his back, and despite a brief recovery, died on June 21, a little over twenty-three years old.

He is always pictured as a young Jesuit with a crucifix, lily, and scourge. In the retablo shown here he has the additional attributes of coronet laid aside (signifying his rejection of his noble life), a skull (symbol of penitence and *memento mori*), and books (symbols of wisdom), and he is kneeling on a typically Mexican *petate*, or straw mat.

Aloysius is distinctive among saints in that his facial features are consistent in paintings and retablos. He is almost always shown with a definite physiognomy marked by a rather pronounced nose and receding hair. He is considered the patron of young students and of those choosing their professions, and is particularly thought of as the patron of youth and purity.

The retablo shown here has unusual sophistication and polish, indicating that the artist was above average in training and ability. Evidently he thought so too, for he has signed his name, "Zepeda M. F.," in the lower righthand corner. This signature suggests an attitude rare among retablo artists—the painter saw himself as an artist-creator, not simply as a craftsman.

SAN MARTÍN DE TOURS

Forced into the army against his will when he was fifteen by his officer father, Martin lived a life more fitting to a monk than a soldier, although he was not formally a Christian. While stationed in Amiens an incident is said to have occurred which tradition and art have made famous. One day during a hard winter a poor man almost naked and trembling from the cold was begging alms at the gates of the city. Martin noticed that no one paid any attention to him and, having nothing to give but his armor and clothes, he cut his cloak in two and covered the poor man with half of it. That night Martin in his sleep saw Jesus clothed in the half-cloak saying, "Martin yet a catechumen has covered me with this garment." Martin was immediately baptized.

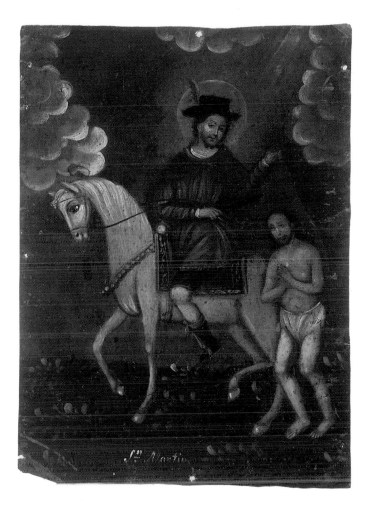

It is this incident in his life that is portrayed in folk retablos as
well as in almost all sophisticated European depictions of him. Al-
though he was a favorite saint in Mexico during the nineteenth
century, retablos of him are not abundant. He is always seen as
portrayed here, a young caballero dividing his cloak with a knife or
sword while a poor man meekly waits to one side. Invoked when
someone has a cold or lacks clothing, this saint is also the patron
of beggars, shirt-makers, tailors, and especially soldiers. Earlier tra-
ditions also include his protection for horses, although this is a
forgotten aspect of his patronage today.

Several characteristics place the retablo shown here in the red
bole group. Saint Martin's face is strongly similar to that of Saint
Isidore (fig. 64) and of Christ as "The Eucharistic Man of Sorrows"
(fig. 9). The painting also includes the label which sometimes marks
retablos in the red bole group.

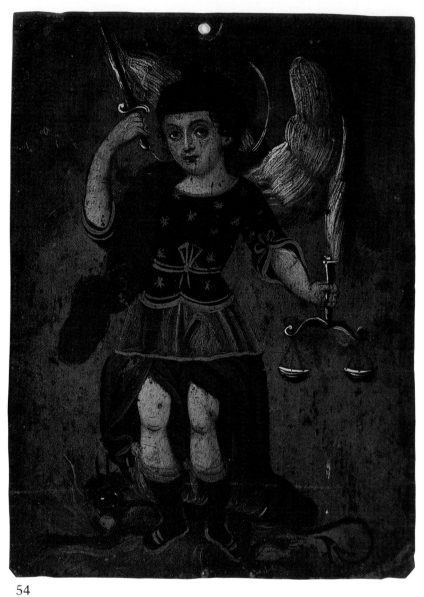

54
San Miguel
Saint Michael, Archangel, R.M.
Sept. 24
5" x 7"

SAN
MIGUEL

Christian tradition ascribes to the Archangel Michael the role of general of heaven's angels and protector of the Church Militant. He is dramatically described in Revelation 12 : 7–9 as leading his angels in battle against a dragon, "That old serpent called the Devil and Satan." Consequently, he is always pictured in Catholic art, and similarly on retablos, as young and beautiful, dressed in mail and helmet or something simulating battle dress. He is subduing a demon or has just trampled him underfoot.

When shown with scales or balances in his hand, he is acting in the capacity of weigher of men's souls. It is not unusual to see him illustrated in this folk art with both sword and scales; having subdued the demon, he stands on him with flaming sword triumphant, holding the scales in his other hand. The pose suggests a more immediate victory over the Evil One in the conflict over men's souls.

In figure 54, Michael stands almost as if he had been told to cease his battle and pose with his attributes. Reinforcing this impression is the benign-appearing monster, complete with goatee and mustache, patiently resting with his head on his hand—obligingly ceasing to struggle until after the picture was "taken." Most retablos resemble this illustration in composition and attributes, occasionally replacing the scales by a shield. The carefully painted details on this very small retablo suggest that it belongs with the red bole group.

Figure 55 has several unusual characteristics. Michael is shown again as a warrior with scales, but here his role as a soul-weigher is more clearly defined. Beneath him, shackled and in flames which signify purgatory, are people, including a bishop and a rare figure in retablo art—a nude woman. Although lacking the fine features of many red bole paintings, this retablo has a strong family resemblance to this group.

Saint Michael is a favorite character in Catholic belief, but he is

not very common in the retablo art form. He is not technically a saint, but the title is often applied to archangels and other holy persons to denote reverence.

Saint Michael is sought by sinners against temptation and at the hour of death.

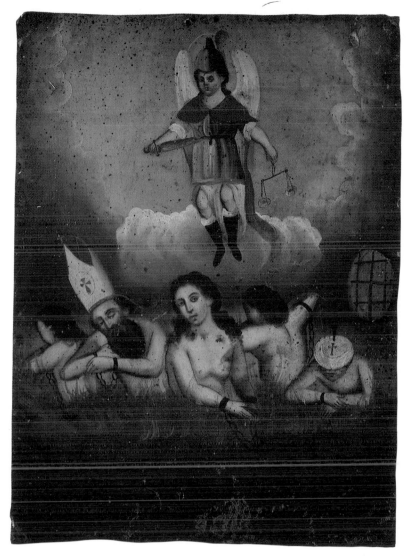

55
San Miguel
Saint Michael, Archangel, R.M.
Sept. 24
10″ x 14″

56
*San Pascual
Bailón*
Saint Paschal
Baylon,
O.F.M.,
d. 1592, R.M.
May 17
7″ x 10″

SAN PASCUAL
BAILÓN

The son of poor shepherds, Paschal was born on Whitsunday, hence his first name. He spent his life until he was twenty-four as a shepherd and then was finally admitted to the barefoot Friars Minor, having been refused six years before. He was extremely devoted to the sick and poor and managed to secure special delicacies for them. He was noted for his cheerfulness in his devotions or penances, and was particularly reverent toward the Sacrament, kneeling for hours at a time in front of it.

Although various accounts written about him do not mention specifically this aspect of his life, popular legends consider him the patron saint of the kitchen and of cooks. Tales are told of his duties in the kitchen miraculously accomplished while he spent his time in adoration of the Sacrament.

Invoked for cheerfulness and named the patron of eucharistic confraternities and shepherds, his role as patron of cooks is one of the most commonly represented in retablo art. Scenes of Mexican kitchens are carefully shown, including dishes, cooking implements, dressed meat, and usually the kitchen cat. The saint is occasionally shown in a manner that suggests levitation while praying, and the monstrance containing the Sacrament appears supported on a cloud above and to one side of Paschal. This saint also may be sought to prevent cattle plagues and contagious ills and is said to advise one of coming death three days beforehand.

In the retablo shown here the monstrance and the saint's face are carefully drawn. Extra care also has been given to the habit and attributes. The gilt paint, which has darkened considerably, serves as additional embellishment. The onions and the chilis on the floor indicate a kitchen setting, as does the pot on the flame. However, the flat background and the position of the cooking pot destroy any feeling of depth

57
San Rafael
Saint Raphael,
Archangel,
R.M. Oct. 24
4¾″ x 6½″

SAN
RAFAEL

Saint Raphael, with Saint Michael, is the most popular of the seven archangels in Mexican art. His name signifies "God has healed," and this healing function is related in the Book of Tobias, wherein he restores sight to the father of Tobias. His guarding of young Tobias on his journey also is stressed, and because of these two main elements in his legend, he became the patron against eye ailments and for safe journeys. He also was invoked against plagues and malaria.

In the example shown here Raphael appears with the costume, pose, and attributes which typify him in the tin paintings. He holds the traveler's staff, gourd, and cloak, and the fish with which he and Tobias sought to cure the father's blindness. Generally he wears a diadem. Peculiar to both him and Saint Michael is the robe cut, tied, or blown away, exposing the legs and high boots or sandals. This is a typical stylistic characteristic in the language of the baroque movement.

Retablos depicting Raphael illustrate the naive artist's tendency to alter a motif or character to meet the tastes of his clients. In retablo art Raphael always appears alone, without Tobias, but his appearance has been altered to make him a symbol for both. Raphael is reduced from the powerful guardian and agent of God of the Old Testament to the boyish appearance of Tobias, from an imposing archangel to an appealing *putto*.

SAN RAMÓN NONATO

This saint's true story is wrapped in legends and mystery due to the lack of reliable material. He was accepted into the order of Our Lady of Mercy in Barcelona and was sent to Algiers to ransom Christian hostages from the Moors. After expending the funds given him, he gave himself to free another hostage. He used this opportunity as a prisoner to convert Mohammedans to Christianity and was saved from being condemned to death for his efforts by influential Christians who were waiting to be ransomed. However, he was severely clubbed. He nonetheless continued in his conversion efforts and in giving spiritual comfort to Christian slaves. The enraged governor then had him whipped at every street corner and directed that his lips be pierced by a hot iron and a padlock inserted. He was freed eight months later and returned to Spain. Made cardinal by Pope Gregory IX, he died at the age of thirty-six on a journey to Rome on foot.

A popularly portrayed saint in Mexico, he is frequently seen on retablos. He is always pictured as a Mercedarian cardinal with the badge of his order displayed somewhere on his habit. His personal attributes include a palm with three crowns ringing it, signifying chastity, eloquence, and martyrdom (although he was only tortured, not martyred). He always is holding or receiving a monstrance, an allusion to his receiving communion from the hands of an angel when dying.

His last name *Nonatus*—"not born"—commemorates his caesarean birth at the time of his mother's death. For this reason, he is the patron of midwives and women giving birth. Because of his efforts at ransoming prisoners, he is also the patron of innocent people falsely accused. The padlock on his lips and the silence it implies made the Mexican folk regard him additionally as the patron for silence. Many of the retablos of this saint have the mouth area completely rubbed away. There is a tradition that to eliminate gossiping or someone's continuous talking, the mouth of the saint

58
*San Ramón
Nonato*
Saint
Raymond
Nonatus,
Card., O.
Merc., d. 1240,
R.M. Aug. 31
10″ x 14″

is to be rubbed. Current beliefs include the fastening of a five-cent piece to the mouth with a wad of gum to convince the saint that help is needed in these situations.

In the retablo shown here the careful attention to detail—especially the bouquet on the table and the stylistic devices of the draperies—suggests the red bole group. However, the hands are mere indications, and the facial features are not carefully defined. The mouth has been partially rubbed away by the faithful.

59
Santa Rita de Casia
Saint Rita of Cascia, O.S.A., d. 1456, R.M.
May 22
10″ x 14″

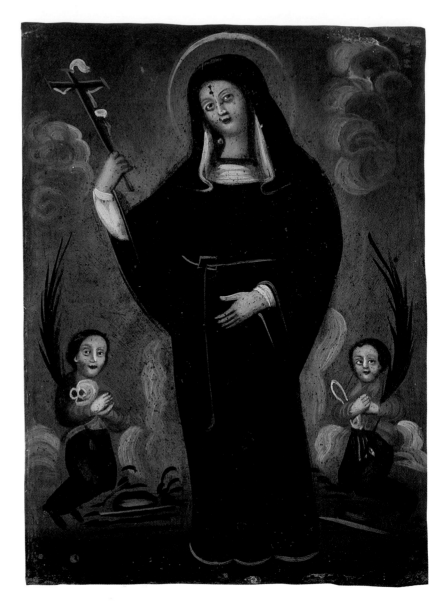

SANTA RITA
DE CASIA

Respecting her parent's wishes that she marry instead of entering
an Augustinian convent, Saint Rita spent eighteen years of her life
in absolute terror of the dissolute man she was forced to marry. Her
exemplary life finally moved him to reform, but he was killed in a
brawl under circumstances that made their two sons vow to avenge
him. They died, however, before this purpose had been accom-
plished, and thus Rita's way was now clear to enter the convent
which, after refusing her three times, relaxed its rule of allowing
only virgins to enter.

Saint Rita was particularly devoted to the sufferings of Christ,
and, after she had heard an eloquent sermon on the crown of thorns
by Saint James della Marca in 1441, a strange physical reaction oc-
curred. As she knelt in prayer she became acutely conscious of
pain, as if a thorn had detached itself from the crucifix she was
contemplating and imbedded itself in her forehead. This wound be-
came so offensive that she had to be secluded from the rest; and
with the exception of a pilgrimage to Rome during the year of the
jubilee in 1450 when the wound healed temporarily, she lived prac-
tically as a recluse.

It is this wound on her forehead, signified by a thorn, that most
easily identifies her. Dressed as an Augustinian nun, she appears
with symbols of penance and contemplation. Generally she is ac-
companied by two smaller figures on either side, probably repre-
senting her two sons.

She is invoked as patroness of desperate cases or helper in im-
possibilities because of an incident which occurred at the time of
her death. She had asked a visitor to bring her a rose from a gar-
den. The visitor went, knowing that the season was not advanced
enough for roses, but found a whole bush blooming and brought
her one. She is also considered to be a model for married women.

The retablo shown here exhibits an adroit use of detail and tech-
nique. Note especially the inclusion of hats near the two smaller
figures. Such characteristics suggest that this retablo is related to
the red bole group.

60
San Roque
Saint Roch, d. 1337, R.M.
Aug. 16
10″ x 14″

SAN ROQUE

Although about all that can be said with certainty about this saint is that he was born in Montpellier and nursed the sick during the plague in Italy, legends about him provided artists with subject matter to present him as he is seen here.

He is always shown as a pilgrim. It is related that in this role he arrived in Rome during a plague and devoted himself to caring for the sick, often healing them by simply making the sign of the cross over them. At Piacenza he contracted the plague himself, but not wishing to be a burden on anyone, he dragged himself off to the woods to die. He was miraculously fed by a dog, whose master found Roch and cared for him.

This saint is usually represented as here illustrated, but missing in this retablo is the bread in the dog's mouth and the plague mark which Roch usually points to. His clothing, hat, staff, gourd, and the dog define him. The reason for the inclusion of the book, a symbol of learning or wisdom, is not clear.

Although still revered as a popular saint for protection against pestilence in European countries today, in Mexico Roch is rarely seen on retablos and never in current religious depictions. It can only be assumed that he was invoked for the same things in the New World as he had been in Spain, that is, for protection against plagues and against rabies.

A number of typical characteristics put the retablo shown here in the red bole group. Compare especially the face with that of the other saints painted by this group.

61
Santa Rosa de Lima
Saint Rose of Lima, O.P.,
d. 1617, R.M. Aug. 26
or 30
10" x 14"

SANTA ROSA DE LIMA

This saint has the distinction of being the first in the New World
to be canonized. She was born in Lima in 1568 and lived thirty-one
years wholly in voluntary penance and prayer. Although she was
quite attractive, to humble herself she deliberately attempted to
destroy her looks by plunging her hands into lye or by rubbing
her face with ointments that would disfigure and cause pain. She
joined the third order of Saint Dominic, took the vow of chastity,
and, choosing as her patroness Saint Catherine of Siena, endeav-
ored to model her life upon hers, although she lacked the person-
ality and intellectual capacity of the great Dominicaness.

Saint Rose had many mystical experiences which were investi-
gated during her lifetime, including the vision of Christ as a child.
These were pronounced by an ecclesiastical commission as of di-

vine origin. She lived as a recluse until the last three years of her life in a hut in a garden. Her death in 1617 was preceded by a lengthy and painful illness.

She is easily identifiable by her Dominican habit and the crown of either thorns or roses around her head. The crown recalls the symbolism of martyrdom, but in her case it alludes to her preferring the punishment of the thorn crown to the crowns of roses given her by her parents, complimenting her on her beauty. Her vision of Christ is a common theme. Patron of Lima, Peru, she had limited popularity in retablos and was not specifically sought for aid in Mexico.

Compared to other retablos, the painting shown here exhibits a rather hard and tight technique. Although the saint is precisely correct in her appearance, the stiff style somewhat impairs the effect of this depiction.

SANTIAGO

Saint James, brother of Saint John the Evangelist, son of Zebedee, was called "the Greater" to distinguish him from another apostle by the same name who was younger. In Spanish, the name Santiago evolved as a corruption of San Diego.

By birth this James was a Galilean fisherman with Peter and Andrew. Certain apocryphal "acts" in Greek—not written earlier than the eighth century and quite fictitious—relate of his preaching in Spain, his death in the Holy Land, the transportation of his body back to Spain, and the miraculous happenings concerning his burial in Compostela. A dubious story strenuously defended by some Spanish scholars, this tale nevertheless made Santiago the most important saint in Spain, and Compostela was a site of immense importance for pilgrimages.

In the battle of Clavijo against the Moors in 834, the appearance of this saint dressed in armor upon a white horse rallied the Spaniards to victory. Since then, the Church Militant has used him as a symbol in its fight against infidels and heretics, and he has appeared in his soldier role most commonly in Spanish and Spanish colonial art, his mild biblical life forgotten.

He came to the New World as the patron of Spain and of soldiers at the time of the conquest; with his appearance and aid during battles in Mexico, he assisted in the defeat of the Indians as he had in that of the Moors. In the New World no less than fourteen apparitions of him were recorded in battles, first between the Spanish

62
Santiago
Saint James the Greater,
Apostle, d. 44, R.M.
July 25
9″ x 13″

and the Indians and later between the Spanish and the Mexicans,
fighting in the last two instances on the side of the Mexicans.

With the overthrow of colonialism in Mexico, the demand for
this saint's image seems to have waned. Although he was well
known and popular, retablos of him are scarce. In addition to his
roles as patron of soldiers and of Spain, Santiago was also sought as
protector against all ills and for the fertility of mares.

He most often appears in retablo art astride a white horse, carry-
ing a banner with a red cross, and trampling down Moors. He is
usually superhuman in size compared to the several Moors, who
are shown in various degrees of defeat and flight. He is often repre-
sented as a triple personality: apostle, pilgrim (identifiable by his
cape and hat), and soldier. We see especially the latter two aspects
in the example shown here. The horse's anatomy in this painting is
quite believable, although the proportion of the saint who rides
him is not realistically accurate.

SAN VICENTE
FERRER

This saint's life is so overladen with legends that no satisfactory account of him has yet been written. Popularly he was presumed born of English or Scottish parents in Spain. His parents, in response to prophecies of his future greatness, are said to have raised him very religiously and with a great love for the poor. Intellectually precocious, he received the Dominican habit in 1367, and before he was twenty-one was a reader of philosophy at Lérida, the most famous Catalan university.

Vincent is generally regarded as one of the most powerful preachers medieval Catholicism had, turning many careless believers to penitents and converting many Jews. He felt himself to be the instrument chosen by God to announce the impending end of the world. In fact, he declared himself at one time to be the angel of judgment foretold by Saint John (Revelation 14:6). He traveled widely, and legends suggest that he event went to England and Ireland. He was said to have the gift of tongues, for when he spoke his sermons, all his listeners understood what he said, no matter what their nationality. He is credited with healing the schism in the Catholic Chuch which began when the French Cardinal Robert of Geneva took the name of Clement VII and claimed himself pope in opposition to Urban VI, hastily elected in response to a popular cry for an Italian pope.

Vincent is shown in retablo art as a Dominican. He always is depicted with wings, his most readily identifiable attribute, perhaps referring to his belief in his angelic role as stated in Revelations. The book indicates his effectiveness as a preacher, and the crucifix is usually interpreted as a symbol of preaching the Christian faith. In European paintings, the upraised finger pointed to an image of Christ on a scroll with the Latin inscription *Timete Dominum et date illi honorem quia venit hora judicii eius* ("Fear the Lord and render him honor because his judgment hour is coming"). In retablo art, however, the image of Christ and the scroll have disappeared, leaving the finger pointing skyward. A trumpet is con-

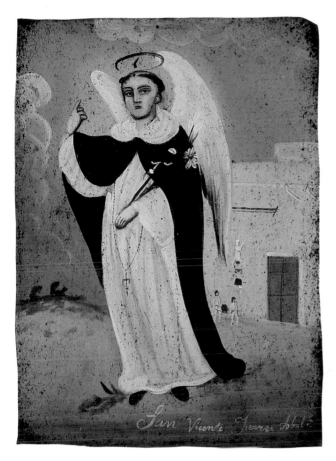

63
San Vicente Ferrer
Saint Vincent Ferrer,
O.P., d. 1418, R.M.
April 5
10″ x 14″

sidered another one of his identifying attributes as well as the flame over his head. These elements may occasionally occur in Mexican folk paintings.

The retablo shown here depicts the legend that while Vincent was passing some masons working on a building, one fell. He was asked to help, and, although he was famous for his miracles and cures, he had given his promise to the bishop not to perform any. While he went to ask permission to help, the main remained suspended in mid-air. When he returned, he helped the man to a safe landing. Because of this legend he became patron saint of stone masons and also was invoked by the Mexican folk to alleviate headaches.

Although thinly and sketchily painted, the retablo shown here exhibits some pleasing elements of design. The saint's wings pick up the sinuous curve of his robe and cloak, revealing the ease and spontaneity the artist must have felt in painting this simple household picture.

64
San Ysidro
Labrador
Saint Isidore
the Farmer,
d. 1170, R.M.
May 10
10″ x 14″

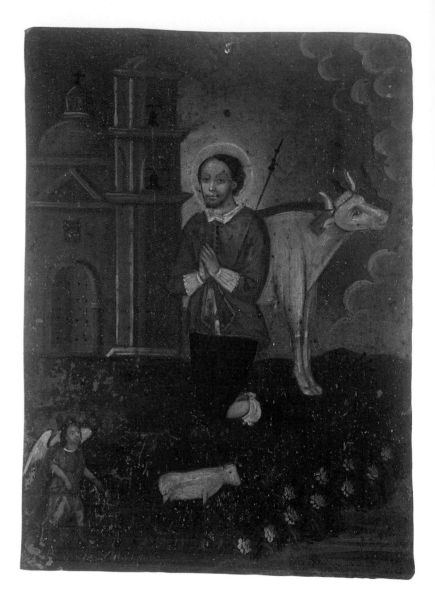

SAN YSIDRO
LABRADOR

This saint is one of the most popular saints among the common people because he is the patron saint of farmers. Born near Madrid of a poor family just after the beginning of the twelfth century, he was an uneducated farm laborer. Deeply devout, he dressed as a hermit, prayed regularly, and gave everything he owned to the poor. Popular tales relate that, as an industrious farmer, he worked on Sundays. The Lord cautioned him, threatening and materializing a plague of grasshoppers and a torrential rain. Still Isidore continued in his faith and worked on the Sabbath. The Lord threatened him for the third time—this time with bad neighbors—and Isidore consented to observe the Sabbath. Even more popular, however, is the tale that he could not attend church because of the large amount of work he had to do, and the Lord sent an angel to plow the field. It is in this aspect that he is most commonly seen.

On retablos this saint always is surrealistically shown much larger than the angel and cattle. Sometimes, as in the example shown here, the angel appears with one small set of oxen while Isidore appears with another more his own size. While the angel plows, Isidore prays. This saint is prayed to for concerns affecting livestock, agriculture, and good weather—even for picnics.

On the retablo pictured here, Saint Isidore exhibits the typical red bole group face. Other trademarks of this group are the obvious care in the depiction of the hands and lace cuffs, the quickly sketched flowers in the lower right, and the shadows detailed with light and dark brushstrokes. The crude portrayal of the cattle indicates that when the artist had to deviate from his formula to portray something new, he used memory and imagination, not observation of the actual subject. The severe damage in the lower left of this retablo was caused by rust.

PART 3
THE MEXICAN
EX-VOTO PAINTING

Ex-votos, because of their importance for comparison with retablos, deserve at least brief consideration here. Dramatic and charming, these little story paintings reveal much about the Mexican people and their art.

An ex-voto is a votive painting hung on a church wall or placed near a particular image to commemorate the recovery of the donor from some grave danger. Each is a receipted bill for spiritual or physical boons received. Truly anecdotal, the painting illustrates a written text that relates the circumstances of the cure or rescue. The written commentary is often so full of regional dialect and phonetic spelling that it is impossible to translate it and still maintain the flavor.

The ex-voto tradition—the placing of some object indicative of a healing or blessing—probably dates back to the Greeks. The custom followed the Spanish to the New World, and pictorial stories of divine aid, constituting a public offering of thanks to the holy person invoked, were placed in Mexican churches as soon as they were built.

During the colonial epoch and until the end of the eighteenth century the offering of votive pictures was almost wholly confined to the wealthy. After the achievement of independence from Spain, the common man adopted the ex-voto for his own. Now he too made public his testimony of faith, for the ex-voto painting depicted events in graphic terms for easy transmission to everyone, even the illiterate. By far the greatest number of ex-votos were produced for the masses, for after the custom became popular with the illiterate classes it was abandoned by the wealthy.

The change in the social classes using ex-votos produced a number of changes in the paintings themselves. Prior to the nineteenth century, ex-votos had been done on canvas. Now tin became the most popular material. The character of the painting also changed, with the naive artists forming their own clichés and modes of ob-

servation. The graphic methods of these painters (many of whom also produced retablos) were primitive, and their concepts of perspective and color developed a distinct flavor. "So many people painting so many things common to all developed a language."[1]

The Artists

Roberto Montenegro describes the outlook of the ex-voto painter thus:

Stringent needs or rare intuition obliged the Mexican painters of the first half of the 19th century to begin their work painting the so-called "retablos" [ex-votos] and it is to their credit and at the same time to the advantage of these artists that they had no examples to guide them nor school of painting to follow. They pictured nature with the sincerity that is apparent in their work, ingenuously and with no other thought than to set down what appeared before them without hurry and without interest. No foreign review came to disturb their peace nor to vary their program. Their creative activity limited itself to work in the endeavor to advance further and further toward perfection in the immense pleasure of painting.

The lack of technique, the discretion of the use of tone and inimitable charm of the fashion of the time, created a school which affords us a sensation of sincerity and makes us see in those old and timeworn portraits the qualities which by their own merit, obliges us to give them a place of preference in our admiration.[2]

These words point up important differences between the painting of retablos and the painting of ex-votos. The retablo, with its simple format illustrating a single figure, could be copied exactly from many sources. The miraculous cure or rescue depicted on the ex-voto, however, had to be constructed solely from the imagination. It is true that the holy persons pictured on ex-votos could be copied from traditional sources, but the paintings as a whole were the products of the artists' own creativity. Many problems of perspective, color, and shading are handled in a fresh, new way which would not have been possible with copying, and solutions to problems in depicting the narrative—such as showing two or three simultaneous scenes of action—offer striking originality.

Although an ex-voto could have been painted by the person experiencing the miracle, it was traditionally done by a specific individual in the village or barrio. The client would go to him and relate his experience, and the artist interpreted this in paint. Only after

the client was satisfied would he take the ex-voto to a church or shrine and place it next to the image invoked or nail it into the wall nearby.

Before the twentieth century these votive paintings were always anonymous, perhaps because the artist felt that the experience truly belonged to the person to whom it happened, or more likely because his work was simply a trade and he was on an artisan level. This product was not for the glorification of the artist, but rather for the commemoration of a miraculous event. Today, however, ex-votos are being signed with the painter's name and address.

The Artistic Characteristics

Although changes have occurred over the past centuries in the materials and formats of these paintings, certain characteristics have remained constant. Ex-votos usually show some person prostrate with illness and members of the family or interested persons gathered around praying for the sick person's recovery. Or in an equally tense and dramatic manner, the ex-voto represents an accident or incident where the victim escapes certain death from some frightful circumstance. Occasionally, likenesses seem to have been attempted in the principal characters, but more often than not, physical characteristics melt into a type favored by the artist. Lavish attention is given to costume and to the careful rendering of interior scenes. Hierarchical scaling is used, and the figures are placed above each other, allowing everyone to be seen and counted. Pyramidally arranged groups are common, especially in earlier ex-votos. Such conventionalization of perspective heightens the charm and often intensifies the dramatic quality.

The composition of the votive painting is arranged in horizontal bands with the written text appearing at the bottom, the action or miracle portrayed in the middle section, and at the top, less carefully defined, if at all, the area occupied by the image or images invoked. "Man is a kind of deep-air animal crawling on rock bottom, his face lifted to a stratosphere where the holy beings dwell. These in turn bend over the ledge of the dense pool, in search of their faithful."[3]

The saints and manifestations of Christ and Mary pictured on ex-votos are so numerous that they rival the vast crowds of godlings in the Aztec theogony. The popularity of the holy personages who appear in retablos is far more general than that of the local miraculous saints or Madonnas who were the recipients of ex-

votos. Whereas most people may recognize a distinct type portrayed on a retablo, few can identify correctly by local title the image placed on an ex-voto, unless it is from a popular shrine known throughout Mexico.

The slice of life offered to the viewer of these paintings varies from the colonial period to the nineteenth and twentieth centuries. While a great deal of attention is given to clothing and interiors in both early and late ex-votos, different effects are sought and achieved by the different classes. In ex-votos done for the wealthy up to the end of the eighteenth century, there is a reflection of upper-class concern for riches and ostentatious appearances. Gold leaf might be applied. Later a similar magnification is seen among the offerings of the poor, but for a different reason. Bare interiors are transformed into luxurious red brick floors; *petates* or crude pallets become raised, sometimes canopied beds with sumptuous bolster cushions; jewelry is indicated that might never have existed; the men wear immaculate white or brand-new blue overalls, while the women appear in voluminous petticoats and bright rebozos. Here dirt and rags are reserved for the villain. In ex-votos, the poor can dream and present a perhaps more suitable offering to a saint than an exact portrayal of their surroundings might afford.

Throughout this phase of Mexican art, faith and sincerity are immediately expressed. The event is reduced to its most simple dramatic elements, and the entire story surrounding the circumstances has an admirable directness. The characters portrayed reflect the calm serenity of faith, a faith in the reality of the marvelous which results in a description without falseness or overemphasis because there is never a feeling that this was an extraordinary event. No one is trying to sell anything. "The picture, therefore, is the first thing a picture should be, convincing."[4]

The Development and Decline

The period of most prolific production of the ex-voto in Mexico parallels that of the retablo. However, unlike the retablo, the personalized ex-voto could not be replaced by the colored lithograph. It continues to be produced in a small way, but for the most part the quality has deteriorated into something akin to comic book art (complete in some cases with dialogue, enclosed in bubbles, coming from the characters' mouths). Occasionally a well-painted ex-voto of a recent twentieth century date is found, suggesting a remnant of the former tradition. In general, though, the day of the ex-

voto has passed, and the little paintings are being replaced by the more realistic and perhaps more graphic method of illustrating favors and healings by silvered milagros (tiny tokens symbolizing the favor received), photographs, braces, crutches, and even x-ray plates.

As the tradition has declined, Mexican artists and authors have come to appreciate the heritage of the ex-voto. Several feel that ex-votos were the only redeeming feature of Mexican art during the nineteenth century and the administration of Porfirio Díaz.[5] Their value as almost a pure art, independent of academic beliefs or prior inhibiting artistic education, has also been commented on, particularly by Diego Rivera.[6] The paintings of Gabriel Fernández Ledesma recall ex-votos, of which he has a large and partially published collection. Roberto Montenegro expresses their value as "a document indispensable to the understanding of Mexican painting, from the Pre-Cortesian frescoes, codices, and ceramics, through the murals of the 16th century convents, the colonial epoch with its Spanish influence, and the personal romantic paintings of the 19th century—especially the portraits—to the contemporary school of pictorial representation."[7]

In addition to their artistic merit as natural works of art employing abstract expression and evoking significant moods and messages, ex-votos are of great importance as sociological studies. An examination of all the ex-votos in any one shrine or church would produce a fascinating record of the people's hopes and fears, their thoughts, lives, and experiences, a record more honest than the fullest statistical study. In the words of Brenner:

From place to place and period to period, significantly, occupations, situations, official clothing, progress in caravan against a changeless endless background, vibrant of human trouble and of racial agonies throughout. Plagues, droughts, conflicts, are dated and described. The very emotion concurrent is charted, in kind and quality. In the quiet of miracles some years, the violence others; in the faith that makes them numberless, [the ex-voto] . . . is a moving record of a nation, a stethoscopic measure of its heart.[8]

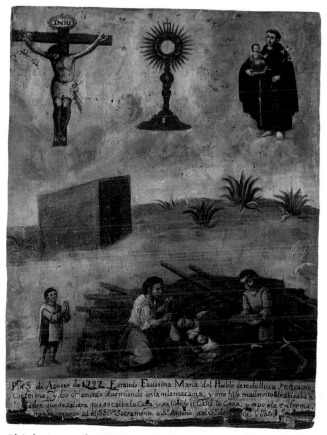

El 3 de Agosto de 1797 Estando Faustina María del Pueblo de teololluca en cama enferma y dos criaturas durmiendo en la misma cama, y otro hijo mallorsito le abisaba a la madre que se saliera que se caiba la Caza y saliendo el Callo la Caza y tapo ála enferma instante invoco al el SSmo. Sacramento, a Sn. Antonio, a el Sr. de chalma, y libero——

On the 3rd of August of 1797, when Faustina María of the town of Teololluca was sick in bed with her two children sharing the same bed, another son a little older advised his mother to get out because the house was falling. As soon as the boy went outside the house collapsed and covered up the sick woman: instantly she invoked the Holy Sacrament, St. Anthony, the Lord of Chalma, and it freed [them].

This little oil on canvas was collected in an area north of Mexico City, where it was the only ex-voto in the entire church. It features exceptionally fine detailing on the faces and hands. The men are especially worth noticing. Both wear a garment common during a much earlier period, a simple cloth split in the middle and worn in the manner of a poncho. The three images invoked are as large as the characters involved in the calamity, a commonly seen device. This painting gives a strange feeling of desolation through its limited space and tilting background.

66
Ex-Voto 1825
9⅝" x 12"

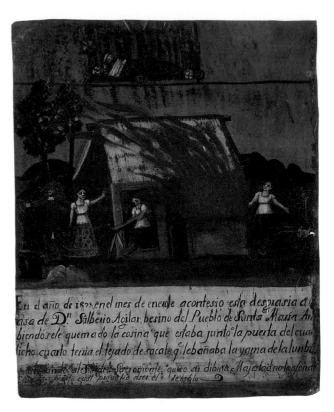

Flames engulfing the side of
a thatched house provided a
particularly lively scene for this
ex-voto painter. The blues and reds
comprise sharp color contrasts,
adding to the excitement of the
misfortune. Most of the characters
are posturing dramatically while
one woman, perhaps Doña Aguilar,
is carrying an article of furniture
through the window. The holy
image invoked has been partially
rusted away. He is separated from
the earthly scene by a heavy
painted line.

En el año de 1825 en el mes de enero, le acontesio esta
desgrasia a la casa de Dn. Silberio Agilar, besino del Pueblo
de Santa Maria. Habiendosele quemado lo cosina que estaba
junto a la puerta del cuarto, dicho cuarto tenia el tejado de
sacate qe lebañaba la yama de la lumbre y inbocando al Sr del
Sacromonte quiso su dibina Majestud no le ofendera el fuego
por lo cual prometio asen el retablo.

In the year of 1825 in the month of January, this misfortune
happened to the house of Don Silverio Aguilar, resident of the
town of Santa Maria. The kitchen of the house was on fire,
which was close to the rest of the house that had a roof made
out of grass. The flames from the fire of the kitchen came very
close to this roof. Invoking to the Lord of Sacromonte, the Lord
prevented the rest of the house from catching fire. This is why
(she or he) promised to make this retablo.

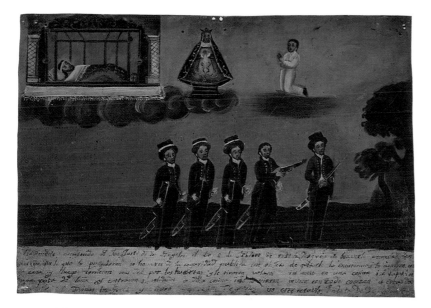

Haviendole acontecido A Jose Justo de los Angeles el dia 8 de Febrero de 1850 la Desgracia de haverle acomadado un ———: por lo que lo perciquieron 10 hombres de la seguridad publica con objeto de quitarle la excistencia lo ayaron en su casa y luego corrieron tras Del por las huertas y le tiraron valasos ise metio en una cosina ise tapo con una poca de leña y entraron 3 soldados a dicha cosina i no lo vieron invoco con todo corazon a estas dos Divinos Imagines y hubo ——— ——— De gracias ise este retablo ——— ———

Having happened to Jose Justo de los Angeles on the 8th of February of 1850, the misfortune of having committed a ———: This is why ten men of public safety [police or soldiers] followed him with the purpose of ending his existence, they found him at his house and then they ran after him through the farms and the soldiers started shooting after him. He then got into a kitchen of a house and covered himself with some wood. Then three soldiers entered the kitchen and they did not see him. He invoked with all his heart to these two divine images and there was ——— ——— In gratitude he made this retablo in the ——— ——— ———

The key to the disaster depicted on this ex-voto lies in the missing words. However, the text which still can be read indicates that José was the man with the gun, not the receiver of the shot. José also appears above the military scene, this time in civilian clothes. He is praying to two figures, Our Lord of Sacromonte and Mary in her manifestation of "La Soledad."

68
Ex-Voto 1850
12½″ x 17″

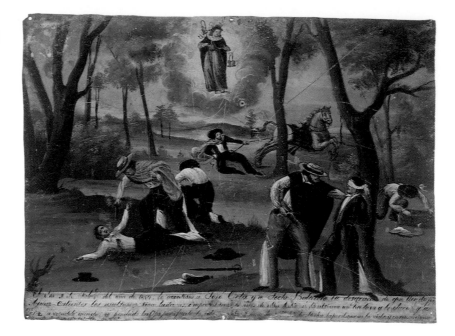

El dia 5 de Feb del año de 1850, le
acontesio a José Ortiz y a Teclo Baltierra
la desgracia de que llendo por Aguas
Calientes los asaltaron sinco ladrones, e
improvisado uno de ellos le dio a
Baltierra un Balaso y lo ———— y a Ortiz
aviendolo incado y Vendado los Ojos
para fucilarlo invoco al Santo niño de
Na. Sa. de Atocha les perdonaron la vida
y en reconociemento didico este retablo.

On February 5, 1850, to José Ortiz and
Teclo Baltierra fell the misfortune that,
while traveling by Aguas Calientes,
they were held up by five thieves, and,
improvidently, one of them shot
Baltierra, and ————, and Ortiz, having
had him kneel and having blindfolded
him in order to shoot him; he invoked
the Holy Child of Atocha to spare their
lives, and in gratitude he dedicates this
retablo.

In the ex-voto shown here, a highly trained artist—perhaps of European
origin—details a common occurrence in nineteenth century Mexico.
Care has been taken to make the villains thoroughly despicable. They are
bearded, while the victims are clean shaven, and the bandit attacking
Ortiz has a cigarette drooping insolently from his mouth.

The horse has a quality of the European Renaissance, and the bandits
have a European look. The complex and nicely executed sylvan landscape
bears no resemblance to the scene of the crime mentioned in the text.
Instead it gives the impression of a stage backdrop for the action. This
effect is heightened by Ortiz's feet, which project onto the text.

The rendering of the Child of Atocha is also interesting. Always seated
in retablo art (e.g. fig. 6), this holy person appears here in a standing
position. The appearance of the lower body in comparison with the torso
and head indicates that the artist was more familiar with the traditional
seated figure.

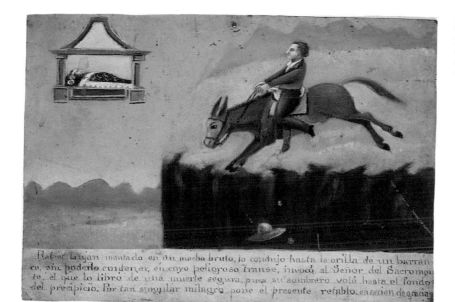

Rafael Lujan montado en un macho bruto, lo condujo hasta la orilla de un barranco, sin poderlo contener, en cuyo peligroso transe, invocó al Señor de Sacromonte, el que lo libró de una muerte segura, pues sa sombrero voló hasta el fondo del precipio. Por tan singular milagro pone el presente retablo en accion de gracias.

Rafael Lujan mounted on an unbroken mule which conducted him to the edge of a cliff, without being able to control it, he invoked the Lord of Sacromonte in this dangerous situation. The Lord of Sacromonte saved him from a sure death, since his hat was blown to the bottom of the precipice. For this unique miracle this retablo is presented as an act of gratitude.

Although this rather subtle ex-voto is undated, the costume of Señor Lujan places it in the mid-nineteenth century. Another interesting clue is the folded item hanging down in front of the saddle. Most likely this is an *arma*, a simple piece of leather which was pulled over the rider's legs for protection from the brush. This kind of covering commonly was used in Mexico until the twentieth century, when chaps cut to fit over the legs became more popular.

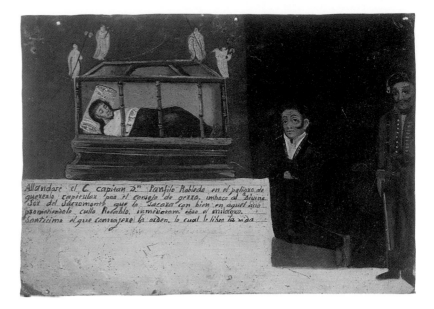

Allandose el C. capitan Dn. Panfilo
Robleda en el peligro de queserlo
capitular por el consejo de gerra.
imbocó al Divina Sor del Sacromonte
que lo sacara con bien en aquel
año prometiendole cullo Retablo,
immediatamte obro el milagro.
Santisima el que contragere la orden,
lo cual le libro la vida

When C. Capitan Don Panfilo Robleda
was in danger of being captured by the
war council, he invoked the divine
Señor del Sacromonte so that he will
help him come out well of this affair.
After he promised this retablo
immediately the miracle worked and
this miracle brought the order in which
his life was spared.

The costumes place this undated ex-voto in the mid-nineteenth century.
However, the text barely outlines the miracle, leaving it unclear as to why
the captain was brought before the war council and not specifying which
war was being fought. Additional words appear in pencil beneath the
painted legend, but unfortunately these are illegible. The figures at the
four corners of the case holding the holy figure are an unusual embellish-
ment by the artist. Perhaps saints or wingless angels, they hold symbols of
the passion.

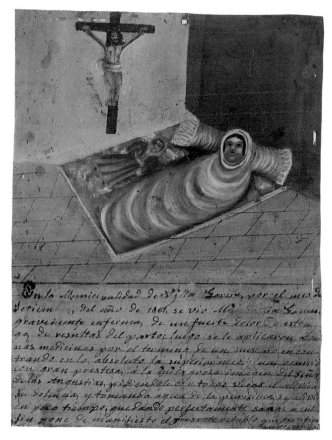

The tradition of portraying scenes with more luxuries than in reality is well illustrated in this ex-voto. Although Señora Gomez lies on a pallet on the floor, she is supported by a sumptuous bolster cushion. To bring the figures even more into the viewer's attention, the entire pallet has been tilted forward. The child appears as a small adult, as do most children in folk art.

En la municipalidad de Villa Garcia, por el mes de Setiembre del año de 1861, se vio M——— Gomez, gravemente enferma, de un fuerte dolor de estomago, de resultas del parto; luego se le aplicaron medicinas por el termino de un mes: no encontrando en lo absoluto la superior medicina, ocurrio con gran prestesa, a la milagrosa imagen del Senor de las Angustias, pidiendole con todas ———, el alivio á su dolencia, y tomando agua de la purísima, se alivio en poco tiempo, quedando perfectamente sana: á cullo fin pone de manifiesto el presente retablo que testifica la superioridad.

In the municipality of Villa Garcia, during the month of September of the year 1861, M——— Gomez found herself gravely ill of a severe stomach ache as a result of childbirth. Then several medicines were applied to her for one month. Not having found absolutely the superior medicine, she turned with great haste to the miraculous image of the Lord of Anguishes, asking him with all ——— the cure of her ailment, and, drinking the water of the Purest Conception, she was cured in a short time, remaining perfectly healthy, to which end she manifests this retablo that testifies to the superiority.

72
Ex-Voto 1861
10" x 13⅞"

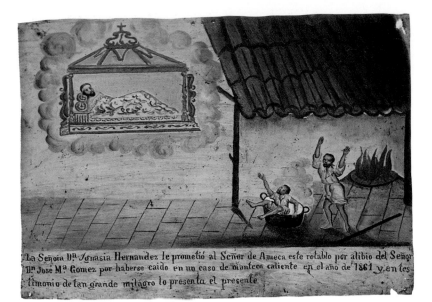

La Señora Da. Ignasia Hernandez le prometió al Señor de Ameca este retablo por alibio de Señor Dn. José Ma. Gómez por haberse caida en un caso de manteca caliente en el año de 1861 y en testimonio de tan grande milagro lo presenta el presente

Señora Ignacia Hernández promised the Lord of Ameca [Lord of Sacromonte] this retablo for having Señor José María Gómez healed of the injuries he received when he fell in a pot containing hot lard in the year of 1861, and in testimony of such a great miracle she presents this retablo.

This ex-voto is distinguished by an unusual oriental appearance. The posturing of the figures and the manner in which they are shaded suggest Chinese and Japanese paintings, as do the designs on the case containing the holy figure and the spiraling clouds. However, direct oriental influence on a̅ folk artist would be unlikely. The size of the figures, the sparseness of detail, and the color combinations are nicely planned and work well together.

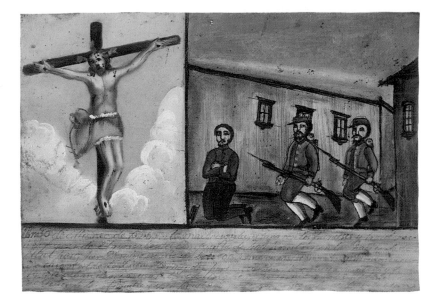

El 30 de Marzo de 1864 en la madrugada atacaron los franceses traidiroes a la fuerza de Aguascalientes compuesta de 400 hombres en la hacienda de Eltal paso, perdiendose en este combate 400 hombres entre muertos y heridos en cuyo caso el Soldado Lucas Hernandez, perteneciente a esta fuerza herido ya y fugitivo, se vio milagrosamente libre de los que ———

At dawn on March 30, 1864, the French and the traitors attacked the garrison at Aguascalientes, made up of 400 men, at the hacienda of Eltal canyon, 400 men, dead and wounded, being lost in this battle, in which case the soldier Lucas Hernandez, of the garrison, wounded and fleeing, was miraculously freed from those who ———

Although not very artistically exciting, this ex-voto depicts the time of the French intervention in Mexico, dramatizing the tremendous resistance of the Mexican people. Soldier Hernandez probably did not kneel to pray with two French soldiers marching behind him, but the artist took liberties with reality in order to graphically depict the enemy yet show the donor praying.

74
Ex-Voto 1870
7" x 10"

This ex-voto demonstrates an unusual artistic ability. Each of the personalities portrayed had a different facial expression, and all are believable. A concern for realism shows in Monica's limp, wet clothes and in the careful depiction of the side view of the well, which has been opened to allow the viewer to see the miracle in its full impact. The little girl who discovered the emergency gestures toward the picture, and one of the figures pulling Monica out of the well appears to have wings. The subtle grays and blues of the earthly scene contrast nicely with the red and white figure of Christ.

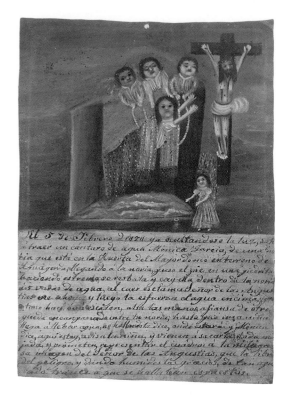

El 5 de Febrero de 1870, ya ocultandose la luz, sale á traer un cántaro de agua Mónica García, de una noria que está en la huerta del mayordomo en terreno de Aguagorda, Llegando á la noria; puso el pie en una piedrita haciendo estremo, se resbala y cay ella dentro de la noria á 5 varas de agua, al caer exclama Señor de las Angustias me ahogo y luego la esfuerza el agua encima, y pronto se hace á un escalon, alsa las manos, afiansa de otro, queda encompanada entre la noria, hasta que una niña llega á llevar agua, no hallondola dice, onde estará: y Mónica dice, aqui estoy, avisa la niña, y vienen á sacarla, toda mojada y prometen, representár el cuadro a la milagrosa imagen del Señor de las Angustias, que la libró del peligro, y dando humildes las gracias, de tan apurado trance á que se hallaban espuestos.

On the fifth of February of 1870, when night was falling, Mónica García goes to bring a pot of water from a well in the orchard of the landlord, in the land of Aguagorda. Arriving at the well, she puts her foot on a small stone, reaching very far; she slips and falls into the well, at a depth of five yards. Upon falling, she exclaims, "Lord of Anguishes I am drowning!" And then, the water pushes her to the top, and soon she reaches a step, raises her hands, and grabs another [step]. She remains suspended in the well until a little girl arrives to take water; not finding it [or her], she says, "Where would it [or she] be? And Mónica says, "Here I am." The little girl carries the news, and they come to take her out, all wet, and they promise to erect a picture of the event to the miraculous image of the Lord of Anguishes, who saved her from the danger she was exposed to, giving their humble thanks.

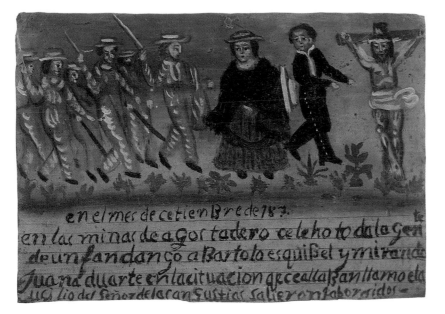

en cl mes cetienbre de 187. en los minas
de Agostadero celeho toda la gente
de un fandango a Bartolo esquibel y
mirando Juana duarte en la cituacion
que ce allaban llamo el aucilio del Señor
de las angustias salieron faboresidos.

In the month of September of 187.
[1870] in the mines of Agostadero all
the people of a party attacked Bartolo
Esquivel, and Juana Duarte, seeing in
what situation Bartolo was, asked for
the help of the Lord of Anguishes. In
receiving his favors, they came out all
right.

The text of this ex-voto has been read by many, and each has had a
different interpretation. Various translations of "celeho toda la gente de
un fandango" allow different conclusions. Does "fandango" mean a party,
a dance, or a riot? Are the two main characters having an affair? The
phonetic spelling makes the exact meaning difficult to determine. The
color and action are nicely presented, and the characters seem to be
dancing across the top of this ex-voto.

76
Ex-Voto 1875
7" x 9¼"

This is a faithful duplication of a neoclassic altar of the nineteenth century. This rather cold and sterile style replaced most of the dramatic baroque altars during this time. The gold leaf or paint which once decorated the pillars on this ex-voto has worn away. The marbling effect may not be an attempt to depict real marble, but an exact duplication of the altar maker's painting on a wooden base. Notice the addendum to the text, written in a different hand.

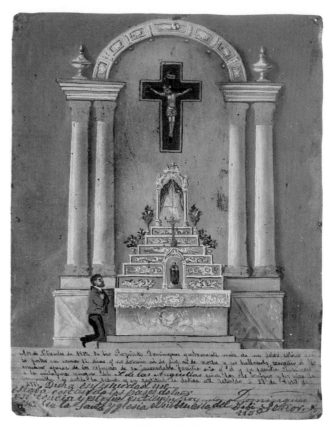

El 15 de Nobiembre de 1875, se bio Pioquinto Domínguez grabamente malo de un dolor colico que lo portro en cama 12 dias qe no dormia ni de dia ni de noche y no hallando remedio a lo umano apesar de los esfuersos de su inconsolable familia asta q' el y su familia ocurrieron a la milagrosa ymagen del S. de las Angustias quien los allo benigno y les hizo la maravilla de darle la salud y en gratitud te dedica esta retablo a 27 de Abril de 1876.

Dicha enfermedad me estaba cortando los pasos de la existencia y esto fue en tiempo. Pioquinto Domínguez ———— la Santa Yglesia el nobenario del divino Señor.

On the fifteenth of November of 1875, Pioquinto Domínguez was very gravely ill of the colic that put him in bed twelve days, during which he did not sleep either day or night, and not finding human remedy, despite the efforts of his inconsolable family, until he and his family went to the miraculous image of the Lord of Anguishes, who found him sick and performed the marvel of giving him health, and in gratitude he dedicates to Thee this retablo on the twenty-seventh of April, 1876.

Such infirmity was shortening the steps of existence, and this was timely. Pioquinto Domínguez [will recite] in the Holy Church the novena of the Divine Lord.

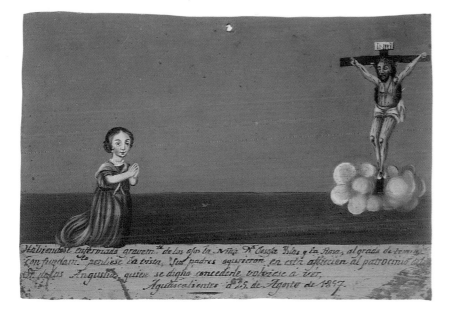

Habiendose enfermado gravemnto. de los ojos la Niña Da. Josefa Yslas y la Rosa, algrado de temrse confundamnte. perdiese la vista, sus padres agurieron en esta affliccion al patrocinio del Sr. de las Angustias quien se dignó concederle volviese á vér.

<div align="right">

Aguascalientes a
29. de Agosto de 1897.

</div>

Finding herself gravely ill in the eyes, the little girl Josefa Yslas y La Rosa, to the degree of being afraid of losing her sight, her parents went, in this affliction, to the patronage of the Lord of Anguishes, who deigned to grant to them that her sight would return.

<div align="right">

Aguascalientes,
August 25, 1897.

</div>

 This ex-voto is one of many which simply depict an individual praying, the image prayed to, and the text. In cases of illness there often was not much else to portray. On the ex-voto shown here, Doña Josefa has particularly large eyes, perhaps a special concern of the artist because of the little girl's affliction.

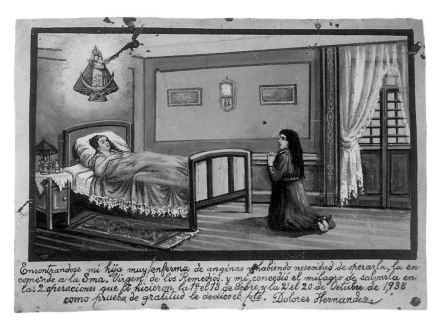

En contrandose mi hija muy enferma de anginas y habiendo nesecidad de operarla, la en comende a la Sma. Virgen de los Remedios. y me concedió el milagro de salvarla en las 2 operaciones que le hicieron la 1ª el 13 de Sebre y la 2 el 20 de Octubre de 1938 como prueba de gratitud le dedico el pte. Dolores Hernández

En contrandose mi hija muy enferma
de anginas y habiendo nesecidad de
operarla, la en comende a la Sma. Virgen
de los Remedios, y me concedió el
milagro de salvarla en las 2 operaciones
que le hicieron la la. el 13 Sebre y la 2 el
20 de Octubre de 1938 como prueba de
gratitud e dedico el pte.

<div align="right">Dolores Hernández</div>

Finding my daughter very ill from
tonsils and needing an operation, I
commended her to the Holiest Virgin
of Remedies, and she granted me
the miracle of saving her in the two
operations that were performed on her,
the first on the 13th of September and
the second the 20th of October of 1938.
As proof of gratitude I dedicate the
present.

<div align="right">Dolores Hernández</div>

This ex-voto gives the viewer a glimpse of an upper middle class bedroom in Mexico in the 1930s. The lace on the spread and curtains and such items as the clock, paintings, nightstand, and lamp were luxury items. Despite all of this emphasis on detail, the perspective is realistically incorrect. Dolores Hernández's black clothes suggest that she may be in mourning.

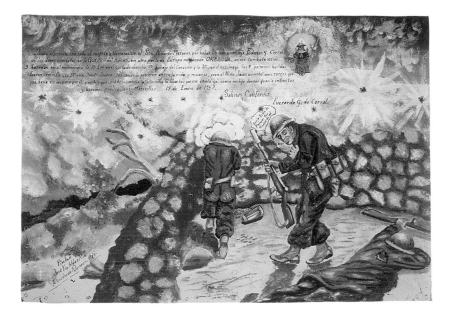

Dedico el presete con todo el respeto y Veneración al Sto. Niño de Plateros, por haber librado a mi hijo Federico G. Corral, de los duros combates en la GUERRA del Año 45. en una parte de Europa nombrado OKENOUA. en ese combate sufrió. 3 heridas en el mismo día la 1a. fue en el costado derecho. 2a. hahajo del Corazón y la 3a. en el estómago. las 2 primeras heridas fueron con rifle y la 3a. con Ametralladora. las cuales lo pusicron entre la vida y muerte. pero el Niño Jesus escuchó mis ruegos que que hasia en mi casa por él: y mi hijo que acada momenta lo aclamaba lo liberto: por eso tanto yó, como mi hija damos gracia infinitas y hasemos público sus Maravillas 17 de Enero de 1957.

<div align="right">Salinas, California
Everarda G. de Corral</div>

I dedicate this retablo with respect and veneration to the Holy Child of Plateros for having saved my son Federico G. Corral from the heavy fighting in the war of the year of 1945 in a part of Europe called Okinawa. In that fighting he suffered 3 wounds in the same day. The first one was in the right side, the second one beneath his heart, and the third one in his stomach; the first two wounds were done by a rifle, and the third one with a machine gun. These wounds had him between life and death, but the child Jesus listened to my prayers that I was making in my house for him, and he also listened to my son who used to acclaim him every moment. The Holy Child of Plateros saved him. That is why I and my son give infinite thanks and we make public his power. January 17, 1957.

<div align="right">Salinas, California
Everardo G. de Corral</div>

This ex-voto is typical of the modern effort in an almost comic book style, complete with words in bubbles. How Señor Corral came to live in California is open to speculation, but that he came from Mexico and occasionally went back there is clear. The artist who signed his name to this ex-voto lives in Rincón de Romos, a town in the State of Aguascalientes south of Plateros, Zacatecas, the site of the shrine of the holy figure to whom the painting is dedicated. Notice that this ex-voto was painted twelve years after the miracle occurred, a not uncommon delay.

80
Ex-Voto 1960
9⅝" x 13⅞"

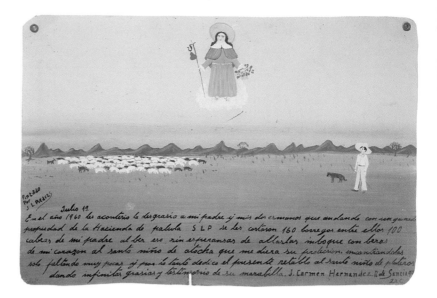

81
Ex-Voto 1961
8⅞" x 11¾",
oil on
Masonite

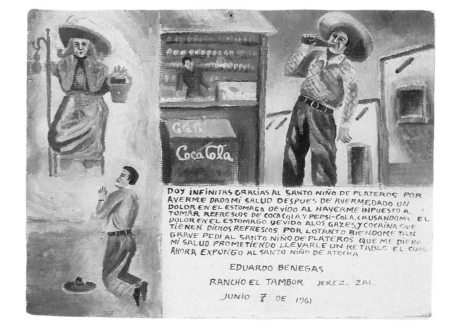

Julio 12
En el año 1960 les aconterio la desgrasia
a mi padre y mis dos ermanos que
andando con un ganado propiedad de la
Hacienda de Palula SLP se les cortaron
160 borregos entre ellos 100 cabras de
mi padre al ber eso sin esperansas de
allarlas imboque con beras de mi
corazon al santo niño de atocha que me
diera su protecsion. encontrandoles solo
faltando muy pocas y por lo tanto,
dedico el presente retablo al santo niño
de plateros dando infinitas grasias y
testimonio de su marabella.
j. Carmen Hermandez R. de Santiago,
Zac.

On July 12, 1960, a misfortune occurred
to my father and two brothers while
they were herding sheep, property of the
Hacienda Palula, San Luis Potosí. One
hundred sixty head were separated,
among them 100 goats of my father.
Upon seeing this and with no hope of
finding them, I invoked with sincerity
in my heart the Holy Child of Atocha to
give me his protection. Having found
most of them, I dedicate this retablo to
the Holy Child of Plateros, giving
infinite thanks in testimony to his
wonder.
J. Carmen Hernandez, R. de Santiago,
Zacatecas

This ex-voto is remarkable for a spacious feeling of fields and
mountains. This openness is increased by placement of the lettering of
the text on the foreground rather than in a separate block of space. The
proportions of the shepherd and his dog in relation to the flock and
mountains is quite good, giving the viewer an idea of the loneliness a
shepherd must sometimes feel. This ex-voto bears the name of the artist,
a feature rare in the older paintings.

Doy infinitas gracias al Santo Niño de
plateros por averme dado mi Salud
despues de averme dado un dolor en el
estomago devido al haverme impuesto a
tomar refrescos de coca cola y pepsi-cola
causandome el dolor en el estomago
devide a los gazes y cocaina que tienen
dichos refrescos por lo tanto biendome
tan grave pedi al Santo Niño de Plateros
que me diera mi salud prometiendo
llevarle un retablo el cual ahora expongo
al Santo Niño de Atocha.
Eduardo Benegas, Rancho el Tambor
Jerez, Zac., Junio 7 de 1961

I give infinite thanks to the Holy Child
of Plateros for having given me my
health after I had a pain in the stomach
from becoming used to drinking Coca-
Cola and Pepsi-Cola refreshments,
causing me this pain in the stomach due
to the gases and cocaine that these
refreshments have. Therefore, seeing
myself so ill, I asked the Holy Child
of Plateros to give me my health,
promising to take him a retablo which
I now display to the Holy Child of
Atocha.
Educardo Benegas, The Drum Ranch,
Jerez, Zacatecas, June 7, 1961

This modern ex-voto offers thanks for relief from a modern complaint—
stomach problems. Perhaps this trouble is not as frightening as plague
or smallpox, but it was an immediate worry for which Señor Benegas
sought remedy in a time-honored tradition. The painting on this ex-voto is
crude, but unlike most modern ex-voto paintings, this one does not bear
the artist's signature.

PART 4
SUPPLEMENTARY
MATERIAL

APPENDIX A
SURVEYS REGARDING THE POPULARITY OF RETABLO SAINTS

The following three surveys were made independently of one another. They are the only investigations concerning the popularity of retablo saints that this writer has been able to uncover or promote.

The first survey involves the collection in the Taylor Museum of Art, Colorado Springs, Colorado, acquired by W. S. Stallings in the 1940s mainly from towns in the state of Guanajuato. There were sixty-four retablos in his original purchase and, while the number is relatively small to support broad conclusions, it nevertheless supports the percentages arrived at by the other two surveys. A breakdown of the Stallings purchase[1] is as follows:

N. S., Refugio de Pecadores	17.1%
Divino Rostro	15.6
Mater Dolorosa	10.9
San José	7.8
El Niño de Atocha	6.2
N. S. de Guadalupe	6.2
La Trinidad	4.6
El Sagrado Corazón	3.1
Mano Poderosa	3.1
Others	25.4

These percentages might be altered slightly when it is considered that Carillo y Gariel grouped under the theme "Rostro Divino" images of Christ showing the head, neck, and shoulders with a rope around the neck. Strictly speaking, "Rostro Divino" refers to the image of the face only, as it was supposed to have appeared on the napkin of Veronica. The "portrait" of Christ lassoed is called *Ecce Homo* (see fig. 2).

Included in the category called "others" are the Virgin Mary in her advocation of N. S. de Carmen and Purísima Concepción, SS.

Francisco de Asís, Francisco de Paula, Buenaventura, Cayetano, and Clemente, all totaling roughly one percent each.

—

The second breakdown was made by Reginald Fisher, longtime researcher and collector of retablos.[2] Fisher offers these percentages on the basis of personal observation over the period of several years, rather than using any specific totaling, for he does not mention the exact time or size of the sample. In the retablos observed by Fisher, N. S. de Refugio averages around twenty-five percent of the entire production, and next in popularity, with percentages of from five to ten percent are: La Guadalupana, Mater Dolorosa, La Sagrada Familia, San José, La Trinidad, San Jerónimo, El Niño de Atocha, and San Francisco de Paula.

—

The third supportive investigation is a specific tally taken by this writer in Nogales, Sonora, November 1966. A tourist-oriented border town sixty-five miles south of Tucson, Arizona, Nogales began featuring the popular paintings on tin in some colonial furniture and curio shops around 1964. In November 1966, 341 recently arrived retablos were examined. Their origins ranged throughout the "retablo belt," their condition was anywhere from excellent to scruffy, and they had not been picked over by customers. They had all been brought to Nogales by a peddler from Guadalajara, Jalisco, who had collected them individually from small settlements in the Bajio section of Mexico, then sold them to different shops. The table which follows gives the results of examination of this group of retablos.

NOGALES SURVEY, NOVEMBER 1966

Retablo	Percent	Number
N. S., Refugio de Pecadores	18.48	63
Mater Dolorosa	15.24	52
La Sagrada Familia	7.33	25
San José	7.03	24
La Trinidad	4.68	16
San Jerónimo	3.81	13
El Niño de Atocha	3.51	12
N. S. de Guadalupe	3.51	12
San Antonio de Padua	3.22	11
Santa Rita	2.63	9
San Francisco de Paula	2.34	8
El Alma de María	2.05	7

San Camilo de Lelis	2.05	7
Purísima Concepción	1.75	6
San Rafael	1.75	6
San Ysidro Labrador	1.47	5
Santa Librata	1.47	5
Mano Poderosa	1.17	4
Santa Isabel de Portugal (?)	1.17	4
San Ramón Nonato	1.17	4
El Sagrado Corazón	1.17	4
N. S. de la Luz	Less than 1%	3
El Hombre Eucaristico de Dolores	"	3
La Piedad	"	3
El Divino Rostro	"	3
San Vicente Ferrer	"	2
Ecce Homo	"	2
San Luis Gonzaga	"	2
San Francisco de Asís	"	2
La Huida a Egipto	"	2
San Juan Nepomuceno	"	2
San Juan Bautista	"	2
Santa Gertrudis	"	1
N. S. de Atocha	"	1
San Leonardo	"	1
Cristo a la Columna	"	1
Jesús Nazareno, N. S. de la Misericordia, or N. S. de Labrador	"	1
Santa Lucía	"	1
La Sagrada Familia con Santa Ana y San Joaquín	"	1
San Miguel	"	1
Unidentifiable Virgin Statue Paintings	2.05	7
Unidentifiable Madonnas with Child	.58	2
Unidentifiable Saints (badly mutiliated)	.58	2

APPENDIX B
A CAPSULE HISTORY
OF COLONIAL MEXICAN ART

When the Spanish arrived in Mexico, they found a rich and complex artistic tradition. However, the early clerics who directed the Indians in construction of buildings and in painting and sculpture discouraged the use of traditional native forms, for they saw in them the expression of pagan beliefs. Still, the union of the two civilizations often formed a unique style in the early sculpture and architecture—especially in small details of decoration and ornamentation and in certain stylistic devices such as flattened forms and bold color schemes. But no powerful overtones of the Indian artistic heritage pervaded official colonial art, despite frequent contentions to the contrary by nationalistic writers.

The history of Mexican colonial art largely parallels that of Europe. Ironically, this is partially due to the fact that there were few European-trained artists of renown working there who might have positively influenced New World artistic orientation. Lacking strong artistic direction, Mexican painters became copiers of the latest European fashion. Instead of originality, protest, or criticism, the criterion for excellence became the ability to produce an acceptable, predictable product.

Major trends in colonial Mexican art directly reflect stylistic changes in the European paintings used as models. A logical development can be seen from the late manneristic paintings of Simón Pereyns, the first important European painter to work in Mexico, arriving in 1566. In the following twenty-four years until his death he contributed dozens of altar paintings, most of which, unfortunately, have been lost. For inspiration, Pereyns relied upon engravings by European painters such as Martín de Vos. He probably also used imported originals by this highly influential manneristic artist. Manneristic approaches, such as the elongation of figures, twisted forms combined with high coloration, and a certain jewel-like preciousness in lighting, continued in Mexican art into the early 1600s, with a few early baroque innovations introduced by Alonso Vásquez and his contemporary, Baltasar de Echave Orio.

Raphael may be considered another early model, if not directly, then through the medium of the Spanish painter Juan de Juanes. The sweetness and softness of Raphael was emphasized, and this quality, which many times in Mexican art borders on sentimentality, is retained through the years that follow.

By the mid-1600s the full baroque movement of drama and twisted, swirling forms exemplified by Zurbarán and Rubens provided heavy influence. The colonial painter used Zurbarán's large areas of light and shade, modeling effects, mood, and realism, and the movement and sumptuousness of Rubens. Unfortunately the fluidity and understanding of artistic elements exploited by those two men were not imparted to colonial artists, who managed to turn everything into a stereotype of terse, tight realism dredged in sentimentality.

These characteristics were emphasized by the strongest influence in Mexican colonial art—that of Murillo. This southern Spaniard's paintings of holy persons caught in the throes of religious ecstasies, or radiating sweetness, all done with the greatest degree of realism, seemed to fulfill what every Spanish and Mexican patron of the arts desired. The dry formula of heavy drama, contrasts in light and color, and twisting action, combined with overwhelming tenderness and delicate beauty—all tied together by stringent realism—would last until the early nineteenth century.

Mexican artists such as the Juárezes, the Correas, and Miguel Cabrera, working in styles heavily influenced by Murillo and steeped in sentimentality, enjoyed great popularity (see La Trinidad, frontis). Products of their brushes and workshops and the work of their imitators dating from the mid-1600s until the early 1800s were highly sought after and can be found today adorning almost any church in Mexico. It was this type of painting that the provincial retablo painter could see and copy (see La Sagrada Familia, fig. 1).

In the late eighteenth century the neoclassic style, the frigidity of Mengs that was in vogue in Madrid, was transported to Mexico, complete with plaster casts of newly discovered classical sculpture. This mode fast became fixed in Mexican art, challenging the sentimental baroque, for it was proclaimed by colonial Mexico's first artistic center, the Academy of San Carlos, established by charter in 1785. The first to teach painting as something apart from the huge altar pieces, the academy became a school and ministry of official taste. Its students were taught what good taste was and the proper techniques and rules to describe beauty. Far away in the provinces, the folk artist remained unaware of these dictates, and the retablo movement was unaffected by the neoclassic mode.

Although many writers have treated the academy-dominated pe-

riod of Mexican art (late 1700s through entire nineteenth century) in a negative manner, it did provide a clean break with the baroque style and later coincided with rising nationalism and provided roots for modern Mexican painting. The academy still exists today, although drastically changed and under a different name.

This discussion of artistic trends should not imply that colonial Mexican art as a whole was merely a transplantation of European forms in the New World or that it was lacking in individuals who expressed singularly skillful and highly regarded work. Among the outstanding colonial artists were Alonso López de Herrera, Sebastian López de Argeaga, Pedro Ramírez, and Cristóbal de Villalpando. The achievement of freshness and originality by these Mexican artists despite a milieu which discouraged these traits is indicative of the slumbering artistic independence which later would awaken in the fiercely nationalistic and strongly original artists of the Mexican Revolution and beyond.

NOTES

PART 1

1. The appearance of folk art in so many nineteenth century environments has been explained as a brief interim between court and commercial taste. The freedom provided by the breaking down of the ancient régime and the brief respite of agrarian exploitation allowed time and energy for creation of simple personal objects. But in a country where even the simplest household object has always been adorned for the pure joy of decoration or color, this all-encompassing explanation doesn't quite fit, especially since each individual did not create his own object of worship, but instead purchased those available from traveling peddler/artists.

2. Artes de Mexico, *Retablos Mexicanos*, no. 106, 1968.

3. Reginald Fisher, "Santos— Bultos—Retablos" in *Mexican Iconographic Art* (El Paso: El Paso Museum of Art, 1966), p. 6.

4. Ibid., p. 4.

5. Manuel Toussaint, *Pintura colonial en México* (México: Instituto Nacional de Antropología e Historia, 1965), p. 26; and Pál Kelemen, *Anales del Instituto de Investigaciones Estéticas* 33 (México, D.F.: n.p., 1964), p. 33. In the 1960s an early example of the use of imported material was discovered. Juan Gerson received the inspiration for his murals painted in 1562 in the Franciscan church in Tecamalco from wood engravings from a bible identified as having been printed in Lyon in 1558 ("Lugduni, apud Jacobum de Millis, M.D. LVIII").

6. Pál Keleman, *Baroque and Rococo in Latin America* (New York: Macmillan, 1951), pp. 200– 201.

7. Conversation with Doris Fisher, December 11, 1966, El Paso, Texas. The late Dr. Reginald Fisher had done much research concerning retablos over a number of years, but with the exception of the previously cited bulletin for the El Paso Museum of Art, he left no printed works on the subject.

8. Abelardo Carrillo y Gariel, "Imaginería popular novo-español," in *Encicilopedia mexicana de arte* I (México, D.F.: Ediciones Mexicanas, 1950), pp. 41–42.

PART 2

1. Francois Cali, *The Spanish Arts of Latin America* (New York: Viking Press, 1961), p. 9.

2. Donald Attwater, *A Dictionary of Saints; An Index to the Complete, Revised Edition of Alban Butler's* Lives of the Saints (New York: P. J. Kenedy and Sons, 1958), p. v.

3. In the 1967 *141° Calendario de Mariano Galván Rivera*, an inexpensive popular booklet published yearly by Librería y Ediciones (México, D.F.), fifty-three Juans are listed, indicating the possibility of confusion which can exist even in this small and not totally inclusive work.

4. Old Testament themes were traditionally avoided, as was the nude figure.

5. Anita Brenner, *Idols Behind Altars* (New York: Payson and Clarke, Ltd., 1929), p. 147.

6. Juan Ferrando Roig, *Icono-*

grafía de los santos (Barcelona: Ediciones Omega, 1950), p. 24.

7. The saints themselves are also frequently familiarized, as when Mary becomes lovely by Mexican standards and appears as a plump brunet adorned with pierced earrings and pendant necklaces.

8. Roig, p. 11.

9. Mitchell A. Wilder with Edgar Breitenback, *Santos: The Religious Folk Art of New Mexico* (Colorado Springs, Colorado: Taylor Museum of the Colorado Springs Fine Art Center, 1943), plate 14. In the last half of the fifteenth century the idea of the Immaculate Conception gained great importance. As a result, artists tried to invent an appropriate symbol for it. After a number of attempts, they translated into painted form the Apocalyptic Woman.

10. Abelardo Carrillo y Gariel, "Imaginería popular novo-española," in *Enciclopedia mexicana de arte* I (México, D.F.: Ediciones Mexicanas, 1950), p. 11.

11. Carrillo y Gariel, p. 23 and Reginald Fisher, "Santos—Bultos—Retablos," in *Mexican Iconographic Art* (El Paso: El Paso Museum of Art, 1966).

12. The information given here concerning modern saints' popularity is derived from observation at ecclesiastical supply houses, Catholic book stores, religious supply outlets, and booths inside and outside churches in Mexico, generally in the same areas in which retablos originated.

13. Examination of *Año christiano* by P. Juan Croisset, S.J. (2nd ed. [Madrid: Establecimiento tipografico de Manuel Rodríguez, 1878–85]), a book used in Mexico for daily devotion, discloses no mention of San Martín. Although not every saint is included in this volume, the most popular ones are chronicled.

PART 3

1. Anita Brenner, *Idols Behind Altars* (New York: Payson and Clark, Ltd., 1929), p. 166.

2. Roberto Montenegro, *Mexican Painting (1800–1860)* (New York and London: Appleton-Century Co., Inc., 1933), pp. 14–16. Note that Montenegro uses the term *retablo* instead of *ex-voto*. Although he never defines what he means by *retablo*, from the context and from his use of this term in later articles we can assume he employs it synonymously with *ex-voto*.

3. Jean Charlot, "Mexican Ex-Votos," *Magazine of Art* 42, no. 4 (April 1948): 141.

4. Brenner, pp. 166–67.

5. MacKinley Helm, *Modern Mexican Painters* (New York and London: Harper and Brothers, 1941), p. 8; and Manuel Toussaint, "Colonial Painting in Mexico," *Mexican Art and Life* 5 (1939).

6. Brenner, p. 170.

7. Roberto Montenegro, *Retablos de México* (México, D.F.: Ediciones Mexicanas, 1950), p. 164.

8. Brenner, pp. 164–65.

APPENDIX A

1. This survey is detailed in an article by Abelardo Carrillo y Gariel, "Imaginería popular novo-española," *Enciclopedia mexicana de arte* 1 (México: Ediciones Méxicanas, 1950), pp. 1–45.

2. These observations are contained in the El Paso Museum of Art bulletin by Reginald Fisher, *Mexican Iconographic Art*, under the heading "Santos—Bultos—Retablos" (El Paso: El Paso Museum of Art, 1966).

SELECTED BIBLIOGRAPHY

Retablo art has been largely neglected by modern Mexican authors who, while acknowledging its charm, its contributions to Mexican art, and its gradual disappearance, have failed to apply themselves to specific study of origin, authorship, or even identification of subjects. Apart from the work of Carrillo y Gariel, little except brief mentions or descriptions has been written concerning the Mexican folk retablo. Although a much greater amount of material exists concerning the New Mexican counterpart of this art, most of the noteworthy work in this area was done before 1960.

While there is very little written about the retablo, the related ex-voto enjoys more publicity. Because ex-votos portray dramatic moments and include written texts, they are favorites among writers and collectors of Mexican art and folklore. However, with the exception of Roberto Montenegro's book *Retablos de México*, written material on the ex-voto is descriptive rather than analytic.

The following bibliography is selective in nature, including mainly those works the author found most useful in the course of research for this book. These materials will be helpful to the reader who wishes to explore the subject further.

American Federation of Arts. *Mexican Arts*. Introduction by René d'Harnoncourt. Catalogue of exhibition organized for and circulated by the American Federation of Arts. Portland, Maine: Southurst Press, 1930.

Aradi, Zsolt. *Shrines to Our Lady around the World*. New York: Farrar, Straus and Young, 1954.

Arrendondo, Rosa Camelo, Lacroix, J. Gurría; and Reyes, Valerio C. *Juan Gerson, Tlacuilo de Tacamachalo*. México, D.F.: Instituto Nacional de Antropología e Historia, 1964.

"Art of the Americas," *Art News Annual* 18. New York: The Art Foundation Inc., 1948.

Artes de México, *Retablos Mexicanos*, no. 106, 1968. (México, D.F.)

Attwater, Donald. *A Catholic Dictionary*. New York: Macmillan, 1943.

————. *A Dictionary of Mary*. New York: P. J. Kenedy and Sons, 1956.

————. *A Dictionary of Saints: An*

Index to the Complete Revised Edition of Alban Butler's Lives of the Saints. New York: P. J. Kenedy and Sons, 1958.

Baird, Joseph Armstrong, Jr. *Mexican Architecture and the Baroque*. Vol. 3 of *Acts of the 20th International Congress of the History of Art*. Princeton, N.J.: Princeton University Press, 1963.

Baring-Gould, Sabine. *The Lives of the Saints*. Edinburgh: John Grant, 1914. 16 vols.

Bernardino de Sahagún, O.F.M. *Historia general de la Nueva España*. Madrid: n.p., 1905–7.

Bles, Arthur de. *How to Distinguish the Saints in Art*. New York: Art Culture Publications, Inc., 1925.

Borgés, Pedro. *Métodes misionales en la cristianización de América, siglo XVI*. Madrid: Consejo Superior de Investigaciones Científicas, Departamento de Misionología Española, 1960.

Borhegyi, Stephan F. "A Retablo by the 'Quill Pen Painter'." *El Palacio* 64, nos. 7–8 (1957): pp. 238–42.

Boyd, E. *Saints and Saint Makers of New Mexico*. Santa Fe, New Mexico: Laboratory of Anthropology, 1946.

———. "A New Mexican Retablo and Its Mexican Prototype," *El Palacio* 56, no. 12 (1949): pp. 353, 355–57.

———. "Nuestra Señora de la Manga." *El Palacio* 57, no. 6 (1950): pp. 163, 165.

———. "San Vicente Ferrer, a Rare Santero Subject." *El Palacio* 57, no. 7 (1950): pp. 195, 197.

———. "Our Lady of Refuge, from Frascati to Northern New Mexico." *El Palacio* 57, no. 9 (1950): pp. 275, 277.

———. "The Source of Certain Elements in Santero Paintings of the Crucifixion." *El Palacio* 58, no. 8 (1951): pp. 235–36.

———. "Santos of San Ysidro Labrador." *El Palacio* 63, no. 4 (1956): pp. 99–100.

———. "A Roman Missal from Santa Cruz Church." *El Palacio* 64, nos. 7–8 (1957): pp. 233–37.

Brenner, Anita. *Idols Behind Altars*. New York: Payson and Clarke, Ltd., 1929.

Butler, Alban. *The Lives of the Saints*. Edited, revised and supplemented by Herbert Thurston, S.J. London: Burns, Oates, and Washbourne, 1926–38. 12 vols.

———. *Lives of the Saints*. Complete Edition. Edited, revised, and supplemented by Herbert Thurston, S.J., and Donald Attwater. New York: P. J. Kenedy and Sons, 1956. 4 vols.

Cali, Francois. *The Spanish Arts of Latin America*. New York: Viking Press, 1961.

Carrillo y Gariel, Abelardo. "Imaginería popular novoespañola" in *Enciclopedia mexicana de arte* 1. México, D.F.: Ediciones Mexicanas, 1950.

Carroll, Charles D. "Miguel Aragon, a Great Santero." *El Palacio* 50, no. 3 (1943): pp. 49–64.

Cassidy, Joseph L. *Mexico, Land of Mary's Wonders*. Paterson, N.J.: St. Anthony Guild Press, 1958.

Castillo de Lucas, A. *Folklore Medico-Religioso*. Madrid: A. Castillo de Lucas, 1943.

Castro Mantecón, Javier, and Zárate Aquino, Manuel. *Miguel Cabrera*. México, D.F.: Instituto Nacional de Antropología e Historia, 1958.

Catlin, Stanton Loomis, and Grieder, Terence. *Art of Latin America since Independence*. New Haven, Conn.: Yale University Press, 1966.

141° Calendario de Mariano Galván Rivera. México, D.F.: Librería y Ediciones, 1967.

Charlot, Jean. *Mexican Art and the Academy of San Carlos*

1785–1915. Austin: University of Texas Press, 1962.

———. "Mexican Ex-Votos." *Magazine of Art* 42, no. 4 (1949): 138–42.

Cook, Walter; Spencer, William; and Guidol Ricart, José. *Pintura e imaginería romanicas.* Vol. 6 of *Ars Hispaniae.* Madrid: Editorial Plus Ultra, 1946–47.

Coulson, John, ed. *The Saints: A Concise Biography Dictionary.* New York: Hawthorn Books, 1958.

Croisset, P. Juan, S.J. *Año christiano.* 2nd ed. Madrid: Establecimiento tipográfico de Manuel Rodríguez, 1878–85.

Cruz, Francisco Santiago. *Las artes y los gremios en la Nueva España.* México, D.F.: Editorial Jus, 1960.

Delaney, John J., and Tobin, James Edward. *Dictionary of Catholic Biography.* Garden City, N.Y.: Doubleday and Company, 1961.

Englebert, Omer. *The Lives of the Saints.* Translated by Christopher and Anne Fremantle. New York: Collier Books, 1964.

Espinosa, José Edmundo. *Saints in the Valley.* Albuquerque: University of New Mexico Press, 1960.

———. "Notes on Boyd's Tentative Identification." *El Palacio* 59, no. 1 (1952): pp. 3–17.

Ferguson, George. *Signs and Symbols in Christian Art.* New York: Oxford University Press, 1961.

Fernández Ledesma, Gabriel. "The Meaning of Popular 'Retablos'." *Mexican Art and Life* 6 (1939). (Mexico, D.F.)

Fisher, Reginald. "Santos—Bultos—Retablos." In *Mexican Iconographic Art,* a bulletin issued for distribution to accompany exhibit on Mexican art at the El Paso Museum of Art, July 31–October 16, 1966.

Fremantle, Anne, ed. *A Treasury of Early Christianity.* New York: Viking Press, 1953.

Gaskell, George Arthur. *Dictionary of All Scriptures and Myths.* New York: Julian Press, 1960.

Gibbs, Jerome T. "The Retablo Ex-Voto in Mexican Churches." *El Palacio* 61, no. 12 (1954): pp. 402–7.

Gudiol, José. *The Arts of Spain.* Garden City, N.Y.: Doubleday and Company, 1964.

Hall, Adelaide S. *A Glossary of Important Symbols.* Boston: Bates and Guild Co., 1912.

Halseth, Odd S. Miscellaneous short biographies and descriptions accompanying photographic reproductions of various retablos. *El Palacio* 25, nos. 14–17, 18, 19, 20, 24, 25 (1928); 26, nos. 2–4, 5, 6–7, 9–12, 13–14, 21–22 (1929); 37, no. 3–4 (1934).

Helm, MacKinley. *Modern Mexican Painters.* New York and London: Harper and Brothers, 1941.

The Holy Bible. Douay Edition. New York: P. J. Kenedy and Sons, 1914.

Hoyt, Edith. *The Silver Madonna.* México, D.F.: Editorial Letras, 1965.

Jameson, Anna Brownell. *Sacred and Legendary Art.* 3rd edition. Boston and New York: Houghton, Mifflin and Company, 1857, preface.

Kelemen, Pál. *Anales del Instituto de Investigaciones Estéticas* 33. México, D.F., 1964.

———. *Baroque and Rococo in Latin America.* New York: Macmillan, 1951.

Kubler, George. *Santos.* Monograph issued by Amon Carter Museum of Western Art to accompany an exhibit of New Mexican Santos, June 1964.

———, and Soria, Martin. *Art and Architecture in Spain and Portugal and Their American Dominions, 1500–1800.* Suffolk, England: Penguin Books, 1959.

Lehner, Ernst. *The Picture Book of*

Symbols. New York: Wm. Penn Publishing Co., 1956.

———. *Symbols, Signs and Signets.* Cleveland: World Publishing Co., 1950.

Lovasik, Lawrence G. *Our Lady in Catholic Life.* New York: Macmillan, 1957.

MacMillan, James H. *Fifteen New Mexican Santos.* Santa Fe, N.M.: Libros Escogidos, 1941.

Markova, Nadine. "Living in Guanajuato." *Mexico/This Month* 12 (September–October 1966). (Mexico City.)

Missale Romanum, Ex Decreto Sacrosancti, Concilii Tridentini Restitutum. Atverpiae: Architypographia Plantinia, 1734.

Montenegro, Roberto. *Mexican Painting (1800–1860).* New York and London: Appleton-Century Co., Inc., 1933.

———. *Retablos de México.* México, D.F.: Ediciones Mexicanas, 1950.

Moreno Villa, José. *Lo mexicano en las artes plásticas.* México, D.F.: Colegio de México, 1948.

Moyssén, Xavier, "Pintura popular y costumbrista del siglo XIX." *Artes de México* 56 (1965). (México, D.F.)

Murillo, Gerardo [Dr. Atl]. *Los artes populares de México.* 2 vols. México, D.F.: Editorial Cultural, 1921.

Murray, Peter and Murray, Linda. *Dictionary of Art and Artists.* New York: Frederick A. Praeger, 1956.

New York Museum of Modern Art. *Twenty Centuries of Mexican Art.* With introduction by Roberto Montenegro. New York: Museum of Modern Art, 1940.

Ocha, V., R. P. Ec. Ángel S., O.F.M. *Breve historia de Nuestra Señora de Zapopan.* Zapopan, Jalisco: n.p., 1961.

The Praeger Picture Encyclopedia of Art. New York: Frederick A. Praeger, 1958.

Quinn, Robert M. "The Spanish Colonial Style," *The Colonial Arts of Latin America.* Monograph issued to accompany an exhibit of colonial art at the Tucson Art Center, Tucson, Arizona, January–February, 1966. 7 pp.

Réau, Louis. *Iconographic de l'art chrétien.* Paris: Presses Universitaires de France, 1955.

Roeder, Helen. *Saints and Their Attributes.* London: Longman, Green and Company, 1955.

Roig, Juan Ferrando. *Iconografía de los santos.* Barcelona: Ediciones Omega, 1950.

Rojas, Pedro. *Época colonial.* Vol. 2 of *Historia general del arte mexicano.* México, D.F.: Editorial Hermes, 1963.

Sanchez Pérez, José Augusto. *El culto mariano en España.* Madrid: Consejo Superior de Investigaciones Científicas, Instituto Antonio de Nebrija, 1943.

El santuario de Plateros y el Santo Niño. México, D.F.: Editorial Progreso, 1965.

Sardo, R. P. Fr. Joaquin. *Relación historica del Sto. Cristo del Santuario y Convento de Chalma,* n.p., n.d.

Short descriptions accompanying photographic reproductions of retablos. *El Palacio* 27, nos. 8–10 (1929).

Sitwell, Sacheverell. *Southern Baroque Art.* New York: A. A. Knopf, 1924.

Sodi de Pallares, María Elena. *Historia de una obra pía: El hospital de Jesús en la historia de México.* México, D.F.: Ediciones Botas, 1956. 6 vols.

Tibol, Raquel. *Época moderna y contemporánea.* Vol. 3 of *Historia general del arte mexicano.* México, D.F.: Editorial Hermes, 1963.

Toor, Frances. *Mexican Popular Art.* Edited by McBride and Co. México, D.F.: Frances Toor Studios, 1939.

Toussaint, Manuel. *Arte colonial en México.* México, D.F.: Instituto Nacional de Antropología e Historia, 1962.

———. *Colonial Art in Mexico.* Translated by Elizabeth Wilder Weismann. Austin, Texas: University of Texas Press, 1968.

———. *Pintura colonial en México.* México, D.F.: Instituto Nacional de Antropología e Historia, 1965.

———. "Colonial Painting in Mexico," *Mexican Art and Life* 5 (1939). (Mexico City.)

Trens, Manuel. *María, iconografía de la Virgen en el arte español.* Madrid: Editorial Plus Ultra, 1946.

Vargas Ugarte, Rubén, S.J. *Historia del culto de María en Iberoamérica y de sus imágenes y santuarios más celebrados.* Third edition. 2 vols. Madrid: Talleres Gráficos Jura, 1956.

Voragine, Jacobo de. *La leyenda dorada.* 2 vols. Madrid: Biblioteca Hispania, 1913.

Velázquez Chávez, Agustín. *Tres siglos de pintura colonial mexicana.* México, D.F.: Editorial Polis, 1939.

Violant Simorra, R. *El arte popular español.* Barcelona: Ayma, S.L., 1953.

Voigt, Robert J. *Symbols in Christian Art.* Somerset, Ohio: Rosary Press, Inc., 1952.

Whittick, Arnold. *Symbols, Signs and Their Meaning.* London: Leonard Hall, 1960.

Wilder, Mitchell A., with Edgar Breitenback. *Santos: The Religious Folk Art of New Mexico.* Colorado Springs: Taylor Museum of the Colorado Springs Fine Art Center, 1943.

Wolf, Eric. *Sons of the Shaking Earth.* Chicago: University of Chicago Press, 1964.

Zobelde Ayala, Fernando. *Philippine Religious Imagery.* Manila: Atenco de Manila, 1953.

Zuño Hernández, José G. *Los artes populares en Jalisco.* Guadalajara, Ediciones Centro Bohemio: 1957.

GENERAL INDEX

The following index contains references to general information concerning retablos and ex-votos as well as references to specific place-names, holy persons, and motifs. Page references for the latter two categories appear under the Spanish name with English cross-references to the Spanish, except in cases where the name is similar or identical in both languages. Page references to illustrations appear in **bold italics;** text references are in Roman. Readers wishing to identify holy persons depicted on Mexican folk retablos should refer to the Index of Attributes and Patronages (here cross-referenced as IAP) following this general index.

Abbot, *114*
Acacio, San, 76, **77**
Academy of San Carlos, 5, 173
Adam and Eve, 32, *33*, 34, *36;* Christ as second Adam, 32, *33*, 46; Mary as second Eve, 46
Agnes, Saint, 67
Aguascalientes, Mexico, 163
Alegoría de la Redención, 32, *33*, 34, 45
Allegorical retablos, *28*, *30*, 31, 32, *33*, 34, *35*, 45, 46, *47*
Alma de María, El, *40*, 41, 170
Aloysius Gonzaga, Saint. *See* Luis Gonzaga
Altars: church, 2, *160*, 172, 173; home, 1, 2, *35*, 73, 74. *See also* Churches; Statues
Amaranto, San Gonzalo de. *See* Gonzalo de Amaranto, San
Amecameca, N.S. de, 66, **156**
Ana, Santa, *28*, 29, *79*, *108*, 171
Anatomy, depiction of, 6; interesting examples of, *19*, *42*, *63*, *64*, *80*, *136*
Angels, 46, 56, 89, *140*, *154*, *158*. *See also* Cherubs; Gabriel; Miguel; Putto; Rafael
Angustias, María Santísima de los. *See Pietá, La*
Angustias, N.S. de, *155*, *158*, *159*, *160*, *161*
Animals as depicted on retablos, 41. *See also specific names of animals, IAP*
Antonio de Itzcuintla, San, 66
Antonio de Padua, San, 73, *80*, 81, 149, 170
Apocalipsis, La Virgen de, 46. *See also* Apocalyptic Woman

Apocalyptic Woman, 46, *47*, *52*, *55*, 69
Apocrypha, 67, 76, 78, 109, 111, 137
Apostle saints, 23, 49, 72, *136*, 137, 159
Apprentice artists, 5, 12, 87
Archangels. *See* Angels
Architectural elements, depiction of, 7; examples of on ex-votos, *150*, *155*, *156*, *160*, *162*, *164;* examples of on retablos, *23*, *79*, *89*, *108*, *118*, *140*
Arizpe, Sonora, Mexico, 13
Arma, 153
Art history, Mexican, 4–10, 172–74
Artists: examples of talent and creativity of, *16*, *44*, *50*, *63*, *82*, *118*, *140*, *160;* ex-voto, 144, 145, 147; retablo, 4–5; trained, 3, 8–9, 18, *39*, *120*, *152*, 172–74. *See also* Apprentice artists; Naive style; Red bole group; Signatures of artists; Stylistic influences; Workshop theory; *specific names of artists*
Assisi, Saint Francis of. *See* Francis
Atocha, El Niño de, 24, *25*, 72, 74, *152*, *163*, *164*, 169, 170
Atocha, N.S. de, *48*, 171
Attributes, 6, 7, 54, 66–68; transformation of, 18, 32, *33*, 96, *112*. *See also* Iconography; Imagery; *specific names of attributes, IAP*
Attwater, Donald, 65
Atzcapotzalco, Lady of, 66

Augustinian Order, 71
Aztecs, art of, 172. *See also* Pagan beliefs, transfer of

Baby Jesus. *See* Infant Jesus
Bailón, San Pascual. *See* Pascual
Bajío section of Mexico, 169
Baroque tradition, 2, 5, 6, 7, 9, 129, 160, 172, 173, 174. *See also* Chiaroscuro; Grand Manner
Behold the Man. *See* Ecce Homo
Benedict of Palermo, Saint. *See* Benito de Palermo
Benedictine Order, saint in, 100, *101*
Benito de Palermo, San, *82*, 83
Bishops, *84*, *125*
Black Christ. *See* Negro, El Cristo
Black saints. *See* Dark saints
Black, The. *See* Benito de Palermo
Blacks: artistic uses of, 7; for flesh tones, *26*, 75; symbolic meanings of, 71, 90, 100, *101*, 162
Blas, San, *84*
Blossoms. *See* Flowers
Blues: artistic uses of, 12, 76, *150*, *158;* symbolic meanings of, 16, 37, 70, 73, 81
Bole, as underpainting, 11. *See also* Red bole group
Bonifacio, San, *86*, *87*
Brenner, Anita, 147
Brocht, Pieter van der, 9
Brothers of Saint John of God. *See* Ministers of the Sick

INDEX OF ATTRIBUTES AND PATRONAGES

Predominantly a listing of symbols, attributes, and physical characteristics, this index is designed to help identify holy persons depicted on Mexican folk retablos. Since the specific areas of aid and protection offered by the various saints are often keys to identification, patronages have also been included. Page references to illustrations appear in ***bold italics;*** text references are in Roman. Refer to the General Index (here cross-referenced as GI) for names of specific saints and motifs as well as for general information concerning retablos and ex-votos.

Fishermen, saints invoked by, *61*

Flags. *See* Banners

Flames, *99;* as depicted on ex-votos, *150, 156;* as symbols of hell, 32, *33, 35,* 88, *89;* as symbols of religious fervor, 90, *93,* 138, *139. See also* Heart, flaming; Torch

Flesh tones, dark, *26, 52, 55, 58,* 73, *82*

Flowers: as attributes, 7, 22, 24; as part of blossoming staff, 16, *17, 110;* crowns of, *40,* 90, *116, 136;* as decorative embellishment, 130, *131;* as part of statue paintings, 9, *23, 25, 26,* 71; real, inserted into slits in tin, 7. *See also* Statues; *names of specific flowers*

Fourteen Holy Helpers, saints among, *77, 84, 114, 116*

Franciscan Order, *17,* 29, 71, 72, 73, 88; saints in, 73, *80, 82, 99, 112, 126*

Furniture, depictions of: on ex-votos, 145; interesting examples of, *89, 108;* on retablos, 7

Gamblers, patron of, 90, *91*

Garden, walled, as rosary symbol, 46

Girls, saints invoked by, *80,* 81, *116,* 117. *See also* Youth

God the Father. *See* Father

Gold, symbolic meanings of, *52, 55. See also* Gilt paint, GI; Gold leaf, GI

Gossip, saint invoked against, 72, 130, *131. See also* Accusations; Secret-keeping

Gourd, as attribute, 24, *25, 128, 134*

Grapevine, as attribute, *22*

Green, symbolic meanings of, 16, *108, 110*

Grill, prison: as attribute, *114;* as Passion symbol, 32, *33*

Grotto. *See* Cave

Habits. *See* Robes

Halos, unusual examples of, *48, 61. See also* Tres potencias

Hammer, as Passion symbol, 32, *33, 35, 44*

Hands: as attributes, *28,* 29, 32, *33,* 34, *35;* depiction of, 1, *17,*

26; with fingers pointing skyward, 138, *139;* interesting examples of, *23, 28, 44,* 45, *52, 79,* 90, *91, 102, 114,* 130, *131*

Hats: ex-voto figures wearing, *151, 153, 154, 157, 159, 164;* retablo saints wearing, 24, *25, 48, 84, 132,* 133, *134. See also* Biretta

Headaches, saints invoked to cure, 76, *77,* 138, *139*

Heart, as attribute, *23, 36,* 37, *44;* flaming, *82,* sacred, 100, *101,* 169, 171

Heart disease, saints invoked against, *101*

Helmets: ex-voto figures wearing, *164;* retablo saints wearing, *86, 87, 122, 125*

Heretics. *See* Infidels

Hermit saints, *82, 84, 99, 102, 107, 108, 114*

Hierarchical scaling, 7, 145. *See also* Perspective, GI; Proportion, GI

Holy Ghost, symbols of. *See* Dove; Flames

Holy Helpers, Fourteen. *See* Fourteen Holy Helpers

Home, saint invoked by those seeking, *110*

Horn, as attribute, 106, *107. See also* Trumpet

Horses: as attributes, *136,* 137; patron of, *120;* saint invoked for fertility of, 72, *136,* 137

Husbands: patron of, *110;* saint invoked by those desiring freedom from, *116;* saint invoked by those wishing, *80*

IHS, *104*

Ill. *See* Sick

Imps. *See* Monsters

Infant Jesus: in motifs with Mary, *48, 58, 63, 64;* in motifs with other saints, *80, 91, 110, 136*

Infidels, saint invoked in battle against, *136,* 137

Inkhorn, as attribute, 90

INRI, 32, *33*

Interracial justice, patron for, 75

Invasions. *See* Battles

Jesuit Order, 56, 62; saints in, *104, 120*

Jesús Cristo, symbols of. See Blue; Cross, Crucifix; Heart; Jesús Cristo, GI; Lamb; Purple; Red; *names of specific implements of Passion*

Jewelry: as attribute, *44,* 45, *58, 63, 64,* 78, *79,* 90, *91;* as painted embellishment, 145; real, inserted into slits in tin, 7. *See also* names of specific articles of jewelry

Journeys. *See* Travelers

Kitchen. *See* Cooks

Kitchen implements. *See* Cooking implements

Kneeling: ex-voto figures engaged in, *151, 157, 163;* retablo saints engaged, in, *30, 42, 89, 108, 114, 120, 126, 140*

Labels on retablos, 12, 45, 65; examples of, *44, 50, 77, 84, 87, 89, 101, 118, 120*

Lace, depictions of, *61, 86, 112, 140, 162*

Ladder, as Passion symbol, 32, *33,* 34

Lamb: as attribute on retablos, *frontis,* 29, 31, *36, 84, 99, 140;* on ex-voto, *164*

Lamp, as attribute, 67, 118. *See also* Lantern

Lance, as Passion symbol, 32, *33, 35, 44,* 154

Landscapes: on ex-votos, *150, 151, 152, 153, 163, 164;* on retablos, 7, 12, *79, 84, 112*

Lantern: as attribute, 119; as Passion symbol, 32, *33, 35. See also* Lamp

Lawyers, patron of, *112*

León, Guanajuato, patroness of, *57*

Lepers, saint invoked by, *99*

Librarians, patron of, 106, *107*

Lilies, as attributes, 29, *40, 80,* 81, *82,* 90, *91, 93, 108, 110, 120*

Lima, Peru, patroness of, *136*

Lion, as attribute, 106, *107*

Livestock, saint invoked for health of, *140. See also* Cattle; Horses; Sheep

Lock. *See* Padlock

Lost objects, saints invoked by those searching for, *80*

Secret-keeping, saint invoked for, *112. See also* Accusations; Gossip

Serpent, as attribute, 46

Seven seals, on book, as attribute, 31

Shackles, as attribute, 24, *25, 114*

Sheep, as depicted on ex-voto, *164. See also* Lamb

Shell, as attribute, 24, *25*

Shepherds: as depicted on ex-voto, *164;* patron of, *126*

Shield, as attribute, 123, *136,* 137

Shirt-makers, patron of, *120*

Sick, patron of, *89. See also names of specific types of sickness*

Signatures of artists, 4, 10, 144; examples of on ex-votos, *163, 164;* examples of on retablos, *99, 120*

Skull: as death symbol, 67, *86, 87,* 90; as contemplation symbol, 106, *107, 132,* 133; as penitence symbol, *120*

Slaves, saints invoked by, 58, 82

Smallpox, saint invoked against, *82*

Snake. *See* Serpent

Soldier saints, 76, *77, 86, 87, 97, 120, 136,* 137, *151*

Soldiers, patron of, *120, 136,* 137. *See also* Soldier saints

Souls, as attributes, 32, *33,* 34, *35, 57, 89, 125*

Spain, patron of, *136,* 137

Spear, as attribute, 76, *77. See also* Dagger; Lance; Sword

Sponge, as Passion symbol, 32, *33,* 34, *35, 44, 154*

Staff, as attribute, 16, *17, 19,* 24, *25, 99, 101, 102, 108, 110, 126, 128, 134. See also* Cane; Cornstalk; Crosier; Scepter

Stars, as attributes, *93;* on crowns and halos, *40, 42, 44, 47, 61, 63, 64,* 70, *112;* on garments, *52, 55*

Sterility. *See* Fertility

Stigmata, as attribute, *23, 28, 36, 39, 132,* 133

Stockmen, patrons of. *See* Cattle; Horses; Shepherds

Stone masons, patron of, 138, *139*

Storms, saint invoked against, *57*

Students, young, patron of, *120. See also* Scholars

Subservient figures: as attributes, 7, 67; examples of, *33, 57, 89, 91, 114, 125, 132, 136,* 137

Suffering, saint invoked against, *116. See also names of specific causes of suffering*

Suitors: saints invoked by those wishing, *80;* saints invoked by those desiring freedom from, *116*

Sun, as attribute, 32, *33,* 34, *35, 36, 39, 42,* 70, *89*

Sword: as attribute, 32, *33,* 34, *35, 120, 122, 125, 136,* 137; as Passion symbol, 32, *33,* 34, *35;* of sorrow, *42, 44,* 45. *See also* Dagger; Lance; Spear

Tailors, patron of, *120*

Tears, as attribute, *42, 44*

Temptation, saints invoked against, 106, *107, 122, 125*

Tenebrae, 32, *33*

Thorns, as attribute, *44,* 45, *132,* 133. *See also* Crown, of thorns

Throat, saints invoked against diseases of, *84*

Tilma. See Cape

Titles on retablos. *See* Labels

Tongue, as attribute, 113

Torch, as attribute, 92

Towel: of Pilate, 32, *33;* of Verónica, *20*

Travelers, saints invoked by, 24, *25, 128*

Tree: as attribute, 46, *47;* of wisdom, 32, *33. See also* Landscapes; *names of specific types of trees*

Tres potencias, *26, 80*

Triangle: as symbol of God the Father, *89, 90;* as symbol of Trinity, *36, 39*

Trivial appeals, saints invoked for, *80*

Trumpet, as attribute, 67, *89. See also* Horn

Turban, as attribute, 94, *95*

Urgent cases, saints invoked in, *93*

Veil: as attribute, 43, 67, 70, 100; of Verónica, *20*

Vestments. *See* Robes

Violence, saint invoked against, 24, *25*

Virgen, La, symbols of. *See* Blue; Crown; Dagger; Dove; Gold; Lilies; Moon; Red; Rosary; Roses; Stars; Sun; Sword; Veil

Wafer, as Eucharist symbol, 32, *33,* 34, *35*

Walled garden. *See* Garden

Want. *See* Poor

Warrior saints. *See* Soldier

Wars. *See* Battles

Wealth. *See* Money

Weather, saint invoked for good, *140*

West Indies, patroness of, *101*

Wheat, as attribute, 24, *25*

White, symbolic meanings of, 7, *36, 58,* 70

Wings, as attribute, 138, *139. See also* Angels; Cherubs

Wives, saint who serves as model for, *132,* 133

Woolcombers, patron of, *84*

Wounds: as attributes, *19, 20, 23, 26, 93, 132,* 133; as penitence symbols, 106, *107. See also* Blood; Stigmata

Writing: on ex-votos, 143, 145, 146; on retablos, *89. See also* Ciphers; Dialogue; Labels; Mottos; Signatures; Spelling; *all ex-voto illustrations*

Writing implements. *See names of specific implements*

Yellow, symbolic meanings of, 16, *110*

Youth, patron of, *120*